For Marian —
With Best Wishes —
North Star Workshop —
April 10, '96

Stephen Zullo

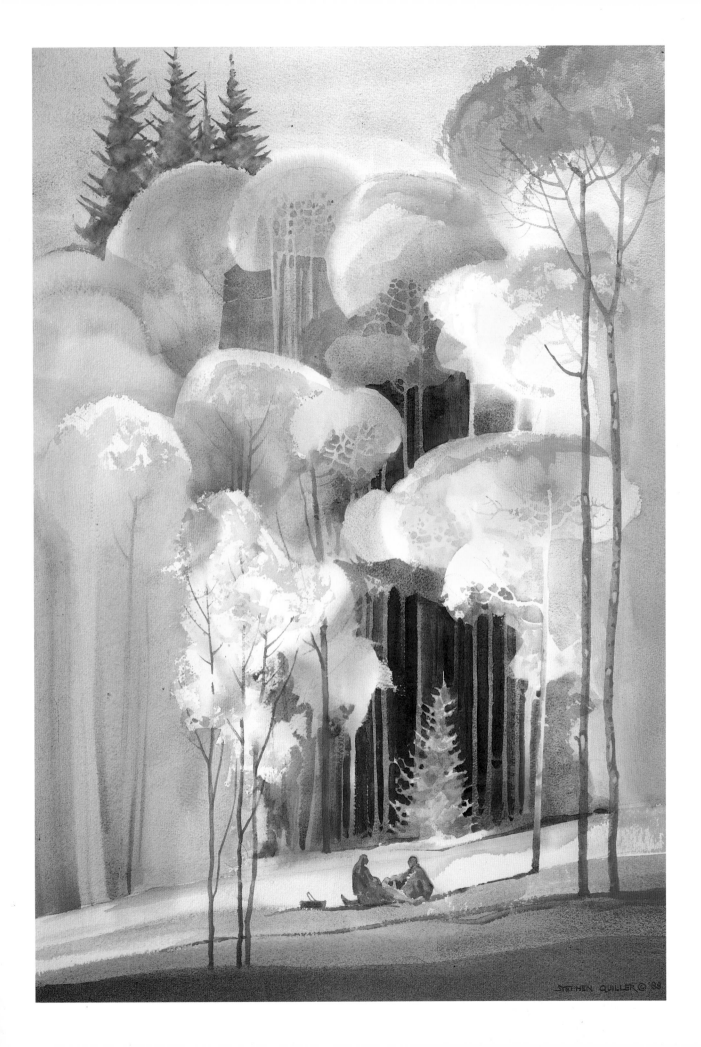

Stephen Quiller © '88

COLOR CHOICES

STEPHEN QUILLER

WATSON-GUPTILL PUBLICATIONS/NEW YORK

Art on first page:
THE PICNIC Transparent watercolor on 300 lb. Arches rough paper,
29" × 21" (73.7 cm × 53.3 cm). Collection of Barbara and Sam Dehlinger.

Art on title page:
OCTOBER CHAMISA Acrylic on Crescent watercolor board No. 114,
23" × 34" (58.4 cm × 86.4 cm). Collection of Les and Marilyn Graf.

Edited by Janet Frick
Graphic production by Stanley Redfern
Text set in 10/13 Century Old Style

All the art in this book, unless otherwise noted, is by Stephen Quiller.

First published in 1989 by Watson-Guptill Publications,
a division of BPI Communications, Inc.,
1515 Broadway, New York, N.Y. 10036

Library of Congress Cataloging-in-Publication Data

Quiller, Stephen.
 Color choices / Stephen Quiller.
 p. cm.
 Bibliography: p.
 Includes index.
 ISBN 0-8230-0696-4
 1. Color in art. 2. Colors—Analysis. 3. Color—Psychological
aspects. 4. Painting—Technique. I. Title.
 ND1488.Q55 1989 89-5799
752—dc20 CIP

Distributed in the United Kingdom by Phaidon Press Ltd.,
Musterlin House, Jordan Hill Road, Oxford OX2 8DP

Manufactured in Malaysia

First printing, 1989

7 8 9 10\98 97 96 95

TO MARTA, CHRISTOPHER, AND ALLISON

Many people have provided their assistance and support during the development of *Color Choices*. Without their efforts this book would not have been possible. I would like to thank the following people:

Bonnie Silverstein for her enthusiastic directives and support in the initial stages of the book.

Candace Raney for her guidance throughout the book's development.

Janet Frick for her invaluable suggestions and editorial directives.

Marta Benson Quiller for her editorial expertise in the polishing of the manuscript.

Artisan Art Supply in Santa Fe, New Mexico, for assistance with supplies during my research on the Quiller Wheel.

Allison Sheldon, art hardware manager in Fort Collins, Colorado, for additional assistance with the color wheel.

Ruth Beckworth for providing me with extensive notes taken from my color theory class, and for further research.

James Schaaf for providing photography equipment and general support.

Cloyde Snook, art department chairman at Adams State College, for general support over the last six years.

Adams State College for providing a facility, students, and a positive environment.

The Mission Gallery in Taos, New Mexico, for the use of paintings that were reproduced in this book.

Collectors of my work, who over the years have made it possible for me to pursue my paths as an artist and author.

Wayne Thiebaud and Wolf Kahn for their assistance in providing autobiographical material and transparencies used in Chapter 6.

The Denver Art Museum, the Museum of Western Art, the American Hispanic Society, the Phillips Collection, and the Glasgow Museum and Art Galleries for providing transparencies used in Chapter 6.

Barbara Whipple for correspondence with museums in developing Chapter 6.

Finally, Joe and Jane Clarke for the beautiful home, study, studio, and incredible environment that were used during the development of this book.

CONTENTS

INTRODUCTION

Color is magic! It can stimulate the eye and create a variety of emotions in viewers of paintings. And what a gift it is to be able to use color in a way that truly expresses what the artist feels! Some painters have a natural color sense. They "feel" by instinct what colors harmonize, without understanding the theory behind it. But most painters can become colorists only by a long process of growth. This process involves reading about color, studying master painters and how they used color, and then applying these ideas to their own work.

A few years ago, I was asked to design a new course to teach at Adams State College, where I work part-time. It could have been anything I wanted to teach. After a lot of thought, I decided to organize a class on color theory. The reason was entirely selfish: Color has always been exciting to me and this gave me an excuse to learn more about it. After much research and experimentation, I developed a course that is now part of Adams's art curriculum. The structure of the class reflects the way I first learned about color.

When I first started painting, I was most interested in technique. Then as I became more familiar with the media, composition became more important to me. As I started to understand composition, expression became important. And to express myself effectively in painting, I needed to know an astonishing amount about color. Thus I began the process of studying color and working with structured color schemes in my painting. The more I worked with these color schemes, the more exciting color became to me. I found that the impressionists and postimpressionists used color in a similar way. I discovered that the more I worked and applied these theories, the more my color sense developed. I was training my eye! As I began to understand structured color schemes more fully, I started to use color more subjectively. But I began to use color subjectively with knowledge. To me the knowledge of color is the key. The more the artist knows about color, the more personal the color can become.

When I teach workshops on color, I approach the subject in a similar way and have had great success. I start with structured color schemes and train the students' eye. Then we move to using color subjectively. By the end of the week, students are seeing color in nature that they have never seen before and are applying color to their paintings more harmonically.

In *Color Choices*, I have the opportunity to approach the subject of color the way I teach it. The first chapter of this book introduces a rather sophisticated color wheel that I have developed over the last ten years. I call it the Quiller Wheel. There are sixty-eight colors specifically arranged on the color wheel in order for the artist to diagram color relationships as accurately as possible. This color wheel will be referred to throughout the book and is the same wheel that I use in my studio. The next three chapters will develop structured color schemes. These schemes are monochromatic,

complementary, analogous, split-complementary, and triadic. Each of these concepts will be explained through illustrations, diagrams, color studies, and finished paintings.

Chapter 5, entitled "Going Beyond Structured Color," describes how I have personalized color and how I get some of my ideas for color. This section includes: (a) my approach to color while working on location; (b) studio painting that is inspired by my on-location studies; (c) painting applications of underlays and overlays using color transparently, translucently, and opaquely; and (d) paintings that are inspired by an inner vision. Chapter 6 is about certain artists past and present, nearly all considered colorists, whom I admire and who have influenced me. Most of these artists have been chosen because they use color in a very personal way. Books about each artist, and galleries and museums that exhibit their work, are also listed for the reader's further reference.

One of my greatest joys is to go to museums and study great works of art. In my eagerness to research the masters and learn how they approached color, I found that all these great painters had one quality in common: They were students their whole lives! Vincent van Gogh studied the seventeenth-century Dutch painter Jan Vermeer and commented on how beautifully the artist used the colors yellow and violet. Winslow Homer carried M. E. Chevreul's book *The Principles of Harmony and Contrast of Colors* with him always and referred to it as his "bible." (This book is still available from Van Nostrand Reinhold, republished in 1967.) At one point in his life, Rembrandt had a tremendous collection of Italian Renaissance paintings. Degas was a student and admirer of Ingres. And this list of masters who studied masters could go on and on.

What really brought this idea home to me was a trip to the East Coast. I was at the drawing and print study room at the Museum of Fine Arts in Boston and asked to see a portfolio of Winslow Homer watercolors. As I was going through the paintings, I commented on a certain area of one of them. The curator remarked that Andrew Wyeth had been in the day before and made a similar comment about that area of the same painting. I told him I had chosen the wrong day to be there! But the point is that a living master, one of the most legendary painters of our time, is still studying and growing. It is my hope that this book can be the start of an exciting adventure for many readers. I believe that by reading this book and actually applying the ideas on color to your own painting, you will develop your work to richer and more powerful expressions.

YELLOW SKY Transparent watercolor, gouache, acrylic, and casein on Crescent watercolor board No. 114, 23" × 34" (58.4 cm × 86.4 cm). Artist's collection.

1 THE COLOR WHEEL

For many years, I have been extremely interested in color as it is used for painting. As I teach water media workshops and discuss technique and paint quality, I notice that many students are struggling with color. And as I read and study, I find that there are many books on the science of color, color and light, nature and color, and color optics; there are also specialty books advocating the use of specific colors to get beautiful effects in painting. What to me has seemed most important and most needed is a book supplying a sound foundation of color for the painter. With this foundation, the artist can then use the color more intelligently and even intuitively.

I was introduced to a book in the mid-1970s entitled *Gist of Art*, by John Sloan. (Its full title is *Gist of Art: Principles and Practise Expounded in the Classroom and Studio*, New York: Dover, 1977.) John Sloan was a great painter and teacher who lived from 1871 to 1951. He was a member of the Ashcan school of painters, who painted the everyday, ordinary life in and around New York City, and was also a member of a group called "The Eight." During much of his career, he taught at the Art Students League in New York City and at one time was its president. His book is about his philosophy concerning all areas of art, including painting and color. In the section on color, he has a chart called the Dudeen Color Triangle, developed by Charles A. Winter. This is a chart designed to help the artist discover which colors will complement each other and work together best.

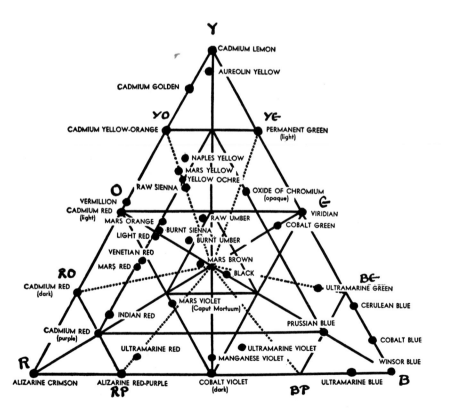

The Dudeen Color Triangle, developed by Charles A. Winter. Painter John Sloan found this color diagram useful. From John Sloan, *Gist of Art: Principles and Practise Expounded in the Classroom and Studio* (New York: Dover, 1977), page 121. Used by permission.

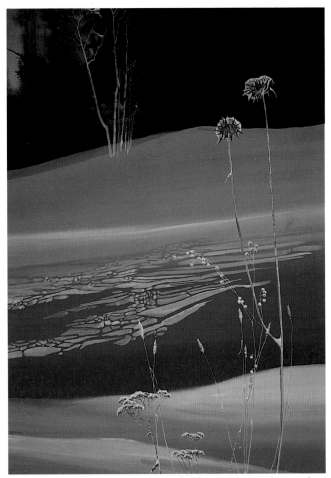

SNOW SHADOWS Acrylic and gouache on Fabriano cold-pressed watercolor board, 29″ × 21″ (73.7 cm × 53.3 cm). Artist's collection.

I experimented with this chart and used it in my paintings of that period, and soon I started to use the triangle in the color theory class that I teach at Adams State College. However, I found that the triangle was confusing. Students were used to a color circle where color relationships were more easily understood and located. I began to develop my own color wheel and found that I had to relocate many of the colors that were on the triangle. In fact, this present color wheel bears little resemblance to the triangle except in its intent to help the artist use color in a beautifully sophisticated way.

My color wheel has sixty-eight pigmented colors, most of them common to water-color, oil, and acrylic. In cases where different manufacturers use different names for the same color (or virtually the same color), many of these names are given on the wheel itself; even more are listed in the chart beginning on page 15. All the colors used are artist quality; it is important that the reader also use artist quality rather than a student grade, because the color can differ greatly. This wheel and the concepts in this book can be used by the artist in any medium. The color wheel represents over ten years of research and experimentation to find the best relationship of colors for the artist.

In this chapter, I will explain what this color wheel is about and why it works. As you go through the subsequent chapters, this color wheel will be referred to many times. Once you become familiar with this chart, you will need to rely on it less and less. Your intuitive color sense will be developing. But even today, I use my color wheel from time to time when I am stumped as to which color to use or when I am searching for the "perfect" color to complement my painting. I always have the color wheel in my studio and carry it with me most of the time on my travels.

WHAT IS A COLOR WHEEL?

This may seem very elementary and redundant, but I feel that it is important to mention the general idea of what a color wheel is and how it works before becoming involved in the specifics of how *my* color wheel works.

Colors are arranged around and inside a circle. All the colors on the outside of the circle are pure, bright colors, and those on the inside of the circle are more neutralized, or duller, colors.

There are three primary colors—yellow, blue, and red. These three colors are absolutely pure and have no other color in them. That is, yellow has no red or blue in it, blue has no yellow or red, and red has no blue or yellow. These three colors are set equidistant on the outside of the circle with yellow at the top, blue on the bottom right, and red on the bottom left. These three colors are the foundation of the color wheel, and all other colors can theoretically be mixed from them.

Secondary colors can be mixed from the primaries and are located exactly midway on the outside of the color wheel between each pair of primaries. There are three secondary colors—green, violet, and orange. Green is a mixture of yellow and blue; violet is a mixture of blue and red; orange is a mixture of red and yellow.

Tertiary colors, sometimes called intermediate colors, are located between and are a mixture of the primary and secondary colors. They are also located on the outside of the color wheel. There are six tertiary colors—yellow green, blue green, blue violet, red violet, red orange, and yellow orange.

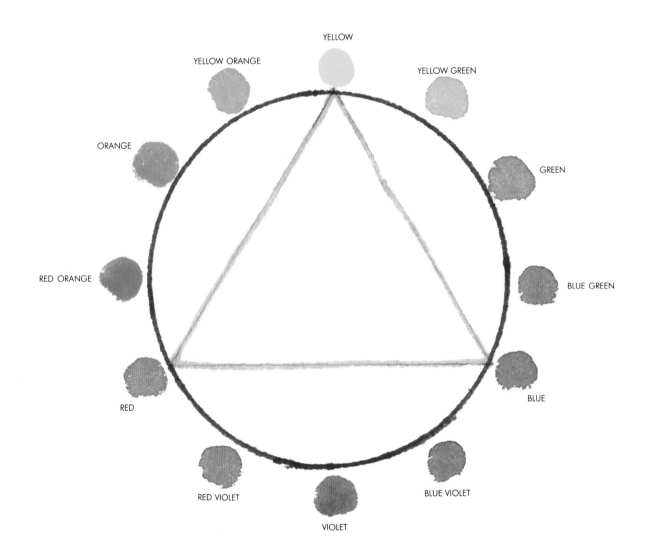

This is an example of a typical color wheel. Notice that the primaries yellow, blue, and red are located on the outside of the color wheel, with yellow at the top, blue on the right, and red on the left. They form the three corners of an equilateral triangle. The secondary colors green, violet, and orange are located halfway between the primaries, and the six tertiary colors (yellow green, blue green, and so on) are spaced halfway between the primaries and secondaries.

MY COLOR WHEEL SPECIFICALLY

You could learn the information just described from any color wheel. But as a painter, I have found it extremely important to become much more specific about the relationships of colors on the color wheel. I could not just say that yellow, blue, and red are primary colors. There are many pigmented names for yellow—that is, manufacturers' names for various gradations of yellow hues. For example, in an art supply store you could buy a tube of cadmium lemon, cadmium yellow pale, new gamboge, Indian yellow, or yellow ochre. The same holds true for the many, many blues and reds. Some yellows are green yellows, some are orange yellows, and some are neutral yellows. But which yellow would work best as a primary yellow that is located equidistant from a particular blue and red? That is the reason for this wheel: to locate all the colors specifically so that they can work best as an instrument for the painter. These colors have been located for the *best optical color balance*. As you go through each specific color, keep in mind that it has been selected for the best relationship with other colors—and ultimately, for the best possible color orchestration for the artist.

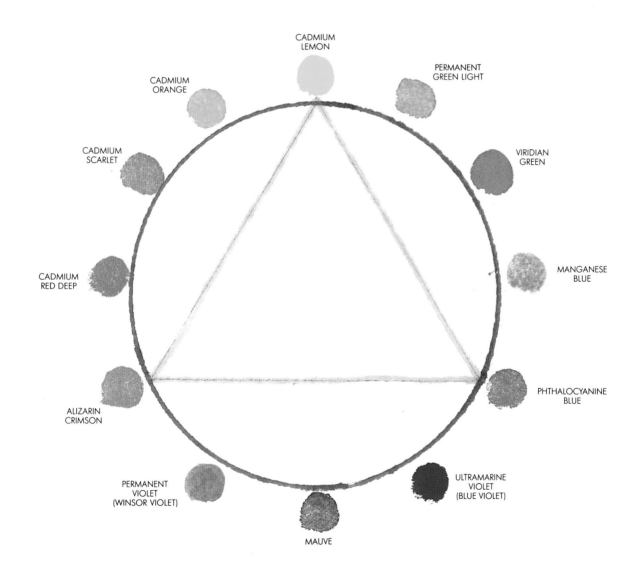

This color wheel identifies the pigmented names of the primary, secondary, and tertiary colors. The primaries are cadmium lemon (yellow), phthalocyanine blue (blue), and alizarin crimson (red). The secondaries are viridian green (green), mauve (violet), and cadmium scarlet (orange). The tertiaries are permanent green light (yellow green), manganese blue (blue green), ultramarine violet (blue violet), permanent violet or Winsor violet (red violet), cadmium red deep (red orange), and cadmium orange (yellow orange). These colors are chosen for best results in color mixing for the painter.

COLORS ON THE QUILLER WHEEL

Here is a list of the primary, secondary, and tertiary colors. All the other colors located on the outside of the color wheel are placed accurately in relation to them. Again, remember that all the colors used in this chart are of artist quality, so you should use a similar quality to ensure accuracy.

PRIMARIES. These colors are represented with a large triangle on the Quiller Wheel.

Yellow: *Cadmium lemon.* A beautiful pristine yellow not to be confused with lemon yellow, which is a somewhat neutralized, semi-opaque color. Aureolin yellow can substitute.

Blue: *Phthalocyanine blue.* A beautiful, highly staining and concentrated color that is a touch on the green side but is in perfect alignment for the blue primary. Winsor blue is the same color. The truest blue is a cobalt blue. Prussian blue, although somewhat neutralized, can be used to substitute as the primary.

Red: *Alizarin crimson.* A rich, deep, highly staining color that is a touch on the blue side but aligned as the perfect red primary for the painter. Permanent rose is a beautiful "airy" color that could possibly be used.

SECONDARIES. These colors are represented with a large diamond on the Quiller Wheel.

Green: *Viridian green.* A beautiful green that is halfway between the yellow and the blue. Phthalocyanine green can substitute, but it is a touch to the blue side; it is also more staining and harder to work with.

Violet: *Mauve.* A beautiful violet that is not too red or too blue. There is not a good substitute for this secondary.

Orange: *Cadmium scarlet.* A beautiful, rich orange. Do not let the name fool you. We are used to thinking of scarlet as a particular color, but this is a true orange. Bright red or possibly vermilion will substitute.

TERTIARIES. These colors are represented with a large square on the Quiller Wheel.

Yellow green: *Permanent green light.* Perfectly located between yellow and green. There is no true substitute.

Blue green: *Manganese blue.* In his book *The Elements of Color* (New York: Van Nostrand Reinhold, 1970), Johannes Itten stated that his was the perfect blue green. Again, no color can substitute.

Blue violet: *Ultramarine violet.* This color is the closest to blue violet that I can find, although it is not perfect. There is a color called blue violet made by Sennelier that works as well.

Red violet: *Permanent or Winsor violet.* Beautiful warm violets that gray out perfectly with permanent green light.

Red orange: *Cadmium red deep.* A somewhat neturalized color that grays out perfectly with its complement manganese blue.

Yellow orange: *Cadmium orange.* A nice, lively color. Do not let the name fool you. We tend to think of the color orange as that of the skin of an orange, but that color—like cadmium orange—is really a yellow orange.

Here is the Quiller Wheel, showing sixty-eight colors and the pigmented names of the primaries, secondaries, and tertiaries. See also the larger version of this color wheel after page 16, and the chart on pages 15 through 17.

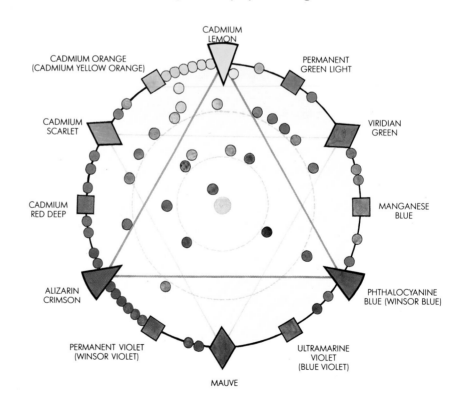

TABLE OF COLORS AND PAINT MANUFACTURERS

Here is a table listing all the colors on my color wheel and some of the brands of paint that manufacture each color. Because there can be minor color variations among brands of paint, the brand used for this color wheel is shown by a large red dot, with small black dots for other brands. There are separate sections for acrylic, watercolor, and oil. Some brands are used for all three media, while others are just used for one or two. This is a good but not all-inclusive list.

ACRYLIC

Columns:
A: WINSOR & NEWTON
B: LIQUITEX
C: GOLDEN
D: HYPLAR (GRUMBACHER)
E: REMBRANDT
F: BOCOUR AQUATEC
G: BRERA

Color	A	B	C	D	E	F	G
CADMIUM LEMON						●	
PERMANENT GREEN LIGHT	•	●	•	•	•	•	•
EMERALD GREEN	•	●				•	•
PHTHALOCYANINE GREEN (A, B, C, G: PHTHALO GREEN; D: THALO GREEN; E: REMBRANDT GREEN; F: BOCOUR GREEN)	•	●	•	•	•	•	•
BRIGHT AQUA GREEN (A, G: TURQUOISE GREEN)	•	●					•
COBALT TURQUOISE (C: TURQUOISE; E: TURQUOISE BLUE)				●		•	
MANGANESE BLUE					●		
CERULEAN BLUE	•	●	•	•	•	•	•
PHTHALOCYANINE BLUE (A, B, C, G: PHTHALO BLUE; D: THALO BLUE; E: REMBRANDT BLUE; F: BOCOUR BLUE)	•	•	●	•	•	•	•
COBALT BLUE	•	●	•	•	•	•	•
ULTRAMARINE BLUE (E: ULTRAMARINE DEEP)	•	●	•	•	•	•	•
DIOXAZINE PURPLE	•	●	•			•	•
MAGENTA (B, G: DEEP MAGENTA)		●					•
PERMANENT VIOLET (B: PERMANENT VIOLET LIGHT; E: PERMANENT RED VIOLET)		●				•	
PERMANENT MAGENTA (A, B: MEDIUM MAGENTA)	•	●					
ACRA VIOLET (A, C: QUINACRIDONE VIOLET)	•	●	•				
PERMANENT ROSE (E: REMBRANDT ROSE; F: BOCOUR ROSE RED)					●	•	
ALIZARIN CRIMSON (B: ALIZARIN CRIMSON HUE)		•			●	•	
NAPTHOL CRIMSON (C: QUINACRIDONE CRIMSON)	•	●	•				•
PERMANENT RED (A, C: QUINACRIDONE RED; B: ACRA RED; D: GRUMBACHER RED; E: PERMANENT RED DEEP; F: BOCOUR RED)	•	●	•	•	•	•	

Color	A	B	C	D	E	F	G
CADMIUM RED DEEP (C: CADMIUM RED DARK)			•		●	•	
CADMIUM RED LIGHT			●	•	•	•	•
LEMON YELLOW					●		
BRIGHT RED						●	
INDO ORANGE RED	•	●					•
CADMIUM ORANGE	•	●	•	•	•	•	•
YELLOW ORANGE AZO (A: AZO YELLOW ORANGE)	•	●					•
CADMIUM YELLOW DEEP (C: CADMIUM YELLOW DARK)			●	•	•		
CADMIUM YELLOW LIGHT	•	●	•	•	•	•	•
SAP GREEN	●				•	•	
HOOKER'S GREEN LIGHT (D: HOOKER'S GREEN)				●			
HOOKER'S GREEN DARK (A, B, G: HOOKER'S GREEN; F: HOOKER'S GREEN DEEP)	•	●				•	•
OLIVE GREEN	●						
CHROMIUM OXIDE GREEN (F: OXIDE OF CHROMIUM OPAQUE; G: CHROME OXIDE GREEN)	•	●	•	•		•	•
INDIAN RED						●	
RED OXIDE (A: RED IRON OXIDE)	•	●	•				•
LIGHT RED (E: LIGHT OXIDE RED)					●		
BURNT UMBER	•	●	•	•	•	•	•
BURNT SIENNA	•	●	•	•	•	•	•
RAW UMBER	•	●	•	•	•	•	•
RAW SIENNA	•	●	•	•	•	•	•
YELLOW OCHRE (B: YELLOW OXIDE; D: YELLOW OCHRE LIGHT)	●	•	•	•	•	•	•

WATERCOLOR

Manufacturer key:
A: WINSOR & NEWTON · B: HORADAM SCHMINCKE · C: HOLBEIN · D: GRUMBACHER · E: REMBRANDT · F: BOCOUR · G: LIQUITEX · H: SENNELIER

Color	A	B	C	D	E	F	G	H
CADMIUM LEMON (G: LEMON YELLOW HANSA)	●		•	•	•		•	•
YELLOWISH GREEN (D: THALO YELLOW GREEN)						•	●	
LEMON YELLOW	●		•	•			•	•
PERMANENT GREEN LIGHT (C: PERMANENT GREEN #1)			•	•			●	•
EMERALD GREEN (A: WINSOR EMERALD)	●		•	•	•	•	•	•
VIRIDIAN GREEN (B: VIRIDIAN GLOWING; G: VIRIDIAN)	●		•	•	•	•	•	•
PHTHALOCYANINE GREEN (A: WINSOR GREEN; B: PHTHALO GREEN; D: THALO GREEN; E: REMBRANDT GREEN; F: BOCOUR GREEN)	●		•	•	•	•	•	•
COBALT TURQUOISE (C, E: TURQUOISE BLUE)	●			•		•		•
MANGANESE BLUE	●			•	•			
CERULEAN BLUE (H: COERELEUM BLUE)	●		•	•	•	•	•	•
ANTWERP BLUE	●						•	
PHTHALOCYANINE BLUE (A: WINSOR BLUE; B: PHTHALO BLUE; D: THALO BLUE; E: REMBRANDT BLUE; F: BOCOUR BLUE)	●		•		•	•	•	•
COBALT BLUE (B: COBALT BLUE DEEP)	●		•	•	•	•	•	•
ULTRAMARINE BLUE (A, G: FRENCH ULTRAMARINE BLUE; B: ULTRAMARINE FINEST)	●		•	•	•	•	•	•
ULTRAMRINE VIOLET			•				●	
BLUE VIOLET								●
MAUVE	●					•	•	•
MAGENTA		●						
PERMANENT VIOLET (A: WINSOR VIOLET)	•	●		•				
COBALT VIOLET (H: COBALT VIOLET LIGHT)	•					●	•	•
PERMANENT MAGENTA	•	●						
ACRA VIOLET							●	
PURPLE MADDER ALIZARIN	●					•		
PURPLE LAKE	●							
PERMANENT ROSE (E: REMBRANDT ROSE)	●		•	•		•		
ROSE MADDER (A: ROSE MADDER GENUINE)	●			•		•		•
ALIZARIN CRIMSON (G: ALIZARINE CRIMSON)	●				•		•	•
ALIZARIN CARMINE	●							
PERMANENT RED (A: WINSOR RED; D: GRUMBACHER RED)	•		•	●	•			
GERANIUM LAKE (D: ACADEMY)						●		
CADMIUM RED DEEP	●		•	•		•	•	•
SCARLET LAKE	●		•	•				
CADMIUM RED LIGHT			•	●	•		•	•

Color	A	B	C	D	E	F	G	H
VERMILION (D: VERMILION LIGHT; G: VERMILLION HUE; H: FRENCH VERMILLION)	•	•	●	•	•	•	•	•
CADMIUM SCARLET	●							
BRIGHT RED	●							
CADMIUM ORANGE (B: CADMIUM ORANGE LIGHT; C, H: CADMIUM YELLOW ORANGE)	●		•	•	•	•	•	•
INDIAN YELLOW	●		•	•	•			•
CADMIUM YELLOW DEEP	●		•	•	•	•	•	•
CADMIUM YELLOW PALE	●			•				
NEW GAMBOGE (D: GAMBOGE (HUE); E, G: GAMBOGE)	●				•		•	•
CADMIUM YELLOW LIGHT		•	●			•		
AUREOLIN YELLOW (H: AWIEOLINE)	●			•				•
GREENISH YELLOW			●					
SAP GREEN (C: SAP GREEN #2; G: SAP GREEN PERMANENT)	●		•		•		•	•
HOOKER'S GREEN LIGHT (G: HOOKER'S GREEN LIGHT HUE)	●				•	•	•	
HOOKER'S GREEN DARK (C: HOOKER'S GREEN; D, E: HOOKER'S GREEN DEEP; G: HOOKER'S GREEN HUE; H: HOOKER GREEN)	●			•	•	•		•
OLIVE GREEN	●		•			•	•	•
TERRE VERTE (G: TERRE VERTE HUE)	●			•		•		
CHROMIUM OXIDE GREEN (A: OXIDE OF CHROMIUM; E: CHROME OXIDE GREEN; H: CHROME GREEN DEEP)	•			•	●		•	•
GREEN EARTH		•		●		•		
COBALT GREEN	●			•		•		•
PRUSSIAN GREEN (G: PRUSSIAN GREEN HUE)	●						•	
PRUSSIAN BLUE	●	•	•	•		•	•	•
INDIGO	●	•	•	•	•			•
VIOLET GREY			●					
MARS VIOLET			●					
BROWN MADDER ALIZARIN (B, D, H: BROWN MADDER)	●	•		•	•			•
INDIAN RED	●		•	•		•		
LIGHT RED (E: LIGHT RED OXIDE)	●			•				
BURNT UMBER	●	•	•	•	•	•	•	•
BURNT SIENNA (G: BURNT SIENA)	●	•	•	•	•	•	•	•
VANDYKE BROWN (B, C, G: VAN DYKE BROWN)	●	•	•	•		•	•	•
RAW UMBER	●	•	•	•	•	•	•	•
RAW SIENNA (G: RAW SIENA)	●	•	•	•	•		•	•
YELLOW OCHRE	●	•	•	•	•	•	•	•
NAPLES YELLOW (E: NAPLES YELLOW LIGHT)	●			•	•			•

Note: Since *Color Choices* was first printed, I have found that some key colors on the Quiller Wheel are not totally lightfast pigments. Artists can still use the wheel exactly as it is to study color relationships and to mix wonderful semineutrals, as explained throughout the book. However, if you intend to sell a painting, the permanence of your pigments is very important. I now substitute permanent rose for alizarin crimson, and magenta for permanent violet. I also replace mauve with a thorough mixture of 40 percent permanent rose and 60 percent ultramarine blue.

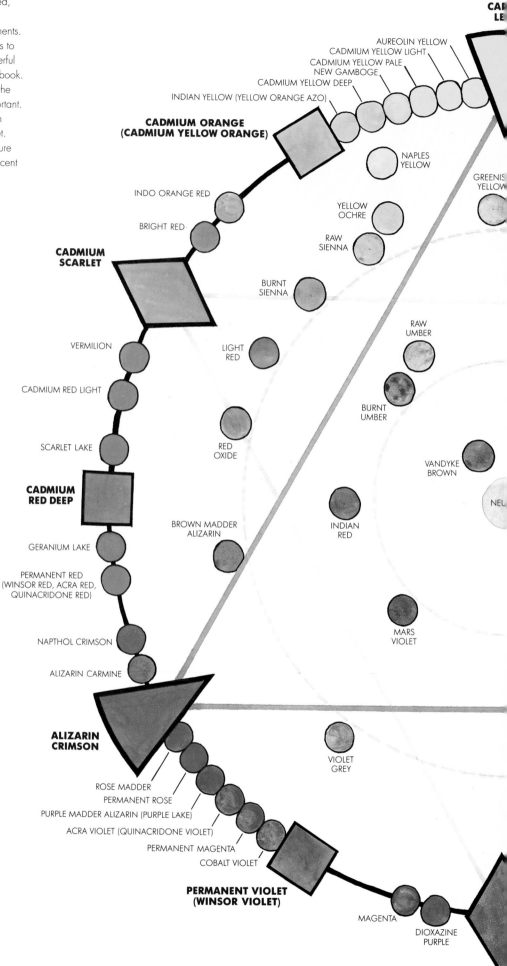

AUREOLIN YELLOW
CADMIUM YELLOW LIGHT
CADMIUM YELLOW PALE
NEW GAMBOGE
CADMIUM YELLOW DEEP
INDIAN YELLOW (YELLOW ORANGE AZO)

**CADMIUM ORANGE
(CADMIUM YELLOW ORANGE)**

NAPLES YELLOW

GREENISH
YELLOW

INDO ORANGE RED

YELLOW
OCHRE

BRIGHT RED

RAW
SIENNA

**CADMIUM
SCARLET**

BURNT
SIENNA

RAW
UMBER

VERMILION

LIGHT
RED

CADMIUM RED LIGHT

BURNT
UMBER

SCARLET LAKE

RED
OXIDE

VANDYKE
BROWN

**CADMIUM
RED DEEP**

NEU

GERANIUM LAKE

BROWN MADDER
ALIZARIN

INDIAN
RED

PERMANENT RED
(WINSOR RED, ACRA RED,
QUINACRIDONE RED)

NAPTHOL CRIMSON

MARS
VIOLET

ALIZARIN CARMINE

**ALIZARIN
CRIMSON**

VIOLET
GREY

ROSE MADDER
PERMANENT ROSE
PURPLE MADDER ALIZARIN (PURPLE LAKE)
ACRA VIOLET (QUINACRIDONE VIOLET)
PERMANENT MAGENTA
COBALT VIOLET

**PERMANENT VIOLET
(WINSOR VIOLET)**

MAGENTA

DIOXAZINE
PURPLE

MAU

QUILLER WHEEL ™

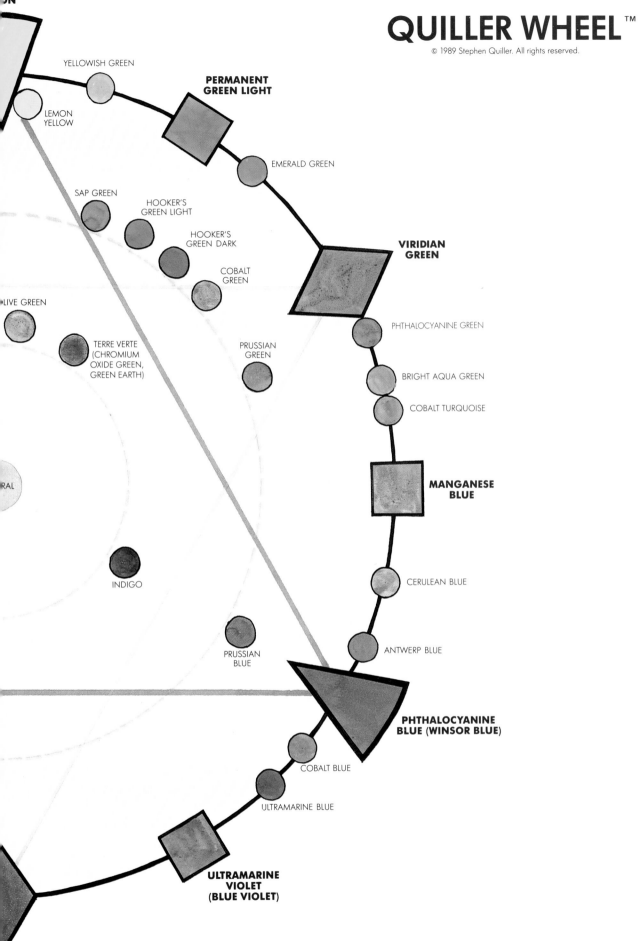

YELLOWISH GREEN

LEMON
YELLOW

**PERMANENT
GREEN LIGHT**

EMERALD GREEN

SAP GREEN

HOOKER'S
GREEN LIGHT

HOOKER'S
GREEN DARK

COBALT
GREEN

**VIRIDIAN
GREEN**

LIVE GREEN

TERRE VERTE
(CHROMIUM
OXIDE GREEN,
GREEN EARTH)

PRUSSIAN
GREEN

PHTHALOCYANINE GREEN

BRIGHT AQUA GREEN

COBALT TURQUOISE

RAL

**MANGANESE
BLUE**

INDIGO

CERULEAN BLUE

PRUSSIAN
BLUE

ANTWERP BLUE

**PHTHALOCYANINE
BLUE (WINSOR BLUE)**

COBALT BLUE

ULTRAMARINE BLUE

**ULTRAMARINE
VIOLET
(BLUE VIOLET)**

	A WINSOR & NEWTON	B HOLBEIN	C GRUMBACHER	D REMBRANDT	E SCHMINCKE MUSSINI	F LIQUITEX	G SENNELIER
CADMIUM LEMON YELLOW B, C, E, G: CADMIUM YELLOW LEMON	●	•	•	•	•		•
LEMON YELLOW A, D: CHROME LEMON; F: LEMON YELLOW HANSA	•	•	●	•	•	•	•
PERMANENT GREEN LIGHT	●	•	•	•	•	•	
EMERALD GREEN B: EMERALD GREEN NOVA; F: LIGHT EMERALD GREEN		•			●	•	•
VIRIDIAN GREEN E: VIRIDIAN GLOWING	●	•	•	•	•	•	
PHTHALOCYANINE GREEN A: WINSOR GREEN; C: THALO GREEN; D: REMBRANDT GREEN; E, F: PHTHALO GREEN	●		•	•	•	•	
BRIGHT AQUA GREEN						●	
COBALT TURQUOISE D: TURQUOISE BLUE	●	•		•			
MANGANESE BLUE E: MANGANESE CERULEAN BLUE	●	•	•		•		
CERULEAN BLUE F: CERULEAN HUE; G: CERULEAN BLUE IMITATION	●	•	•	•	•	•	•
ANTWERP BLUE	●						
PHTHALOCYANINE BLUE A: WINSOR BLUE; C: THALO BLUE; D: REMBRANDT BLUE; E, F: PHTHALO BLUE	●		•	•	•	•	
COBALT BLUE B, C, D, E: COBALT BLUE DEEP	●	•	•	•	•	•	•
ULTRAMARINE BLUE A: FRENCH ULTRAMARINE; B: ULTRAMARINE BLUE DEEP; D, E, G: ULTRAMARINE DEEP	●	•	•	•	•		•
ULTRAMARINE VIOLET				•	•		●
MAUVE A: PERMANENT MAUVE	•	●					
DIOXAZINE PURPLE							●
PERMANENT VIOLET A: WINSOR VIOLET; D: PERMANENT RED VIOLET; F: PERMANENT LIGHT VIOLET	●			•	•	•	•
COBALT VIOLET B, C, D, F: COBALT VIOLET LIGHT; G: COBALT VIOLET PALE	●	•	•	•	•	•	•
PERMANENT MAGENTA F: LIGHT MAGENTA	●					•	
ACRA VIOLET	●						
PURPLE MADDER ALIZARIN	●						
PURPLE LAKE	●						
PERMANENT ROSE D: REMBRANDT ROSE	●				•	•	
ROSE MADDER A: ROSE MADDER GENUINE	•	●	•	•		•	•
ALIZARIN CRIMSON	●			•	•		•
PERMANENT RED A: WINSOR RED; E: PERMANENT RED #3; F: ACRA RED	●				•	•	
GERANIUM LAKE	●	•		•			•
CADMIUM RED DEEP	●	•		•	•	•	
SCARLET LAKE D: CADMIUM RED SCARLET; E: PERMANENT SCARLET; F: SCARLET RED	●	•		•	•	•	

	A WINSOR & NEWTON	B HOLBEIN	C GRUMBACHER	D REMBRANDT	E SCHMINCKE MUSSINI	F LIQUITEX	G SENNELIER
CADMIUM RED LIGHT		•	●	•	•	•	
VERMILION E: VERMILION RED TONE; G: CHINESE VERMILLION	●	•	•		•		•
CADMIUM SCARLET	●						
BRIGHT RED B: LIGHT RED BRIGHT	●	•					
CADMIUM ORANGE B, G: CADMIUM YELLOW ORANGE	●	•	•	•	•	•	•
INDIAN YELLOW	●	•	•		•	•	•
CADMIUM YELLOW DEEP	●	•	•		•	•	•
CADMIUM YELLOW PALE	●						
CADMIUM YELLOW LIGHT		•	●	•	•	•	•
AUREOLIN YELLOW	●	•		•			
GREENISH YELLOW		●					
SAP GREEN F: SAP GREEN PERMANENT	●	•		•			•
OLIVE GREEN	●	•		•			•
TERRE VERTE	●	•		•			•
CHROMIUM OXIDE GREEN A, B: OXIDE OF CHROMIUM; C, D: CHROME OXIDE GREEN; E: CHROME GREEN LIGHT; G: CHROME GREEN PALE	●	•	•	•	•	•	•
GREEN EARTH E: VERONA GREEN EARTH; F: GREEN EARTH HUE			●			•	•
COBALT GREEN B: COBALT GREEN PALE; D, E: COBALT GREEN LIGHT	●	•		•	•		
PRUSSIAN GREEN	●						
PRUSSIAN BLUE	●	•	•	•	•	•	•
INDIGO D: INDIGO EXTRA	●	•		•			•
VIOLET GREY		●					
MARS VIOLET	•	●	•				•
BROWN MADDER ALIZARIN C, G: BROWN MADDER; D: ALIZARIN BROWN MADDER	●		•	•			•
INDIAN RED E: INDIAN RED LIGHT	●	•	•	•	•	•	•
RED OXIDE D, E: TRANSLUCENT RED OXIDE				●	•		
LIGHT RED	●	•					
BURNT UMBER	●	•	•	•	•	•	•
BURNT SIENNA	●	•	•	•	•	•	•
VANDYKE BROWN C, F, G: VAN DYKE BROWN	●	•	•	•	•	•	•
RAW UMBER	●	•	•	•	•	•	•
RAW SIENNA	●	•	•	•	•	•	•
YELLOW OCHRE E: YELLOW RAW OCHRE	●	•	•	•	•	•	•
NAPLES YELLOW D: NAPLES YELLOW LIGHT EXTRA; E: NAPLES YELLOW LIGHT	●	•	•	•	•	•	•

LOCATING COLORS ON THE OUTSIDE OF THE QUILLER WHEEL

It is known that true opposite colors on the color wheel complement each other and work visually together very well, as we will see in the following chapters. How can one determine which colors are true opposites and thus perfectly compatible? In referring to my color wheel after page 16, you can locate a truly opposite or complementary color by going directly through the center of the color wheel. This is the small gray circle that is labeled "neutral." Thus, cadmium lemon's true complement is mauve, and alizarin crimson's is viridian green, and so on. To make sure this is true, let's take the two complementary colors cadmium lemon and mauve, and mix them. They should reach a point where they gray each other out and neither color can be seen. Now let's take the same cadmium lemon and mix it with ultramarine violet. Because they are not true complements and ultramarine violet is on the blue side of mauve, the neutral should have a greenish mud look, confirming that they are not complements. Now let's take cadmium lemon and mix it with permanent violet. Because permanent violet is located on the red side of the true complement mauve, the neutral should have an orange mud look.

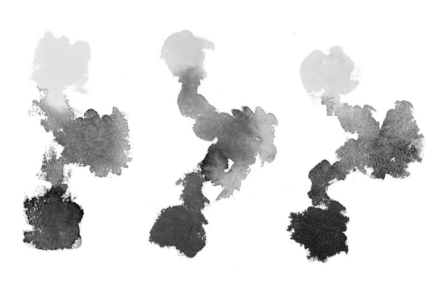

This diagram shows how exact complements totally gray each other out. The two colors at the far left are cadmium lemon and mauve, which are true complements. Notice that when they are mixed together, there comes a point where they are neutralized or grayed out: When the middle wash is looked at closely, neither the yellow nor the violet can be seen. The next two studies use the same cadmium lemon, but the central study uses permanent violet, which is located on my color wheel to the red side of mauve, and the far left study uses ultramarine violet, located on the blue side of mauve. See how the neutral color mixed in the central study is a reddish mud and the neutral color on the far right study is a greenish mud. This means that neither of these two colors is the true complement to cadmium lemon. This same process of experimenting can be done with every color to find its true complement.

PRIMARY, SECONDARY, AND TERTIARY COMPLEMENTS

The same graying out can be tested with all colors to see whether they are true complements. By the way, do not confuse the term *graying* with the color gray. This term means strictly that in the mixed neutral, neither complementary color can be seen. It is simply a neutral color, not necessarily gray. When two colors do gray each other out, it means two very important things:

1. These are true complementary colors that will create optimum optical color balance if used together well.

2. These two colors will create beautiful semineutrals and thus an appealing visual quality when mixed correctly.

In case you are wondering about the difference between neutrals and semineutrals, semineutrals are the intermediate steps as mixtures of pure colors approach a neutral. In neutrals neither complement is visible; a semineutral contains more of one pure color than the other. This idea is illustrated in the accompanying chart showing how the primary, secondary, and tertiary colors form semineutrals and gray each other out.

OTHER PURE COMPLEMENTARY COLORS THAT CREATE BEAUTIFUL SEMINEUTRALS

Not only do the primary, secondary, and tertiary colors create pleasing semineutrals, but they also create all the remaining pure colors (those located on the outside of the color wheel, between the primaries, secondaries, and tertiaries). Again, the way to test whether these colors complement is to try graying them out. If they truly neutralize each other, they are complements. They will mix to form beautiful semineutrals and can be very effective in painting.

Here are a few that are located on my color wheel. In addition to the colors shown, try any of the colors on the outside of the color wheel that have a color directly opposite to see whether they will gray out.

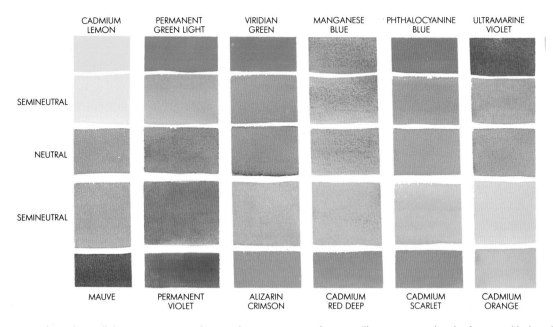

CADMIUM LEMON	PERMANENT GREEN LIGHT	VIRIDIAN GREEN	MANGANESE BLUE	PHTHALOCYANINE BLUE	ULTRAMARINE VIOLET

SEMINEUTRAL

NEUTRAL

SEMINEUTRAL

MAUVE	PERMANENT VIOLET	ALIZARIN CRIMSON	CADMIUM RED DEEP	CADMIUM SCARLET	CADMIUM ORANGE

This illustration shows how all the primary, secondary, and tertiary colors and their complements on my color wheel gray each other out. The top and bottom row of colors are the pure colors, and the middle row is the grayed-out neutral created by mixing the complements. The rows immediately above and below the neutral row are semineutral colors that have been mixed from the two complements. True complements create beautiful semineutral colors.

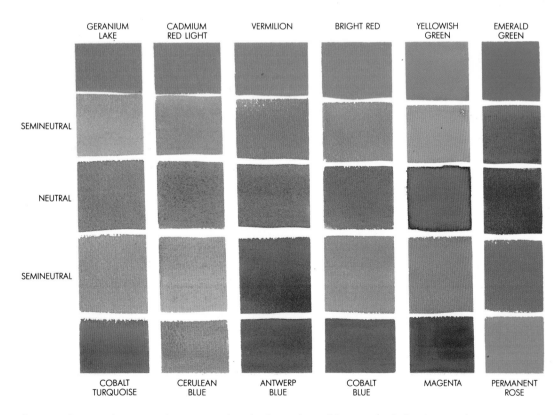

GERANIUM LAKE	CADMIUM RED LIGHT	VERMILION	BRIGHT RED	YELLOWISH GREEN	EMERALD GREEN

SEMINEUTRAL

NEUTRAL

SEMINEUTRAL

COBALT TURQUOISE	CERULEAN BLUE	ANTWERP BLUE	COBALT BLUE	MAGENTA	PERMANENT ROSE

Here is a diagram of some other pure colors on my color wheel that are true complements and gray each other out well. If you refer to my color wheel after page 16, you will see that these colors are located directly across from each other. Again, the top and bottom rows are pure complementary colors located on the outside of the color wheel. The middle row is the mixture of the two complements when they are completely neutralized, and the rows immediately above and below the neutral row are examples of the beautiful semineutrals that the complements can make. Incidentally, there are a few colors that neutralize each other very well, but when the actual mixture is put on the watercolor paper, the colors tend to separate. One of the colors will stain the paper evenly, while the other (whose pigment is more granular) will settle into the pockets of the paper. One example on this chart is cadmium red light and cerulean blue. Cerulean blue has a granular quality, settling in the recessed areas of the paper.

LOCATING COLORS ON THE INSIDE OF THE QUILLER WHEEL

All the colors located inside my color wheel are semineutral colors that can be purchased by these names at various art supply stores. Every one of these colors has been somewhat neutralized, and that is why they are located on the inside of the color wheel. But how did I decide exactly where to put them?

I had a great time experimenting and was somewhat surprised to find how exact this procedure can be. For example, I would choose an earth color such as burnt sienna; knowing it was warm, orangish brown, I would start by painting a swatch of the tube color burnt sienna and then take the complements cadmium scarlet and phthalocyanine blue and try to mix a semineutral that would match the swatch. The neutralized warm brown made by these two colors was too red, so I added some cadmium orange, which is really a yellow orange, until the color matched perfectly. I could determine how far to move the color

toward yellow orange by the amount of cadmium orange that was added. Then I determined how far toward the center neutral to place the color by the degree the color had been neutralized by its complement. Incidentally, the two light gray dotted circles inside the color wheel help identify the degree of neutrality of the color. The larger light gray circle is less neutralized, and the smaller inner circle is more neutralized. All these semineutral colors were located in the same manner. You might try to mix a few of these earth colors yourself to find how exacting this can be. Many times in the actual painting process, the mixing of a semineutral is more effective than using color straight from the tube because of the mingling of the various colors of pigments that make up the mixture. Here is a chart showing a few of the manufactured earth colors and mixtures of complements that match them.

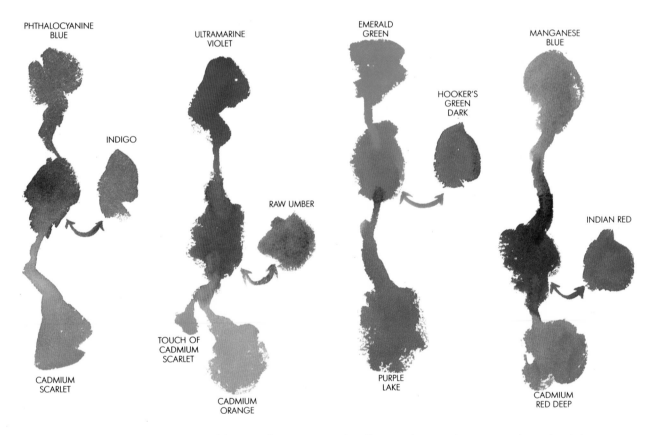

PHTHALOCYANINE BLUE

INDIGO

CADMIUM SCARLET

ULTRAMARINE VIOLET

RAW UMBER

TOUCH OF CADMIUM SCARLET

CADMIUM ORANGE

EMERALD GREEN

HOOKER'S GREEN DARK

PURPLE LAKE

MANGANESE BLUE

INDIAN RED

CADMIUM RED DEEP

Here are four manufactured earth colors and their complementary mixtures. Starting at the far left is the color indigo. The isolated round color swatch is the actual tube color of indigo. To its left are the complements phthalocyanine blue and cadmium scarlet, and the matching color their mixture creates. The next color is raw umber. The complements ultramarine violet and cadmium orange with a touch of cadmium scarlet will duplicate this color. Hooker's green dark can be matched by the complements emerald green and purple lake. Finally, Indian red can be duplicated with the complements manganese blue and cadmium red deep.

EARTH COLORS AND THEIR COMPLEMENTS

Now let's take a look at some manufactured semineutral earth colors and their complements to see how they will neutralize each other. Some of these colors have another manufactured earth color that is in the right location to neutralize. Refer to my color wheel after page 16 to see how they are located.

Complementary earth colors can be used together in an exciting way whenever pure color is not needed. Various subdued atmospheric conditions or somber scenes are appropriate for these color combinations. Try these color complements and see what kind of results you can achieve.

Here are some manufactured semineutral earth colors and their complements. Some of the complements are also manufactured earth colors. The manufactured semineutral color is located at the top, and the complements (which are sometimes pure color and sometimes semineutral) are at the bottom. The central row of gray washes shows the neutralized mixture of the complements, and the rows immediately above and below are the partially neutralized semineutrals.

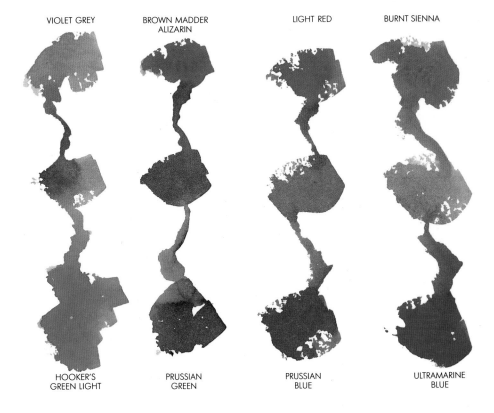

VIOLET GREY BROWN MADDER ALIZARIN LIGHT RED BURNT SIENNA

HOOKER'S GREEN LIGHT PRUSSIAN GREEN PRUSSIAN BLUE ULTRAMARINE BLUE

HOW TO FIND COLORS NOT ON THE WHEEL

Colors not listed on the Quiller Wheel can easily be located by placing a swatch on white paper and seeing where the color lies in relationship to the colors already on the wheel. The color could easily be the same color as one already on the wheel but have a different name. Actually, some of the colors on the wheel are already known by different names when purchased from different companies. For instance, permanent red, Winsor red, Acra red, and quin or quinacridone red are all located in the same spot but known by different names depending on their different media and manufacturers. The same is true for phthalocyanine, thalo, Winsor, Rembrandt, or Shiva blue or green.

USING THIS COLOR INFORMATION FOR OTHER MEDIA

The Quiller Wheel and the information in this book are meant for artists in all media. I am primarily a water media painter, so the majority of the studies and paintings in this book are done in water media. How then can this wheel be used for other media? Many of the colors used in the other media, including gouache, casein, pastel, oil pastel, and colored pencils, are also common to this color wheel, and color relationships can be determined in exactly the same manner. The differences may be in the names of colors and how they are mixed. For example, in oil pastel, pastel, or colored pencil, the overlapping or layering of the medium may be used to mix color or neutralize color, rather than premixing the color on the palette as one could in watercolor or oil.

The information regarding the principles of color is common to *all* art media. The considerations of value, intensity, and color proportion are the same. So with very little adjustment, an artist using any medium or combination of media should benefit from using this book.

MIXING FRESH, VIBRANT COLOR

Have you ever tried to mix a rich, fresh, vibrant violet with a red and a blue, only to have the resulting color look dead or neutralized? By referring to my color wheel, you can determine how to mix fresh color.

Within each color family of reds, blues, greens, oranges, violets, and yellows, there are warmer and cooler colors. As an example, let's look at the color family of blue. If we look at the Quiller Wheel after page 16, the primary blue is phthalocyanine blue, sometimes referred to as Winsor or thalo blue. As mentioned earlier, it is a touch to the green side but still is the best blue for a primary because of its location in relation to the other two primaries. The blue colors to the left of phthalocyanine blue, such as cobalt blue, ultramarine blue, and ultramarine violet, have increasing touches of red as they move toward the primary red, which is alizarin crimson. They are referred to as warm blues or "red" blues. On the other side of phthalocyanine blue are "yellow" blues such as Antwerp blue, cerulean blue, and manganese blue. As they move closer to the yellow primary, which is cadmium lemon, the color has increasingly more yellow, giving it a green-blue cast.

The same is true with the reds. Colors to the right of alizarin crimson, such as rose madder or permanent rose, are cooler blue reds, while the colors on the other side of alizarin crimson, like permanent red and cadmium red deep, are warmer and are yellow reds.

To mix a fresh, vibrant violet, the red and the blue colors should be on the same side of the primary red and blue—that is, within the same one-third of the wheel bounded by them. Good examples would be permanent rose as the red and ultramarine blue as the blue. These two colors will make any beautiful red violet, violet, or blue violet.

An example of poor choices for mixing a violet would be cerulean blue and permanent rose. Because cerulean blue is to the yellow side of primary blue (in other words, it is a greenish blue), the mixture has a third color besides the blue and the red. The green in the blue deadens the red, resulting in a somewhat neutralized violet.

This also happens if the choice of red is warm, such as cadmium red deep. Because this red is to the yellow side of primary red (in other words, it is an orange red), the orange in it will tend to neutralize its complement of blue, resulting in a dead violet.

This same principle can be used to ensure fresh, vibrant mixtures of oranges or greens. Always choose colors on the same side of the primaries. Here is an illustration clarifying this point.

Here are some studies showing mixtures of vibrant pure violets, as well as neutralized and dead violets. The top study shows rose madder and ultramarine blue, which are both in the lower one-third of the color wheel, bounded by the same two primaries (red and blue). This combination results in beautiful violets. In the subsequent studies, permanent red and cerulean blue are located to the yellow side of the primary red and blue, respectively, resulting in somewhat neutralized to dead violet mixtures.

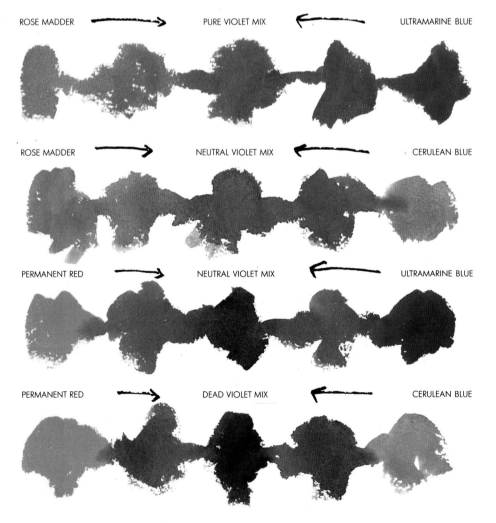

ROSE MADDER → PURE VIOLET MIX ← ULTRAMARINE BLUE

ROSE MADDER → NEUTRAL VIOLET MIX ← CERULEAN BLUE

PERMANENT RED → NEUTRAL VIOLET MIX ← ULTRAMARINE BLUE

PERMANENT RED → DEAD VIOLET MIX ← CERULEAN BLUE

ORGANIZING A WORKABLE PALETTE

In learning to understand color, one thing that can greatly help is organizing a color palette. My palette is based on the primaries, secondaries, and tertiaries on my color wheel. Each of the colors has a true complementary color that is also on the palette. This helps painters to think of complements as opposite ends of the same color, and to neutralize color instinctively by adding the complement. I recommend this palette to any artist who wishes to develop a stronger color sense. It it set up especially for color mixing and will work wonderfully for all the color schemes discussed later in this book.

The table below shows the colors on my palette, any colors that may be substituted for them in a pinch, and colors that should be substituted when painting with acrylic. (For suggested brands of each color, see the table on pages 15 through 17.) It is a good idea to organize your palette systematically so that you know exactly where each color is. Eventually this will let you mix the color and paint almost intuitively, like a musician whose knowledge of his instrument is second nature.

The palette shown is for transparent watercolor, but it will work just as well for oil or acrylic. For these media, use a glass palette resting on a white mat board, so that the actual color can easily be seen. Also, oil painters will need white. Your white will stay cleaner if you use two dabs: one for mixing warm colors, the other for cool colors.

PALETTE COLOR	POSSIBLE ALTERNATE COLOR(S)	SUBSTITUTE COLOR(S) FOR ACRYLIC
Cadmium lemon	Aureolin yellow	Cadmium lemon; cadmium yellow light
Cadmium orange	Indian yellow (yellower)	—
Cadmium scarlet	Bright red; vermilion	Indo orange red
Cadmium red deep	—	—
Alizarin crimson	Alizarin carmine; rose madder	—
Permanent violet	Winsor violet; cobalt violet (redder)	Permanent violet; Acra violet; quinacridone violet
Mauve	—	Dioxazine purple
Blue violet	Ultramarine violet	Mix cobalt blue and dioxazine purple
Phthalocyanine blue	Cobalt blue	—
Manganese blue	Cerulean blue (more blue)	Manganese blue or cerulean blue
Viridian green	Phthalocyanine green (more highly staining)	Phthalocyanine green
Permanent green light	Emerald green (cooler)	—

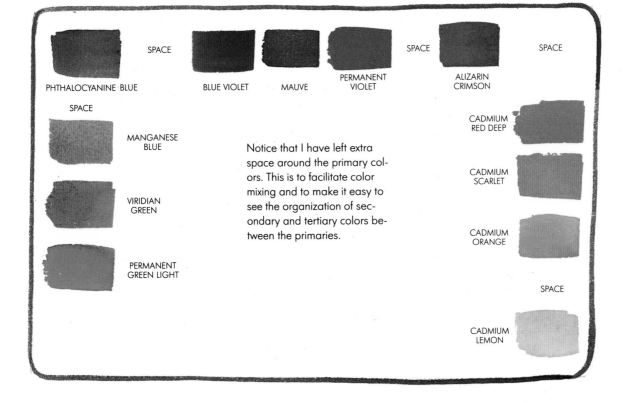

PHTHALOCYANINE BLUE — SPACE — BLUE VIOLET — MAUVE — PERMANENT VIOLET — SPACE — ALIZARIN CRIMSON — SPACE

SPACE

MANGANESE BLUE

VIRIDIAN GREEN

PERMANENT GREEN LIGHT

CADMIUM RED DEEP

CADMIUM SCARLET

CADMIUM ORANGE

SPACE

CADMIUM LEMON

Notice that I have left extra space around the primary colors. This is to facilitate color mixing and to make it easy to see the organization of secondary and tertiary colors between the primaries.

PAINTINGS BASED ON A PURE COLOR PALETTE

My palette will change according to the subject, medium or media, and direction of expression. When I travel and work on location, however, I use the palette shown on page 23. It works well because virtually any color can be mixed from these primary, secondary, and tertiary colors. Also, each color has a direct complement to ensure beautiful semineutrals. When I use this particular palette, I always place the colors in exactly the same location. In doing so, I have become very familiar with the location of all my colors. This knowledge is essential for the mixing of closely related and contrasting colors. An artist who knows his or her palette is freer to focus on the subject and on expression instead of the mechanics of mixing colors.

Here are two paintings done on location in two very different areas, using a palette of pure colors.

This painting was done on location at a small fishing village on the Oregon coast. I was there in November and expected to encounter drizzly, gray weather but instead found clear skies and little wind. I ended up doing a series of on-location studies, trying to capture the feeling of light and the color of boats, the harbor, and reflections in water.

In this particular painting, I was interested in the vertical patterns of the masts and their reflection against the horizontal dock and boat shapes. Most of the color in this painting was mixed from this set palette. Because I was working in transparent watercolor, many decisions about composition, color mixture, and value needed to be made very quickly before the color dried. By having my palette colors organized, I could mix and apply the paint quickly and with confidence. Notice the shimmer of the myriad colors that are repeated throughout the painting, giving a feeling of light, gentle movement, and color balance.

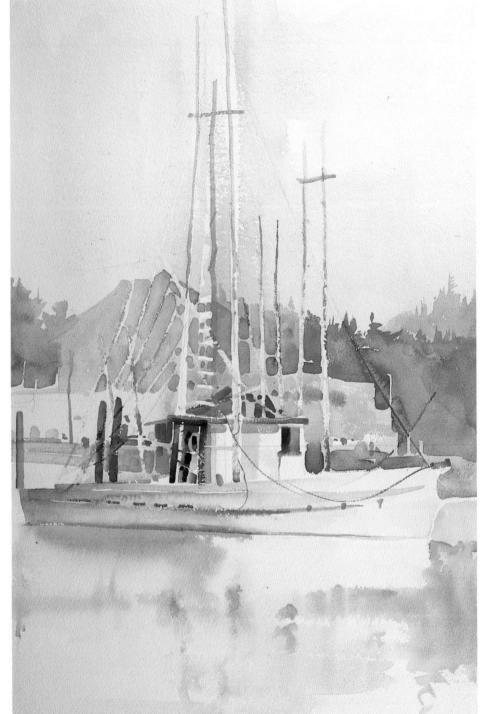

BANDON BOAT PATTERNS Transparent watercolor on 300 lb. Arches rough paper, 22" × 15" (55.9 cm × 38.1 cm) Courtesy of Mission Gallery, Taos, New Mexico.

SOMERSET, ENGLAND Transparent watercolor on 140 lb. Whatman cold-pressed paper, 11" × 15" (27.9 cm × 38.1 cm). Artist's collection.

A short while back, I was in Great Britain during the month of May. The fresh spring air was invigorating, and flowers bloomed everywhere. I found the color there to be very heavy on the greens and violets, totally different than in any other area I had painted. I worked small on quarter sheets and treated each subject as one would in a diary, recording the uniqueness of the area. I ended the trip with twenty-two watercolors from throughout the area; I also visited many of their beautiful art museums.

This study from the Somerset district is typical of the rest of my paintings done there. The fields and hedgerows were every tone and shade of green. The slate roofs, stone buildings and walls, and the general atmosphere were filled with mauve. Carrying this set palette, a quarter-sheet block of watercolor paper, a few

brushes, and a jar of water in my day pack made it easy to roam the countryside and paint.(The biggest problem was driving on the opposite side of the road!)

In this particular painting, notice the simplicity, the directness, and the use of greens and violets, as well as the value of color. I can refer to any one of these works today and recall the light and atmosphere, along with many of the events that happened that particular day.

Working with the greens and violets of England also helped my painting in the Colorado mountains. I had always had trouble with the greens of summer, but after this trip I noticed and used more violets in the dead snags of the forest to mix with my greens. The results have been much more pleasing.

2 MONOCHROMATIC AND COMPLEMENTARY COLOR SCHEMES

Have you ever noticed when browsing through an art museum or gallery that some paintings use very little color, yet have tremendous impact? Artists working in this way are using a limited palette. Throughout history, such artists as Rembrandt, Jan Vermeer, Gustave Courbet, Claude Monet, and Winslow Homer have used limited color to create powerful expressions. I have looked many times at Homer's oil paintings of seascapes painted from his studio in Prouts Neck, Maine, and on close inspection found these powerful paintings to have been produced with simply blue green, red orange, and white.

Two color schemes that use a very limited palette are monochromatic and complementary. When teaching color, I like to start with these two schemes. With either of them, the artist can learn the relationship between value and intensity and not have to worry about using too much color. They are the simplest color schemes to explain, and there is a close relationship between the two. However, in actual application, both of these schemes are difficult to execute. Because each scheme requires only one or two colors, the artist does not have a full palette with which to "decorate" the painting. The painter must rely mainly on value to make the composition work. Value, the relative lightness or darkness of the paint, is what creates the *structure* of the painting and is without a doubt the single most important element to learn in painting. Intensity, the relative brightness or dullness of a color, is also very important and must be considered in both the monochromatic and complementary schemes.

I will demonstrate in this chapter how to approach these color schemes and to consider their many aspects. Each color scheme will be developed through the use of diagrams and studies, and three finished paintings serve as examples for each. By reading through this chapter and doing one's own studies, the artist can master these two color schemes, thus laying the foundation for the more complex color schemes of the later chapters.

WINTER FROST Acrylic over rice paper collage on 300 lb. Arches rough paper, 27" × 21" (68.6 cm × 53.3 cm). Collection of Glenda and Barry Feinsmith.

THE MONOCHROMATIC COLOR SCHEME

The monochromatic color scheme is the simplest of all color schemes. *Mono* means one and *chroma* means color. Most simply, this is a one-color color scheme. But that color can be lightened or darkened in value, and brightened or dulled in intensity.

Value is the most important aspect of this color scheme. If a painting is not working, most artists will change a color—try a red or an orange in hopes that, magically, that will be the cure. But the answer is usually in the value of the color. The artist must ask not only whether the color should be orange but also whether it should be light or dark orange. By contrast, an artist using the monochromatic color scheme cannot change color if the painting is not working; there are only the lightness and darkness to structure the painting and make it work. I recommend that students of color spend a lot of time working with the monochromatic scheme. In doing so, they must come to understand value, and value is truly the most important factor in making a painting work.

VALUE CHART

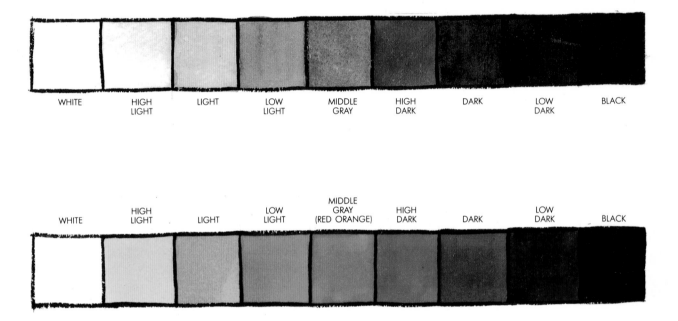

| WHITE | HIGH LIGHT | LIGHT | LOW LIGHT | MIDDLE GRAY | HIGH DARK | DARK | LOW DARK | BLACK |

| WHITE | HIGH LIGHT | LIGHT | LOW LIGHT | MIDDLE GRAY (RED ORANGE) | HIGH DARK | DARK | LOW DARK | BLACK |

In the black and white value chart, notice that there are nine steps from white to black. Actually there are an infinite number of values, but for teaching purposes let's use just nine. Each of the seven values between white and black has a name: high light, light, low light, middle gray, high dark, dark, and low dark. Any three consecutive values can be referred to as analogous values. Thus when talking about a particular area of a painting, an artist might refer to the shapes as analogous light values or analogous dark or middle values. Values that are far apart on the value scale, such as high light and low dark, are referred to as contrasting values. In painting they can be used to direct attention to an area of emphasis. On the second chart red orange is placed in the middle gray area. This is because red orange is actually a middle gray value.

VALUE AND COLOR RELATIONSHIPS

Color and value are generally thought of as separate, but actually every color has a specific value. Generally speaking, yellow is the lightest-value color and violet is the darkest. Red orange and blue green are both considered middle-value colors. The chart on this page will be good to remember for the general values of each color. But within each family of colors these values do not always hold true. For instance, red violet is considered a dark value, and Winsor violet is in that range, but cobalt violet, also considered a red violet, is much lighter. So when looking over this value chart, keep in mind that these are general fundamental values for colors, but there are always exceptions.

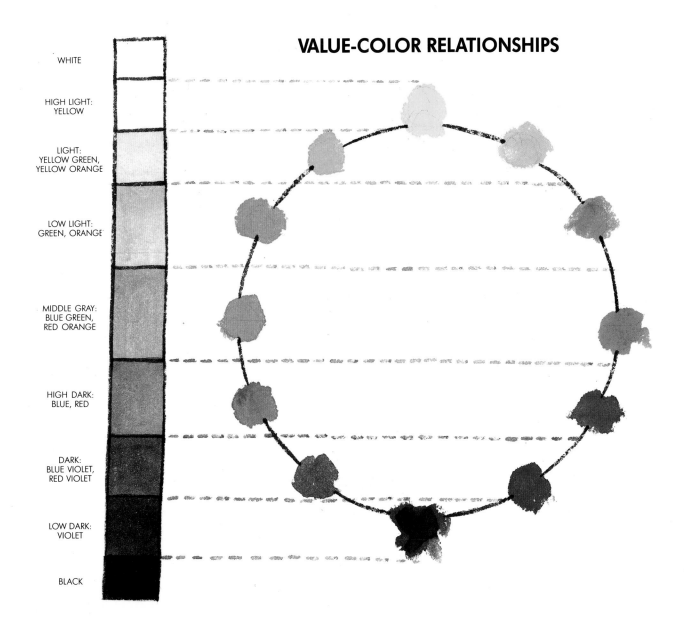

VALUE-COLOR RELATIONSHIPS

WHITE

HIGH LIGHT:
YELLOW

LIGHT:
YELLOW GREEN,
YELLOW ORANGE

LOW LIGHT:
GREEN, ORANGE

MIDDLE GRAY:
BLUE GREEN,
RED ORANGE

HIGH DARK:
BLUE, RED

DARK:
BLUE VIOLET,
RED VIOLET

LOW DARK:
VIOLET

BLACK

This chart shows the relationship of each color to the vertical value chart to its right. Yellow is considered a high light value, yellow green and yellow orange are light values, green and orange are low light values, red orange and blue green are middle gray values, blue and red are high dark values, red violet and blue violet are dark values, and violet is a low dark value.

THE MONOCHROMATIC COLOR SCHEME

THE RANGE OF THE MONOCHROMATIC SCHEME

In the monochromatic color scheme, the painter can lighten the color of the painting with white (or water in the case of transparent watercolor painting), darken the color with black, or neutralize the color with its complementary color. Even though this sounds very simple, a variety of moods and effects can be achieved.

This illustrates the range of a monochromatic color scheme using cerulean blue. The value of the color is changed by lightening with white or darkening with black. In addition, the color is neutralized with its complement cadmium red light. Note that each semineutral and neutral color can also be lightened or darkened with white or black.

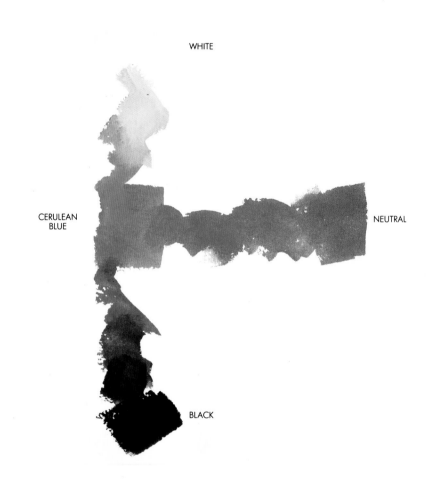

WHITE

CERULEAN
BLUE

NEUTRAL

BLACK

BLACK

Black is the most controversial color in painting. I am including it in this chapter because the artist can theoretically darken colors in value by adding black to the color. In showing the range in a monochromatic or complementary color scheme, black must be included. However, black is actually the absence of color. It absorbs light rather than reflecting light as all other colors do. I never use black in my work, and this includes the family of blacks such as Payne's gray, neutral tint, lamp black, ivory black, and so on.

I have judged many national, regional, and local art exhibitions and viewed many, many paintings. Paintings that have been created using black to mix with color are easy to pick out. The color seems dead. This is because black is subtractive rather than additive. It takes away from the pure color, absorbing it as well as the light.

There are other ways to get a strong dark that resembles

black while still reflecting light and being consistent with the rest of the paint surface. One mixture I have found particularly effective is alizarin crimson, viridian green, and phthalocyanine blue. I use this whenever a strong dark is needed, or sometimes when darkening others colors.

The idea of black, though, is interesting, and some artists use it well. Although most of the French impressionists did not use black in their palettes, Renoir was an exception. He called black the queen of colors, and used it in a very effective way. In his large canvases he would use a solid black as a foil to emphasize a shape. In other words, he was not mixing black with color to darken and dull the color but emphasizing the color by having a black background. Black—or any strong dark—surrounding a colored shape will make the shape seem lighter, brighter, and larger than it really is. It is this principle that Renoir used so effectively to emphasize his figures.

WHITE

White is the presence of all color and reflects all light. It acts just the opposite of black when surrounding a color: It makes the color appear darker, duller, and smaller. Also, adding white to a color lightens and neutralizes the color. This is an excellent way to create neutrals, because the color looks softer and has a pastel quality about it. I mix white with pure color a lot. This gives a clean, pure, pastel visual quality that is particularly effective when placed next to neutrals of mixed complements.

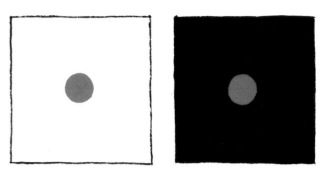

This is an example of how a white or light field and a black or dark field can affect a color. Both red orange circles are exactly the same color and size. But on the white field the red orange circle looks smaller, darker, and duller. On the black field the same circle appears larger, lighter, and brighter.

ORGANIZING VALUES IN A MONOCHROMATIC COLOR SCHEME

As mentioned earlier, in a monochromatic color scheme the artist is primarily working with value. The key to making the painting work is to organize the value in the composition to attract the eye and hold it. Generally, the strongest contrasting values will attract the eye, and they are placed in the area of emphasis. Analogous values create a much quieter, more restful quality and are normally placed in larger outlying areas of the composition. These areas allow the eye to rest and then move on to the active contrasting areas.

If all areas in the composition were active and strongly contrasting, the eye would be disturbed and would have a hard time looking at the painting.

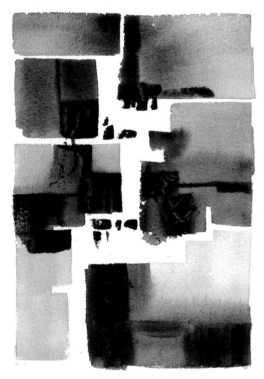

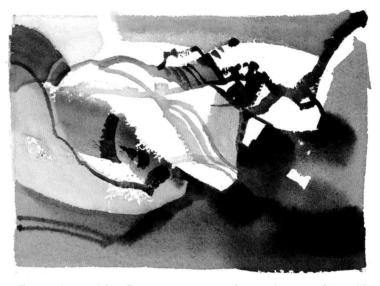

This is a diagonal, free-flowing composition with a curvilinear motif. It could easily resemble rocks and water movement. Again, the stronger contrasting values are in the active areas, while the analogous values are in the quiet, outlying areas.

This is a horizontal-vertical composition with a rectangular motif. Notice that the central areas of emphasis have the strongest contrasting values, while the outlying, more restful areas have values that are more analogous.

THE MONOCHROMATIC COLOR SCHEME

SIX STUDIES

Here are six studies of one group of buildings in northern New Mexico. All these studies use the complementary colors cadmium scarlet (orange) and phthalocyanine blue (blue), plus black and white (water to lighten). Since this is a monochromatic scheme, orange is the one color that shows in the painting, and blue is used to neutralize the orange. Again, the key to each of these studies is the organization of value and the way the pure and neutralized intensity are used.

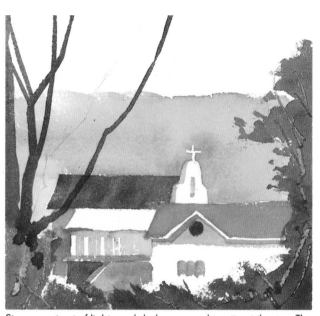

Strong contrast of lights and darks are used to attract the eye. The whites are organized to move the eye around the painting. Also, full-intensity orange is used on some of the roofs to attract the eye. The rest of the color has been neutralized to various degrees to vary the warmth and the movement of the study.

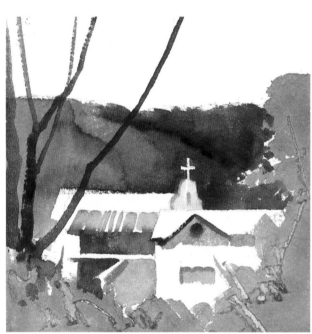

In this study, there is no full-intensity orange. The orange has been neutralized with blue to give a more earthy feel. Value of the orange is the key. The strongest contrasting lights and darks are placed in areas to attract the eye and direct it around the composition.

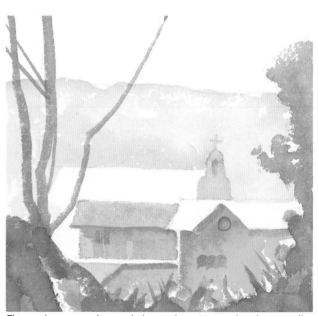

This study uses analogous lighter values. Notice that there is still enough value change between all adjacent shapes so that each shape can be easily distinguished. The lower right building has some full-intensity orange to give it more emphasis. The rest of the composition is painted with varying amounts of neutralized orange.

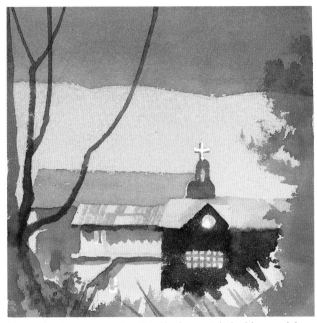

Here value is rearranged so that the lower right building and the tree on the left have the darkest value. This was done to create balance in the composition. The other shapes have less value contrast, but enough to make them look crisp and clearly defined. The orange has been neutralized to create a distinct mood.

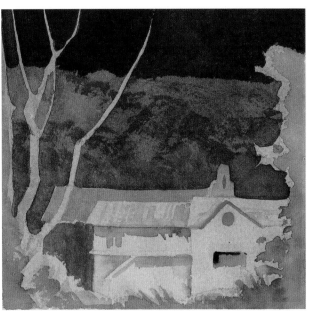

In this study, notice how the warm higher-intensity oranges bring the buildings forward while the cooler, dull neutral intensity oranges of the background areas recede. The full intensity of the orange on the eaves of the lower right roof draws the eye to that area. The strongest values have again been arranged to move the eye through the composition.

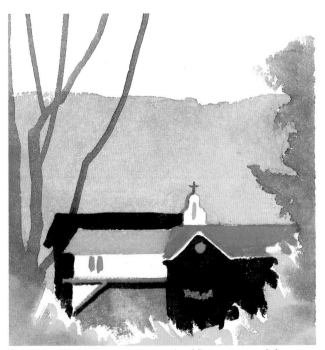

This composition is treated as a study of flat pattern and design. The values contrast, the strongest contrast being white to black, with full-intensity orange in the area of emphasis. Also, the intensity ranges from pure orange in the roof areas to a dull neutral in the surrounding areas.

PAINTINGS USING THE MONOCHROMATIC COLOR SCHEME

Here are three paintings using the monochromatic color scheme. When developing an idea from the initial sketch to the final painting, the artist must consider many things to enhance its expression. First, what is the mood in the painting and what format will best make it work? What type of paint application and medium are best suited for this subject? Finally, what color scheme will best express this mood? These three paintings have taken their own paths in terms of mood, format, paint application, and color. Along with each finished painting is a color chart showing a simple diagram of its color scheme.

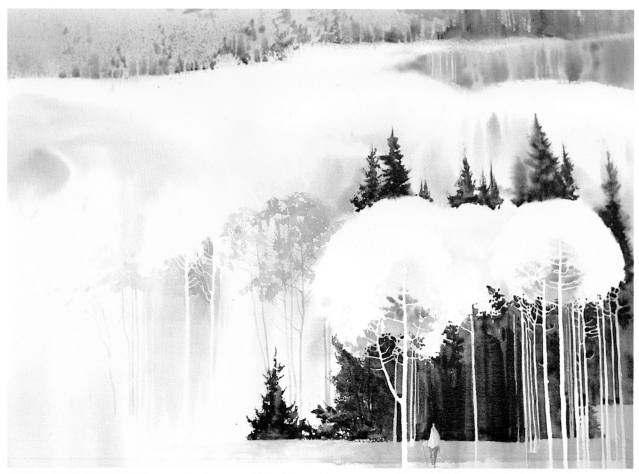

SUMMER ASPEN IMPRESSIONS Transparent watercolor on 200 lb. Arches cold-pressed paper, 21" × 29" (53.3 cm × 73.7 cm). Private collection.

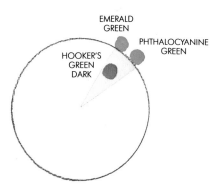

This painting depicts what I feel about an area rather than what is actually there. I have lived in or near the Colorado mountains for many years and have internalized many impressions of the country during all seasons. When I first started painting the aspen and spruce several years ago, my paintings were literal interpretations. As I have become more familiar with the aspen and spruce forms, I became interested in painting them as I see them, in a way that has a deeper meaning to me.

This painting did not have a preliminary sketch. I let the paint flow and worked more by intuition, reacting to what was happening as the paint moved on the surface. Phthalocyanine green, Hooker's green dark, and a touch of emerald green were used to create the impressions of summer. Notice how the strongest contrast forms the areas of emphasis: the spruce, aspen, and figure. The outlying areas have less contrast; the soft aspen forms left of center use quiet, analogous values. I chose watercolor for the medium because of its transparency and because its wet-on-wet characteristics were needed to create the impression of aspen forms.

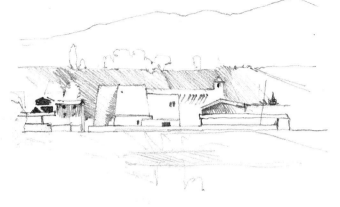

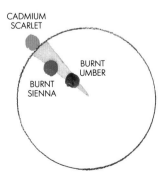

I have done many drawings of the Ranchos de Taos Church from many different angles. It is certainly the most painted church in New Mexico. The early Taos painters, as well as Georgia O'Keeffe and Fritz Sholder, have worked with this subject. Here I was working with a profile and emphasizing the rectangular motif and horizontal format.

In November this is a familiar sight in New Mexico. One of my favorite things to do around Thanksgiving is to sketch the late November light on the field patterns and orchards of this area. The few apples left on the tree remind me of Christmas tree ornaments.

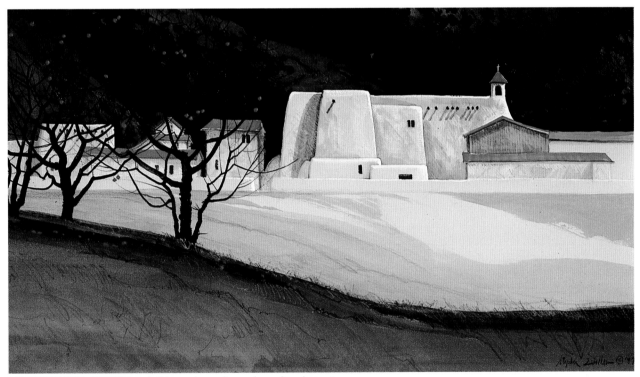

LATE NOVEMBER, TAOS Oil wash, Prismacolor, and gouache on Stonehenge tan paper, 16″ × 29″ (40.6 cm × 73.7 cm). Courtesy of Mission Gallery, Taos, New Mexico.

I am trying to create a mood of late November in Taos, New Mexico; the subject is apple trees and the Ranchos de Taos Church. This is without a doubt my favorite time of year in Taos. Most of the leaves have fallen from the trees, and a long, warm, strong light rakes across the fields, emphasizing the texture and forms of the area. To get this mood, I need strong contrasting values to give a feeling of November light on the church and a feeling of starkness on the almost bare apple trees. The intensities are almost entirely neutral, with a few pure cadmium scarlet notes on the roofs and apples to add life to the painting. This is a direction I like to work when using a monochromatic color scheme. A tan paper toned in burnt sienna lets me focus on lighter and darker values when planning the composition. Basically, the color scheme uses cadmium scarlet, burnt sienna, burnt umber, white, gray, and black.

THE MONOCHROMATIC COLOR SCHEME

Here is a drawing of a prominent mountain in the San Juans. In the drawing, I emphasized the rhythmic flow of the mountain, the texture of the mountainous terrain, and the value that brings out the shapes. I referred to this drawing as I developed the composition of the finished painting.

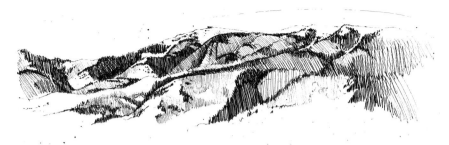

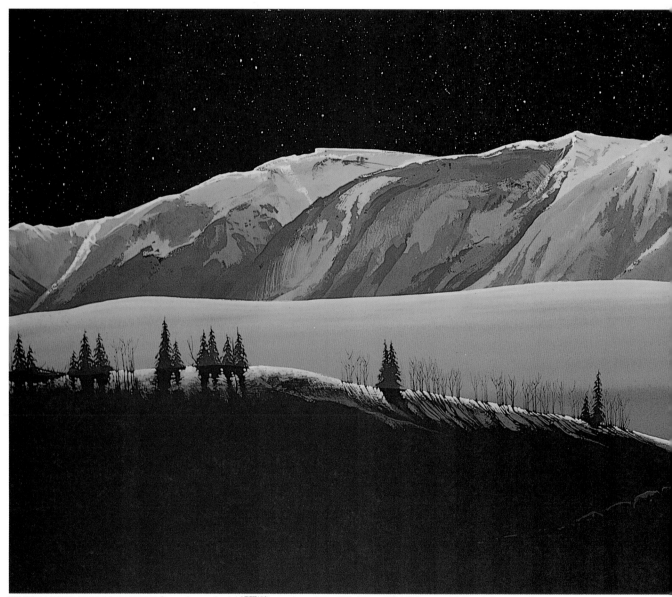

WINTER NIGHT, UPPER SAN JUANS Gouache on Crescent illustration board No. 100, 17″ × 29″ (43.2 cm × 73.7 cm). Private collection.

This is one of my favorite areas in the Colorado San Juan Mountains. In the winter and during a full moon, the snow reflects a lot of light. The landscape takes on all values of a midnight blue color, and the aspen and spruce trees cast long, distinct shadows. I wanted to create that clear, crisp, cold mood of a winter night in the high country. I chose gouache for my painting medium because of the flow of the color and its opaque coverage power, light over dark. Only Prussian blue and permanent white were used, and the whole painting was developed with both analogous and contrasting value relationships. A long, horizontal format was chosen for this painting to accentuate the rhythm of the mountain ranges. And finally, a counterbalance was developed between the upper left mountain and the lower right area where the elk are crossing.

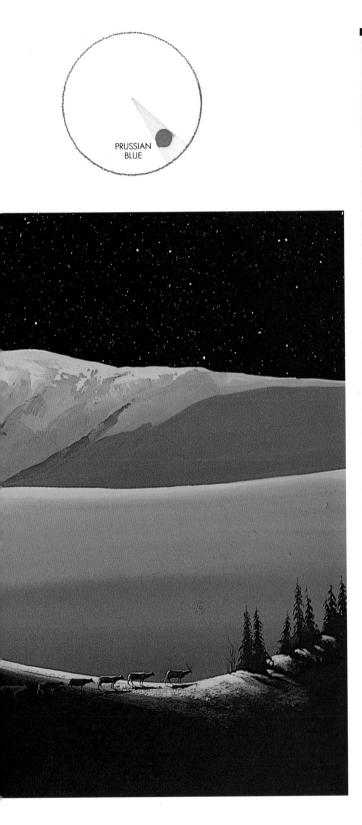

PRUSSIAN
BLUE

WORKSHOP: MONOCHROMATIC COLOR SCHEMES

EXERCISE 1

Do a value chart having nine steps between white and black. Try to make an even progression from each step to the next. In a second chart, use a red orange (such as cadmium red deep) as the middle gray. Develop the light side of the chart by adding white and the dark side of the chart by adding black. This may seem like a mundane exercise, but it is the key to color. If you understand the dark and light relationships of color, you will be on your way.

EXERCISE 2

With a 2H pencil, lightly draw three rectangles approximately 5 inches by 7 inches. Two of them should be horizontal and one vertical. Choose one of three geometric motifs (rectangular, triangular, or curvilinear) and stay only with those shapes, varying the size to make the design interesting. Do not work realistically, but make these abstract shapes have unity through the value of the monochromatic color. Use one color and its complement to neutralize, plus black and white (or water and the white of the paper in watercolor). On one of the designs, work only with analogous light values throughout, thus creating a light, airy feeling. On the next design, concentrate on darker analogous values, leaving no light or white values. This study could project a sinister feeling of gloom or depression. Focus the last image on both contrasting and analogous values, having the contrasting values toward the area of emphasis and the analogous values in the outlying, quiet areas.

EXERCISE 3

Use a toned gray-beige watercolor paper. Or choose a pastel paper of this tone—or make your own, staining the watercolor paper or canvas panels with a thin layer of this color, and let it dry to a middle value. Choose a simple subject (landscape or still life) with some distinct shapes. Do two studies. For the first study select a warm orange color and its complement to neutralize, plus white and black. Use the white to develop the lighter tones and highlights, and the black to develop the darker values and deep contrasting accents. Leave some of the paper untouched and other areas showing through glazes of color. In the second study, use the same image, only use a cool color such as a green and its complement, and proceed in the same manner.

THE COMPLEMENTARY COLOR SCHEME

Complementary colors are directly opposite colors on the color wheel. To find a true complementary color, locate two colors directly opposite each other by going through the inside center point, called neutral, on the color wheel. Thus red and green, yellow orange and blue violet, red violet and yellow green are some of the complementary colors. More specifically, on my color wheel located after page 16, alizarin crimson and viridian green, phthalocyanine blue and cadmium scarlet, and cadmium lemon and mauve, are true complements. This means that they neutralize each other to an accurate neutral, make beautiful neutral colors when mixed together, and complement each other when used together well in a color scheme.

After you have worked with the monochromatic color scheme, the complementary scheme should come easily. The same considerations for value and intensity are needed, and you are simply using one more color. Again, using a very limited palette can create a very effective mood.

Furthermore, the knowledge of complementary colors is important when working with any kind of color palette. It was John Sloan, the great American painter, who stated in his book *Gist of Art* that the painter should think of complementary colors as the opposite ends of one color. In other words, they should always be envisioned together and used together for

best results in a painting. With this in mind, the artist can use complements not only while mixing color, but also when underpainting and overpainting or glazing color over color.

How did this idea of complements get started, and how were reds and greens, blues and oranges, yellows and violets known to be complementary?

These theories all began with M. E. Chevreul, a French scientist who was interested in art. His research led to writing a book in the mid-nineteenth century entitled *The Principles of Harmony and Contrast of Colors*. In this book, which is still in print today, he presented his theories of mixed contrast and simultaneous contrast. This book became a "bible" for the impressionists, the postimpressionists, and also many American painters, including Winslow Homer. In his book, along with these other theories, Chevreul discussed the theory of successive contrast, which today we call afterimage. He noted that after one has stared at a colored circle on a white field for a period of time and then closed the eyes, the complement of that color appears. He further discovered that the eye actually seeks a balance by providing the complementary color. Because of this discovery, many artists since have experimented with ways of applying complementary color that are more pleasing to the viewer's eye.

COMPLEMENTS IN NATURE

From a small brown-red rock with gray-green lichen to a spectacular sunset of a golden yellow sky against gray-violet cumulous clouds with white-gold linings, our earth is filled with complementary colors. All we need to do is observe and enjoy. In the spring, the red-violet crab apple blossoms play against the yellow-green shimmer of new leaf buds. Many of our roadside flowers, like asters and meadow iris, are yellow and violet. The burnt red-orange dead spruce blazes against the

deep blue-green living spruce behind it. Many of the tropical fish are colored with almost fluorescent complementary colors. Take some time and study the color combinations of the wild grasses, the forest vegetation, the color of the earth, and the sky's various atmospheric conditions. Notice how many times they contain complementary colors, ranging from very subtle to earthy to brilliantly intense. Here are four studies of complements in nature.

The illustrations on these two pages show examples of complements in nature. This study is based on a scene outside my studio. Red-violet spring willows play on the deep sap-green to yellow-green piñon and the light yellow-green spring grass. (Here I am not talking about weeping willow trees, but about a shrub more like the pussy willow. It grows especially along river banks, and its bark turns red violet in the spring.)

Here is a study of a pot of Johnny-jump-ups by my studio door. The petals of these tiny flowers play a yellow against a light violet.

This sketch shows a potted coleus plant found in a friend's home. Notice the pure-intensity red violet and yellow green, and their semineutral color relationships.

In this summer New Mexico landscape, the red-orange earth mingles with the blue-green chamisa and sage, and with the cedar and piñon on the hillside.

THE COMPLEMENTARY COLOR SCHEME

WARM AND COOL COMPLEMENTS

What are warm and cool colors? And what does this have to do with painting? Warm colors advance and cool colors recede, which means that the artist can actually create the illusion of depth by the organization of color. On the color wheel, the dividing point is the line from red violet to yellow green. The colors to the left of the line are warm and those to the right are cool. The colors red violet and yellow green can be either warm or cool, depending on the colors surrounding them. If the perimeter colors are cool, they will appear warm; if the surrounding colors are warm, they will appear cool.

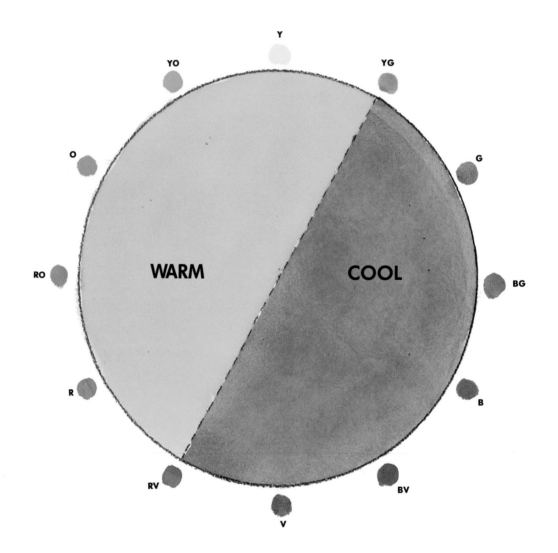

This illustration shows how the color wheel is divided into warm and cool colors. Because warm colors appear to advance and cool colors appear to recede, the artists can use color to create a feeling of depth in a painting.

CREATING BALANCE THROUGH WARM AND COOL COLORS

Artists have found that a touch of the cool complement in a warm color field, or vice versa, is pleasing to the eye. We call this "warm in cool" or "cool in warm." John Singer Sargent was a master of this color application. Study his oils and watercolors and notice that in every area of his compositions, he used the warm-cool theories.

In this study, I used the warm cadmium lemon and its cool complement, mauve. In each area of the study—the sky, rocks, and sand—I added warm to the cool or cool to the warm. Notice that the intermixing of these colors creates a lot of neutral violets or yellows, leaving just small areas of pure color.

Here I used the warm color alizarin crimson and its cool complement viridian green. Notice that in the neutral washes, there are hints of warm in the cool and vice versa. In this study there is actually no pure color. Every area of this study—the trees, rocks, and water—uses the warm-cool theory. Imagine how much less interesting it would be if these shapes were one solid color.

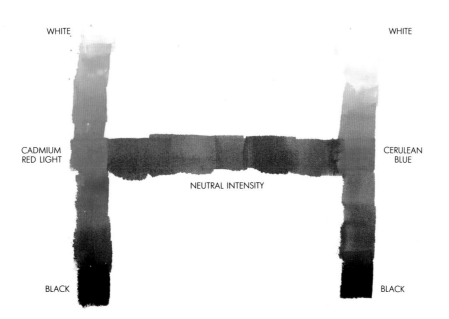

WHITE WHITE

CADMIUM CERULEAN
RED LIGHT BLUE

NEUTRAL INTENSITY

BLACK BLACK

Here is a diagram of the range of two complementary colors, cadmium red light and cerulean blue. Each color can be used to full intensity, lightened with white, or darkened with black. In addition, each color can be neutralized by adding its complement. The neutralized colors can also be lightened with white or darkened with black.

WAYS TO MIX A NEUTRAL

When I talk about neutralizing a color, I am talking of dulling the purity of a full-intensity color. There are four ways to neutralize a color: (a) by adding black, (b) by adding gray, (c) by adding white, and (d) by adding the complement.

Some ways of neutralizing create a much more exciting visual quality than others. On this page are examples of the four ways of neutralizing a color and what happens to the color in each instance.

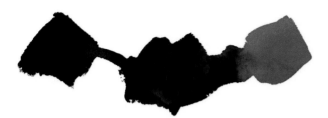

Black is used to neutralize alizarin crimson. Black, being subtractive, absorbs light and the color. The result is a deadening of the color. Many times the resulting neutral will have a gloomy effect. This is not the best way to create a neutral.

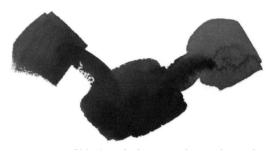

Gray—a mixture of black and white—can be used to make a color lighter, darker, or the same value but duller. Because black is a part of the mixture, it still somewhat deadens the color and is not ideal for creating a neutral.

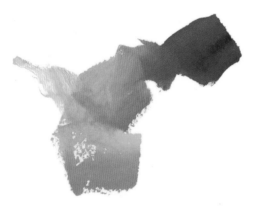

By adding white to the color, the artist lightens the color in addition to neutralizing it. Some colors, like alizarin crimson, take on a cooler look. Neutralizing color in this way creates a beautiful pastel visual quality.

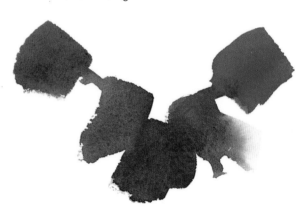

Adding the complement, in this case viridian green, produces tones between the color and its complement. Beautiful visual qualities are created because of the blending and settling of the pigments in the mixture of the two complements.

This is a diagram of the relationship among full-intensity, semineutral, and neutral colors. Full-intensity colors, such as cadmium scarlet and phthalocyanine blue, are located on the outer circle of the color wheel. They are pure colors, direct from the tube, and no color has been added to neutralize the color in any way. Semineutral colors are always located inside the color wheel. These colors have been neutralized to some degree. The colors become duller as they get closer to the center of the color wheel. Many semineutral colors can be used straight from the tube, such as the colors light red, burnt umber, and Prussian blue. Semineutral colors can also be mixed from complementary colors, or from contrasting colors that are not true complements. Neutral color is located directly in the center of the color wheel and is a dull, lifeless color that looks like mud. As explained earlier, this color can be mixed by adding two complements together, such as cadmium scarlet and phthalocyanine blue, until neither color can be seen.

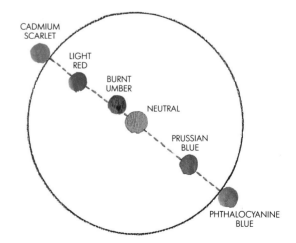

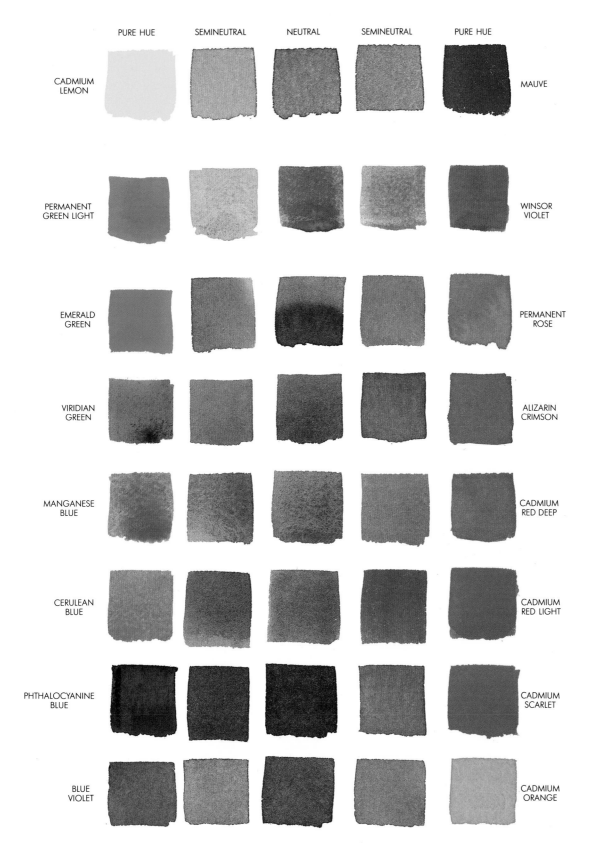

PURE HUE	SEMINEUTRAL	NEUTRAL	SEMINEUTRAL	PURE HUE

CADMIUM LEMON — MAUVE

PERMANENT GREEN LIGHT — WINSOR VIOLET

EMERALD GREEN — PERMANENT ROSE

VIRIDIAN GREEN — ALIZARIN CRIMSON

MANGANESE BLUE — CADMIUM RED DEEP

CERULEAN BLUE — CADMIUM RED LIGHT

PHTHALOCYANINE BLUE — CADMIUM SCARLET

BLUE VIOLET — CADMIUM ORANGE

We cannot just say that red and green are complementary. There are orange reds and violet reds as well as red reds, and yellow greens and blue greens as well as green greens. Here are a few true complementary colors, and an illustration of how they neutralize each other. This chart shows the full intensity, semi-neutral, and neutral of the complements. The true complements are on the far left and right with the semineutrals adjacent to them, and the neutral in the center. Semineutral colors of complements can be very beautiful, as can be seen in this illustration. This is important to know, because the majority of most paintings is painted in the semineutrals, with only a small portion of the composition using pure color.

APPLYING COLOR TO CREATE SEMINEUTRALS

There are many ways to create visual interest by applying semi-neutrals with complements. When you go to a museum, study the impressionists and postimpressionists' approach. Look at the brush strokes and the color interaction. Look at both watercolors and oils. Get up close and study the color and then get back and see how the eye sees the same area.

Here are four examples of different ways to apply color to create semineutrals. They are the standard mixing method, the *alla prima* method, the pointillist method, and the glazing method. All four of these studies use yellow orange and blue violet as the two complementary colors, and acrylic for the medium.

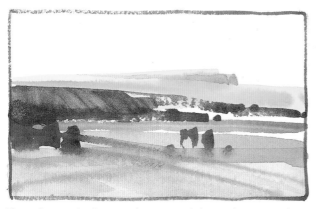

This is the standard watercolor approach for applying neutrals. The transparent washes in this study have been premixed, using the two complements. Even the yellow orange mesa has blue violet in it. Each wash is mixed more to the blue violet side or to the yellow orange side to ensure a beautiful semineutral.

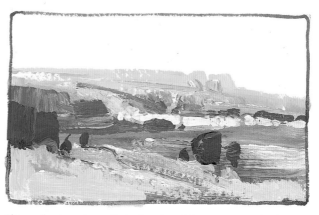

This method can be called *alla prima*, juicy opaque, or broken color. These terms mean applying the paint thickly and directly, and breaking one color adjacent to another color instead of blending the colors. The color in this study also uses semineutrals. In this approach, underpainting and overpainting can be used as seen in the foreground area. The blue violet semineutral was applied and allowed to dry. The yellow orange semineutral was then scumbled over the undercolor, letting some of it come through.

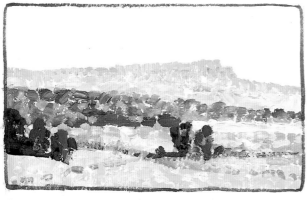

This pointillist approach to applying paint was used by the postimpressionists Seurat and Signac. It is used some today but not a lot. However, the principle behind it, called mixed contrast, is important. The color is pure, with the addition of white, and is applied in small strokes. When the artist places small pure strokes of complementary color next to one another, at a distance the eye will mix the color and see a semineutral.

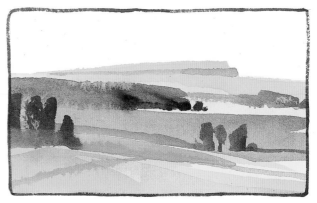

The glazing approach shown here is similar to the standard watercolor approach in that both use a series of transparent washes. Here, however, each wash uses pure yellow orange or blue violet. One wash is applied and allowed to dry. The complementary wash is then glazed over the first wash, creating a semineutral. The amount of color in each wash determines the value and intensity of the semineutral.

SEMINEUTRALS MAKE PURE COLOR SING

The proportion of the semineutral colors is very important. If the artist uses large amounts of full-intensity color, it will overwhelm the eye. This is what the op artists were trying to do. They used full-intensity complements in large areas adjacent to each other to create a vibration for the eye. But to create pleasing color harmony, the artist must remember that juxtaposed intense complements have too much impact. For most painting methods, artists should use smaller amounts. The large areas can be filled with semineutral colors, which are more restful and soothing to the eye. Complementary semineutrals placed next to the small areas of full-intensity color will bring life to that color. When the artist controls the semineutral and full-intensity color well, the composition will simply sing with a harmony of magnificent color.

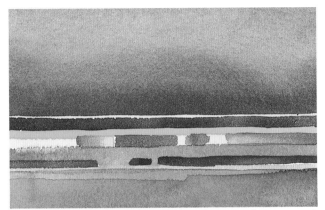

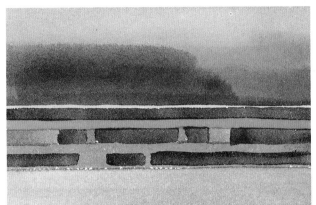

The complements in this study are blue violet and yellow orange. I have used a mixture of ultramarine blue and mauve to get the blue violet and cadmium orange for the yellow orange. Notice that the large masses of color are in semineutrals and the darkest value of the semineutral is next to the full-intensity color.

This is the same composition in green and red. I used viridian green and alizarin crimson. The semineutrals are always to the green side or the red side. Notice how the full-intensity green and red come to life because of the soft, restful neutrals placed next to them.

DOMINANT AND SUBORDINATE COLOR

If equal amounts of each complement are used, it will confuse the eye because both complements are competing for the eye's attention. Because of this, the artist works with dominant and subordinate complements. One of the colors is chosen to be dominant, according to the mood that the artist wants in the composition, and the artist controls its value and intensity in an exciting way. The opposite color is then used in a subordinate way to give the eye balance and relief from the dominant color. Here are two studies using two colors that are complements, cobalt turquoise and permanent red. In the first study, I have tried to use the complements in a negative way, and in the second study, to use them in a positive manner.

Equal amounts of each complement have been used in this study. Also, large amounts of full-intensity color have been used. Notice how the large amounts of pure color overpower the composition, and the equal amounts of cobalt turquoise and permanent red compete rather than complement each other.

Here cobalt turquoise has been used as the dominant color. The large areas have been neutralized to be soothing to the eye, and small amounts of full-intensity color have been used to add life. Permanent red is used in a subordinate manner. Some areas have been neutralized, and small areas of full-intensity color have been used to give balance to the composition and to make the composition more pleasing to the eye.

THE COMPLEMENTARY COLOR SCHEME

SIX STUDIES

As we have seen in the previous studies, there are many things to be considered when working with complementary colors. To get the colors to work well together, the artist must make many decisions. These considerations include how to organize the value, how to organize the intensity, how to utilize value effectively with pure intensity, how the neutrals will affect pure intensity, and which complementary color will be dominant and which will be subordinate.

Here are six studies using complements red (alizarin crimson) and green (viridian green). Notice how the value, intensity, and dominant and subordinate color affects the mood of the composition.

The dominant color is green, used in both analogous and contrasting values. The green has been neutralized to some degree. Red is the subordinate color. It is neutralized with white to create a pink, and used full intensity in small areas along the bank. This study is primarily on the cool side and has a lot of impact because of the contrasting value.

In this study, the mood is quiet and restful. Again, the dominant color is a cool green. The values are more analogous, creating a gentle feeling. The intensity has been neutralized with the complement, or lightened with white in the front bank. Red is the subordinate color, and it is entirely neutralized and lightened. Notice how the color is repeated in order to move the eye around the composition.

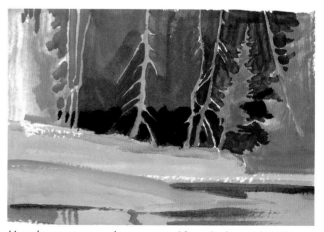

Here the contrast in value is reversed from the first study in this series. The main spruce has some pure-intensity light red, and the surrounding snags and trees are neutralized and lighter in value. The background is dark neutralized green, creating a feeling of sunlight hitting the foreground area.

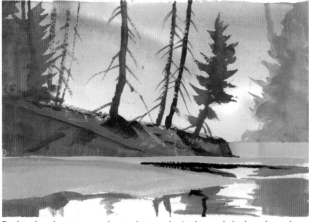

Red is the dominant color in this study. Light and dark red, and bright and dull red, have been used to give a strong impact to the composition. The greatest value contrast is in the area of emphasis, with less contrast in the outlying areas. Full-intensity green has been lightened with white and placed in small accent areas of the composition.

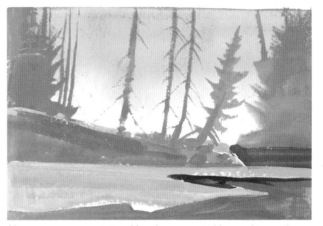

Here a serene, quiet mood has been created by working with primarily analogous light values. The dominant color red has been neutralized and lightened throughout the composition. The subordinate color green has also been neutralized and lightened and placed in small areas to give relief to the warm.

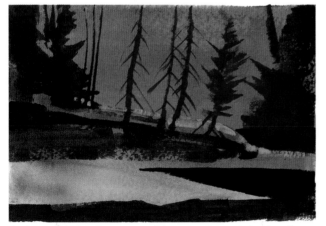

Analogous dark values are used here to give a subdued and somewhat eerie feeling to the composition. The dominant color red has been neutralized and darkened by the green. The subordinate color green also has been neutralized and darkened with the red.

Notice though, how the lightened pure-intensity red and green along the bank's ridge take on a vibrant look against the darker neutrals.

THE COMPLEMENTARY COLOR SCHEME

THREE PAINTINGS

Here are three finished paintings using complementary color. Each of the paintings uses color to best express the mood I wanted to convey. Each of the paintings is different in terms of subject matter: a high mountain lake, the Northwest coast at low tide, an isolated mountain town. Yet the approach to color is similar. Study the color in all three paintings. Why did I choose these colors to best express a mood? How were the dominant and subordinate colors used? How is the relationship between value and intensity handled? The color usage in each painting lets the complements work together in an exciting way.

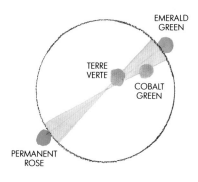

One of my favorite summer pastimes is fishing. Spending a day in the high country on a stream or lake in some remote area gives my mind and soul a chance to regenerate. Many of my ideas for painting come from these times. This painting is the result of a memory of one of those trips: canoeing on a high mountain lake in the early morning with no wind. Because it was done from memory, there were no detailed sketches of the area. The composition developed by my letting the paint flow and reacting to the flow. I actually had a friend pose for me while we were having lunch in a restaurant to get the figure for the canoe. The painting was done in watercolor and casein.

I chose the color for the mood I wanted to create, one of tranquility on a cool, peaceful early summer morning. Emerald green and permanent rose were the complements chosen, with green as the dominant color. The green is actually used in a series of neutrals with no pure intensity. Besides the neutral emerald green, cobalt green and terre verte were used. The subordinate color, permanent rose, is used as a neutral in the transparent washes in the sky and water. It is also used with pure intensity as the underpainting in the large land and tree forms, and as a pure accent on the fisherman's shirt. Notice how the hints of warm permanent rose add a glow and radiance to the composition.

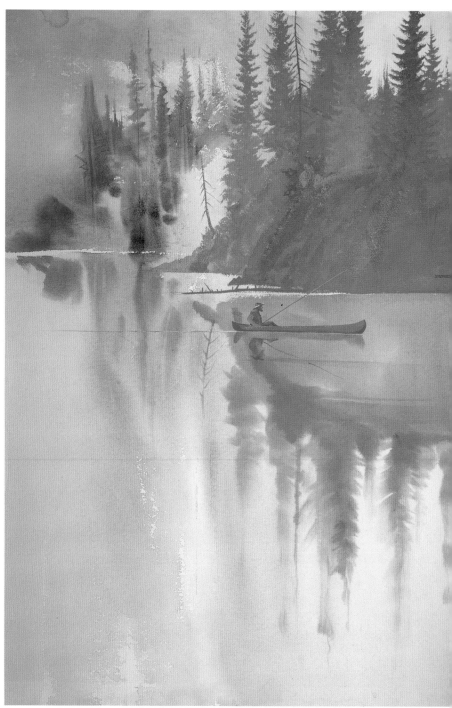

CANOE REFLECTIONS Watercolor and casein on 550 lb. Arches paper, 35″ × 25″ (88.9 cm × 63.5 cm). Collection of Sue Spencer.

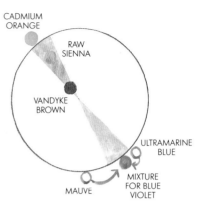

I enjoy doing quick line drawings of the ocean, rocks, and people on the Oregon coast. I move around sketching anything that catches my eye, usually spending no more than five minutes on each sketch. Back in the studio, I can interpret the sketch, personalizing the color and rearranging the composition. This is the line drawing that was used for the painting *Low Tide*.

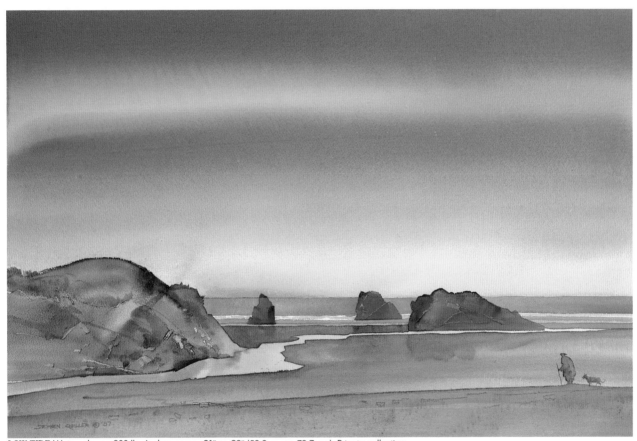

LOW TIDE Watercolor on 300 lb. Arches paper, 21″ × 29″ (53.3 cm × 73.7 cm). Private collection.

I love painting the Northwest coast almost as much as I enjoy painting the Colorado mountains. And though they are 1,500 miles apart, and the subject matter is very different, to me there is a real similarity between the two. During much of the year, both areas have few visitors and are very isolated. The local people seem to have a certain independence about them. The scenery has a ruggedness and danger but also an attraction that keeps pulling me to it.

In this painting, *Low Tide*, I was trying to convey these very things in the seascape: ruggedness, isolation, independence, a

lure of dramatic beauty, and tranquility. To do this I chose to limit my palette to the complementary colors blue violet and yellow orange. The dominant color is blue violet, which is a mixture of ultramarine blue and mauve. Semineutral blue violets are used in large areas of the sky and sand, and full-intensity blue violets are used in small areas of the sea. The subordinate color yellow orange is actually cadmium orange. It is used mainly as a series of neutrals in the sky and sand with a small amount of full-intensity color along the horizon and water inlet. The figure has been incorporated in the painting to give scale to the seascape.

THE COMPLEMENTARY COLOR SCHEME

This is a line sketch for the finished painting *Winter Evening, Creede*. In many of my sketches. I rearrange things for a better composition. Here, though, it was important that the painting represent the area. So I spent time driving back and forth on a road about four miles south of the town, studying the shapes and finding the best composition. I chose this spot because of the strong diagonal from the upper right mountain to the town at lower left.

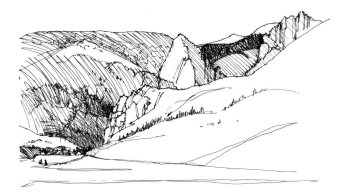

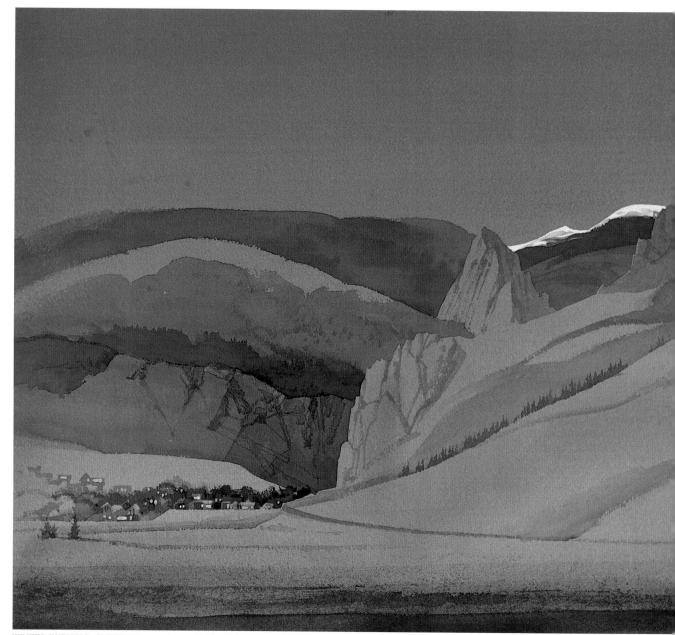

WINTER EVENING, CREEDE Watercolor on 300 lb. Arches paper, 21″ × 29″ (53.3 cm × 73.7 cm). Collection of Jim & Kim Gilfillan.

CADMIUM SCARLET
BURNT SIENNA
BURNT UMBER
PRUSSIAN BLUE
PHTHALOCYANINE BLUE

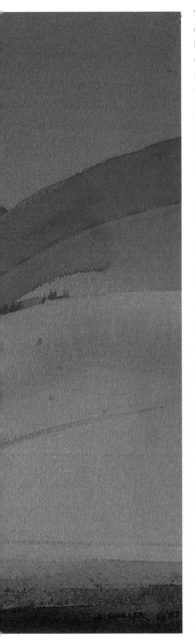

This is a painting of Creede, Colorado—under a full moon late one cold evening in January. Creede is located in the southern San Juan Mountains at about 9,000 feet elevation, and in midwinter the town is very isolated. I have spent a lot of time in this area, and in this painting I wanted to convey the special feelings I have for this place.

I limited my palette to a complementary scheme to create a certain mood. Prussian blue has always been good to me; I have found it very effective for capturing the feeling of night in winter. Here I used Prussian blue and cadmium scarlet for the complements with semineutral colors burnt sienna and burnt umber. The dominant color is Prussian blue to create the evening winter mood. The subordinate color is on the orange side, where the burnt umber and burnt sienna have been touched into the mountains and used more strongly in the foreground as a warm color to help give a feeling of depth. Cadmium scarlet is applied to the lights in the mountain village to give a jewellike shimmer of life to an isolated winter evening. In addition to the color, notice how the value has been controlled. The strongest value contrast is in the mountain peak at the upper right and the town at lower left, creating a counterbalance. The analogous values are used in the more quiet, restful areas of the composition.

WORKSHOP: COMPLEMENTARY COLOR SCHEMES

EXERCISE 1
Select two complementary colors. This exercise focuses on values within the complementary color scheme. Draw three rectangles approximately 5 inches by 7 inches. Two of these can be vertical and one horizontal. Using an abstract geometric motif, concentrate on the values of the colors in the composition. In the first study, use contrasting values in the area of emphasis and analogous values in the outlying quiet areas. In the second study, work instead with analogous light values, and in the third use analogous dark values. In all three designs, use the same color as the dominant with its complement as the subordinate.

EXERCISE 2
Select a simple subject, preferably a composition with a series of rectangular shapes such as sheds and barns, or adobes. Choose two complementary colors, and in the first study explore a full range of intensities from the pure color to the neutral of both colors. Use the pure color as an accent to lead the eye through the composition. In the second design, work entirely with semineutrals. Explore the range of color tones that can be achieved with just two colors, and control the movement in the composition through the value of the color.

EXERCISE 3
The emphasis of this assignment is warm and cool color. Select two complements that are strongly warm and cool, such as yellow orange and blue violet. In the first study, work with the warm color as the dominant. Use a full range of intensities and values. Use the cool complement as an accent and as the subordinate color. In the second composition, use the same subject but reverse the color. Work predominantly cool with subordinate warm accents. Notice the distinctly different mood of each design.

3 ANALOGOUS AND SPLIT-COMPLEMENTARY COLOR SCHEMES

I believe that an artist's knowledge and development of color should be based on tradition. Today we have at our fingertips literally centuries of painting theories developed by the masters. If we can understand their color theories, we will have the foundation on which to build our own knowledge of color. Too many short-lived art movements in the last thirty years have been based on rejection of the past. All great art is the culmination of lifetimes of discovery and knowledge.

Color is just one channel of expression. It is, however, the most emotional element that the artist has to work with. Thus it is important to pursue the knowledge of color theory—as well as drawing, composition, and media technique—for the richest expression of one's art. And the learning can continue indefinitely. I am reminded that Rembrandt, after a lifetime of working, felt that he was "just beginning" to express his personal vision.

There are really only two ways for a painter to use color. The painter can use closely related, analogous colors, or unrelated, contrasting colors. A painter friend of mine who is considered a colorist once said that we may use any combination of colors in a painting as long as the value works. Although I do not entirely agree with him, I believe that his statement has merit. How the value and intensity of color are handled in a painting is as important as the colors selected. With knowledge, an artist can take three or four unusual colors and come out with beautiful expression. It is important to study structured color schemes simply to develop this knowledge and to learn some sure-fire ways of developing beautiful color schemes and color harmony. Painting is like any other art form: Just as in dance, music, or writing, once one has a thorough understanding of all the basics of the art, the rules can be adjusted and expression becomes subjective.

In the last chapter, I discussed value and intensity, introduced the concept of dominant and subordinate color, and described one way to use two contrasting colors in a complementary color scheme. In this chapter, let's take a look at two more color schemes. The analogous color scheme uses three closely related harmonious colors; the split-complementary color scheme uses three closely related colors with one contrasting color.

Read through this chapter to study these two color schemes and my examples of paintings. Try the two workshops included in the chapter, and as you go along, experiment on your own and try your own studies. I recommend doing many small studies before working large and going for your "masterpiece"! You can cover a lot more ground with a series of small examples rather than laboring over a large piece that, when finished, may or may not work. With concentration and persistence, these color schemes will become second nature. Bon chance!

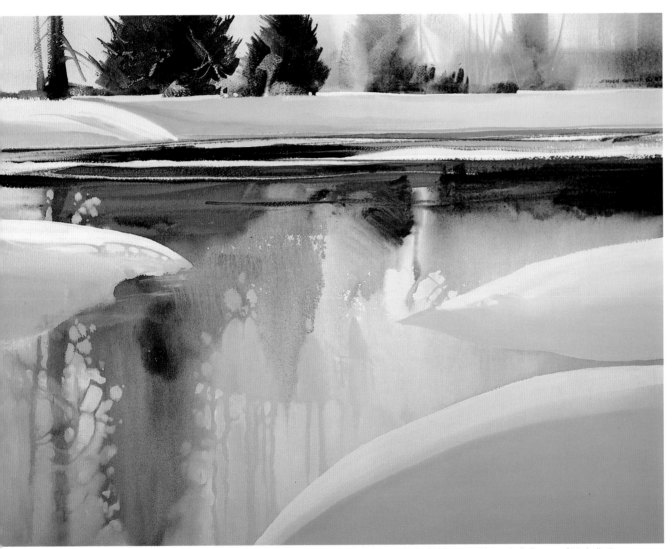

SPRING RUN-OFF REFLECTIONS Acrylic and casein on 550 lb. Arches rough paper, 26″ × 34″ (66.0 cm × 86.4 cm). Collection of Michelle Burns.

THE ANALOGOUS COLOR SCHEME

An analogous color scheme is one of the most beautiful, harmonious schemes to work with because the artist is using adjacent, closely related colors on the color wheel. To determine what colors can be used in this scheme, draw a color wheel and mark the primary, secondary, and tertiary colors.

Any three adjacent colors can be used together for this scheme. In addition, the lighter and darker values of each color and their semineutrals can be used. For the best relationship, one color should be selected as the dominant color, one as the subordinate color, and another to be in between.

Here is a color wheel with the primary, secondary, and tertiary colors listed. Any three adjacent colors can be used to develop an analogous color scheme, as well as the light and dark values and semineutrals of those three hues. Red (alizarin crimson), red violet (cobalt violet), and violet (mauve) are the colors used in this example.

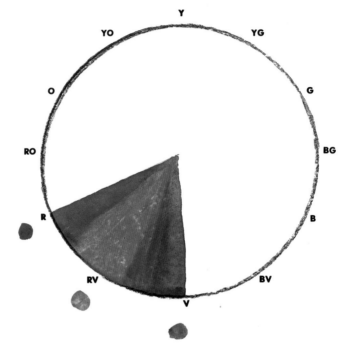

USING ANALOGOUS COLORS IN A STUDY

The same three colors that are shown above can be used in a study for a finished painting. Many things must be considered before starting the study, and most important is the feeling or mood that needs to be expressed in the composition. The red, red violet, and violet are used here to convey a feeling of warmth, activity, and cheerfulness. Any three analogous colors could have been chosen, giving a distinctly different feeling to the composition.

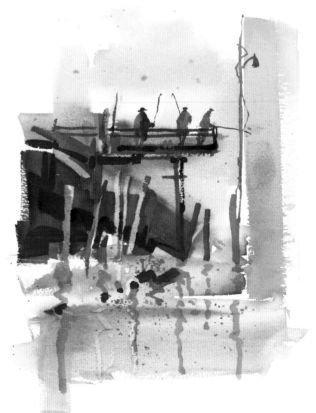

This small study uses the colors chosen in the previous diagram. Notice that the colors vary in value and intensity to develop a harmonious relationship. This idea came from a recent sketch of fishermen, wharf, and pilings in an area close to a small town on the Oregon coast.

SELECTING ANALOGOUS COLORS

Actually, many pigmented colors (that is, colors straight from the tube) can be used in an analogous color scheme. The only prerequisite is that they must be located within the wedge of the three analogous colors. Refer to my color wheel after page 16 and notice the number of colors that can be selected on any given scheme. Note that although all the colors in an analogous wedge can be used, usually only a few are selected.

In this analogous color wedge, the three chosen colors are red orange, orange, and yellow orange. There are actually many colors located on the outside edge of the wheel within this range. Some of these are cadmium red deep, bright red, vermilion, cadmium scarlet, cadmium red light, and cadmium orange. Within this wedge are the semineutral colors yellow ochre, raw sienna, burnt sienna, light red, brown madder alizarin, burnt umber, and Vandyke brown. All these colors could be used in one analogous color scheme, but usually a painting is more unified if the artist chooses just a few.

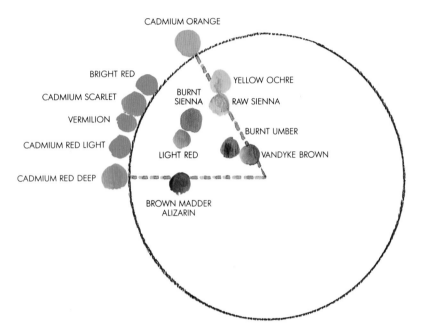

CADMIUM ORANGE

BRIGHT RED

CADMIUM SCARLET

VERMILION

CADMIUM RED LIGHT

CADMIUM RED DEEP

BURNT SIENNA

LIGHT RED

BROWN MADDER ALIZARIN

YELLOW OCHRE

RAW SIENNA

BURNT UMBER

VANDYKE BROWN

ANALOGOUS COLOR SCHEMES CREATE HARMONIOUS COLOR

One popular dictionary defines harmony as "a consistent, orderly, or pleasing arrangement of parts . . . forming a consistent whole." By its very nature, the analogous color scheme is harmonious. Each of the adjacent colors is related to and has part of the other color in it. For instance, in the analogous color scheme yellow green, green, and blue green, the three colors are related because of the middle color, green. Each color has some green, the common color, in it.

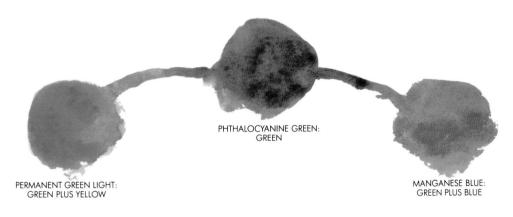

PERMANENT GREEN LIGHT:
GREEN PLUS YELLOW

PHTHALOCYANINE GREEN:
GREEN

MANGANESE BLUE:
GREEN PLUS BLUE

Three colors have been chosen to represent an analogous color scheme: yellow green (permanent green light), green (phthalocyanine or viridian green), and blue green (manganese blue). This combination consists of one secondary color and two tertiary colors that are located side by side on the color wheel. Notice that the tertiary colors yellow green and blue green both have the common color green in them, thus creating a common link and a harmony to the whole.

THE ANALOGOUS COLOR SCHEME

THE FULL RANGE OF THE ANALOGOUS SCHEME

Choosing the harmonious colors of an analogous color scheme is a good start in setting the mood of the painting. The key, however, is in the way the value and intensity are used, allowing the viewer's eye to move throughout the painting, and thus allowing the structure of the composition to be seen. In the analogous color scheme, each color's complement can be used to neutralize the intensity, and white and black can be used to adjust the value. In the previous chapter, I mentioned that full-intensity colors are generally used in small areas, while semi-neutrals can be used in large passive areas. You will also remember that strong contrasting values are used mostly in the area of emphasis, with analogous values in large passive areas.

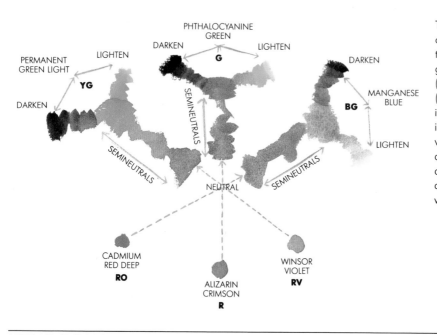

This diagram illustrates the full range of an analogous color scheme. In this example the three analogous colors are yellow green (permanent green light), green (phthalocyanine green), and blue green (manganese blue). The color scheme also includes their semineutrals, created by mixing these colors with their complements red violet (Winsor violet), red (alizarin crimson), and red orange (cadmium red deep). In addition, each color and its semineutrals can be lightened and darkened in value with white and black.

USING DOMINANT AND SUBORDINATE COLOR

For the complementary color scheme, I mentioned that usually it is better to use color in varying amounts, choosing a dominant and subordinate color. This is also true for the analogous color scheme. Usually, one color is selected to be the dominant color. It is used in varying intensities and values in larger areas of the painting. A second color is chosen as the subordinate color and is used in small amounts to accent the composition. The third color is intermediate, used less than the dominant color but more than the subordinate one. Using three analogous colors in this ratio can give a harmonious arrangement of color.

For this study I chose a cool analogous scheme of green (emerald green and phthalocyanine green), blue green (cerulean blue), and blue (phthalocyanine blue). Blue green has been used as the dominant color, blue as the intermediate color, and green as the subordinate color. Notice that all the colors have been repeated in the composition and that the subordinate color green is used in a light, pure tone next to a dark blue to give a strong contrast and a vibrant accent.

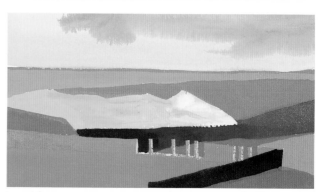

I used the same composition as in the previous study. This time, however, I used a warm analogous scheme of yellow (cadmium yellow light), yellow orange (cadmium orange), and orange (cadmium scarlet). Orange is used as the dominant color, yellow as the intermediate color, and yellow orange as the subordinate color. All the colors have been repeated throughout to emphasize the primary areas and to de-emphasize the secondary areas, thus unifying the composition.

AN ANALOGOUS SCHEME IN A HIGH-KEY RELATIONSHIP

High-key is a term used for colors placed together that are light in value. They can be analogous light values—or even better, the same light value. Adding white to a color will lighten and soften the color, neutralizing it to some extent. The result is a pastel look to the color or relationship of colors. An analogous high-key color relationship is often very pleasing to the eye and can give a soft, shimmering effect, an airy or fantasylike feeling, to a painting. This idea is not new. The impressionists Monet, Pissarro, and Degas used this approach, and so did many later painters, including Bonnard. Usually the paint is applied in light tones that are the same or quite similar in value, but whose analogous color changes. It is quite a lovely sensation for the viewer. Up close, the similar colors of the same value shimmer, while at a distance they almost appear as one color.

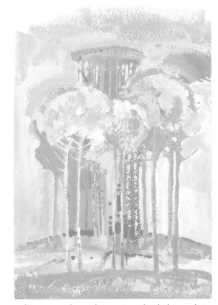

This is an analogous color scheme in a high-key relationship. All the colors are pure and have not been neutralized by their complements. Permanent green light, cadmium yellow light, and cadmium orange are the colors selected. Varying amounts of white have been added to all the colors to give high-key values to the study. Notice that the composition has a pastel quality and a feeling of fantasy. When a painting uses analogous colors of similar value, the eye is treated to a soft stimulating shimmer.

ONE PURE ACCENT, WITH TWO SEMINEUTRALS

The mood and impact of a composition can be controlled by the colors chosen, the intensity of each color, and the value. In an analogous color scheme, one color can be used as a pure-intensity accent surrounded by the related colors in semi-neutrals. The pure-color accent used in small areas will advance and seem brighter than the surrounding colors, yet still relate because it has some of the surrounding colors in it. Pure hue always advances more than the semineutral of the same color, whether the color is warm or cool. This may seem strange when the color is on the cool side. For instance, pure blue will advance more than its semineutral, even though the color is neutralized with a warm orange. The darker the value of the surrounding semineutral color, the brighter the pure hue will seem.

This is a study of some geese that were waiting to be fed. I used the analogous colors yellow orange (cadmium orange), orange (cadmium scarlet), and red orange (cadmium red deep). Yellow orange is used as the pure hue accent, while the other two colors are used as semineutrals. Notice the variation of color in the semi-neutral background, adding subtle interest to the composition. In addition, the dark value of the background allows the pure yellow orange to stand out. The same pure yellow orange is used for the feet of the geese, but appears much darker against the white paper.

ANALOGOUS SEMINEUTRALS

Another way of working with an analogous color scheme is to use all of the color in semineutrals. By using the color this way, the artist can create distinctive moods, such as a foggy, drizzly harbor scene; a wintry evening scene; or a hot, dusty, dry midday landscape. Today there are many paintings of barns and windmills done in the Midwest using raw sienna (or yellow ochre), burnt sienna, and burnt umber. These are really just semineutral analogous colors. Today, because we have so many colors manufactured, we have the option of using semineutral tube paints, or mixing the semineutral from two complements. I generally prefer using the pure color and its complement to mix a semineutral because there is more range of intensity and a more interesting settling of pigments in washes, or general paint application.

This is an example of an analogous color scheme in semineutrals. Notice the grayed atmospheric effect and distinctive mood. The colors are green (viridian green neutralized by alizarin crimson), blue green (cerulean blue neutralized by bright red), and blue (phthalocyanine blue neutralized by cadmium scarlet). There is a subtle mingling of the three colors throughout the painting to give more interest to the semineutrals. The structure of the composition and the area of emphasis are controlled through value.

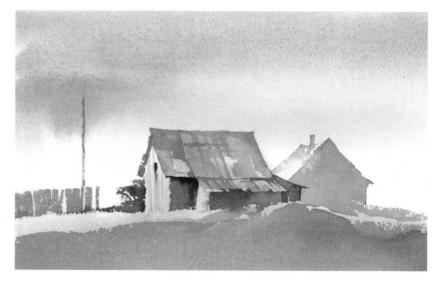

ANALOGOUS COLORS OF FULL INTENSITY

Analogous colors of full intensity can also be used effectively. Large areas of pure-intensity color will definitely attract the eye but will also overwhelm the eye after a very short time of looking. This concept is used today in the advertising industry. Billboards and magazine ads use bright colors to capture immediate attention. Fast-food franchises use bright, warm colors to attract but also large areas of bright color so that the consumer will not want to stay long. Several expressionist painters of the 1920s and 1930s, including Matisse, Vlaminck, and Derain, used bold, bright colors very expressively.

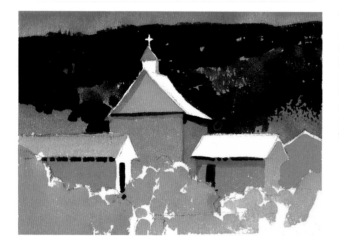

The warm analogous colors have bright, bold relationships. The color is used at full intensity, and black and white add contrast to areas of particular importance. A few semineutrals are used in the background area to prevent it from competing with the foreground. This bright color scheme with high contrast will capture immediate attention. I have noticed that large paintings with vivid colors and strong compositions dominate awards in many of the major competitions, probably for similar reasons. After a short time, however, such color schemes can overpower the eye.

SIX STUDIES

The same three colors in an analogous color scheme can be used in distinctively different ways, depending on the various effects and moods desired. The variations are endless because each of the three colors can be used as either the dominant, intermediate, or subordinate color. Each color can range from a pure intensity to a dull semineutral. And each color can range in value from light to dark. In addition, the relationships in itensity and value of the three colors can vary in their degree of closeness or contrast. Here are six studies of the same composition using three analogous colors of red violet (cobalt violet), violet (mauve), and blue violet. Notice how each study differs in color emphasis, value, and intensity. Also look at how the various moods have been developed, ranging from calm and serene, to austere, to fantasylike, to dynamic and powerful.

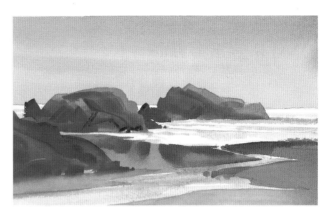

Most of the color in this composition has been neutralized. Pure-intensity accents of red violet have been placed in the foreground and distant rocks. Darker values have been placed next to the pure-intensity areas to help bring them out. The semineutral colors have been placed, for the most part, in the outlying, secondary areas of the composition and are analogous light values. Notice how the strong, contrasting values bring the eye to the area of emphasis.

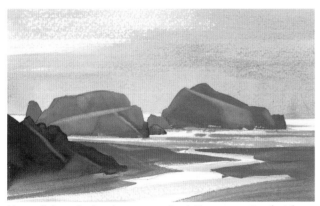

Here, all the color has been neutralized. Even so, notice that the subtle semineutral colors of blue violet, violet, and red violet intermingle to give unity to the color scheme. The values have been organized in the rock forms to become increasingly dark as they come forward, and the warmer semineutral of red violet is used in the foreground sand to bring it forward.

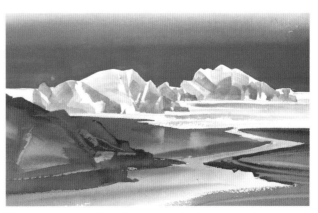

This study reverses the logical sense of color organization by putting pure, strong, contrasting color in the background and the more neutralized color in the foreground. The intense blue violet of the sky contrasts with the white and pale red violet values of the distant rock forms, dramatically directing the eye to that area. The foreground sand, rocks, and tidal pool are of closer neutralized values and become secondary areas. Again, as in the other studies, the color has been repeated throughout the painting.

THE ANALOGOUS COLOR SCHEME

An austere, gloomy mood has been developed in this painting. The values are from middle gray to low dark, and all the color has been neutralized. The less neutralized red violet is used in the foreground, with the more neutralized mauve in the distance. The strongest contrast is in the middle distance, where the blue violet rock meets the sky and water. The contrasting colors attract the eye to that location.

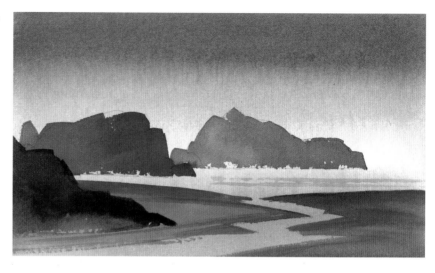

A sense of power, energy, and drama has been developed here, using high contrasting value and pure intensity. Some color has been diluted to neutralize it and lighten its value, but none of the complements or black have been used. All three colors have been used straight from the tube. The darkest colors, violet and blue violet, have been placed in strong contrasting areas to lead the eye there.

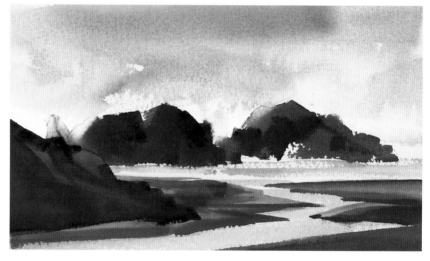

A calm, serene mood has been developed here by using lighter analogous values of three pure colors. The warmest color of red violet has been chosen as the dominant color to give a rich, peaceful quality to the composition. All the colors have been diluted with water to lighten and soften them, and to create a restful mood. Although the values for the most part are analogous, the darker values are in the foreground to give depth to the composition.

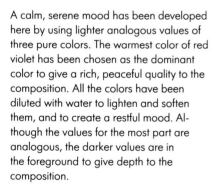

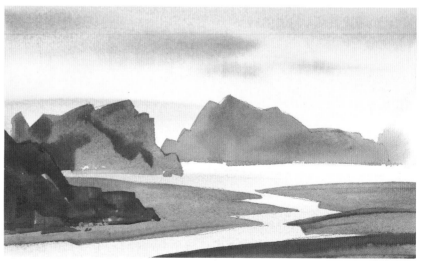

THREE PAINTINGS

The analogous color scheme is a truly harmonious color scheme. As you can see, there are many moods that can be achieved by varying the value, intensity, and dominant-subordinate relationships of three closely related colors. Here are three examples of how the analogous scheme can be used. Using the principles in this chapter, I have created three paintings with distinctly different feelings. *Fishing Village—November Morning* evokes the quality of a cool, damp, drizzly day on the coast at low tide. *Late Autumn Sunflowers* conveys a warm late afternoon in autumn. *Winter Herd* portrays a cold, crisp moonlit evening in midwinter in the high country. The mood of each painting is enhanced by its limited range of color.

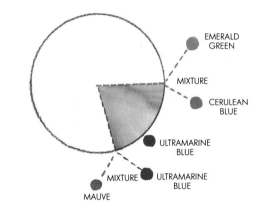

This is the drawing I did from the beach that morning. The light-house was actually much further to the left of the buildings so I just did an informational sketch of it at the lower part of the page. As you can see from my sketch, at one time I thought of placing a woman and some geese on a nearby bank before deciding on my final composition.

FISHING VILLAGE—NOVEMBER MORNING Transparent watercolor on 300 lb. Arches rough paper, 9″ × 28″ (22.9 cm × 71.1 cm). Artist's collection.

The Oregon coast has many moods. Its extremes range from calm, sunny warmth to turbulent stormy gales. On this November trip, I found this small village with its lighthouse on the bay on a cool and misty day. After making a sketch, I went to my motel and developed this painting.

To capture the mood of this particular day, I decided to use an analogous color scheme with misty, foggy colors. From my palette I chose a blue green, blue, blue violet scheme; emerald green is mixed with cerulean blue for the blue green side, and mauve is mixed with ultramarine blue for the blue violet side. I felt that the emerald green would give a little life to the dreary day, while the mauve could add some strong darks.

I rearranged the composition, moving the lighthouse in at the left and choosing a long horizontal format. I was interested in getting an exciting spatial relationship between the positive land, rock, and building shapes and the negative sky and water shapes. The extended horizontal format was important to capture the panorama of the area.

Transparent watercolor seemed to be the ideal medium to express this atmospheric mood. When I paint on the coast, where the air is more humid, I always use a hair dryer in order to speed up the drying time of each wash. I used a variety of wet on wet and control washes to capture the feeling, and I was able to complete the painting that same afternoon.

LATE AUTUMN SUNFLOWERS Casein on heavyweight Crescent illustration board No. 100, 22" × 30" (55.9 cm × 76.2 cm). Artist's collection.

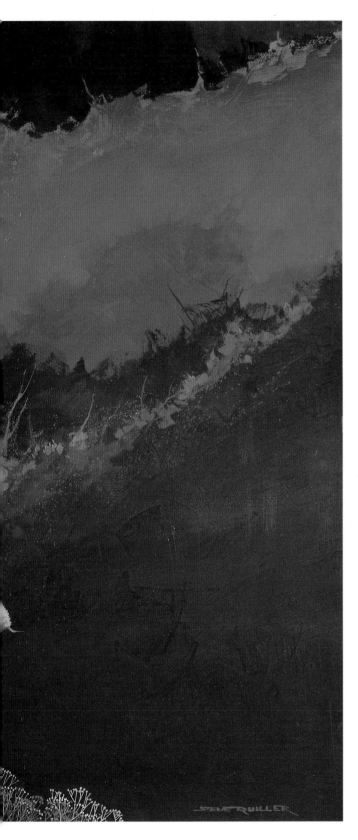

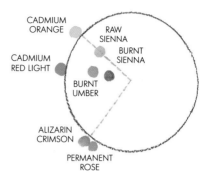

I have been interested in the transformation of vegetation from summer to autumn for many years. As these wildflowers and weeds lose their petals and color, they dry into pods and skeletal structures that, to me, are even more beautiful. The wild iris, yarrow, and blue mountain flax are only a few that dry into magnificent, delicate forms. So it is with sunflowers. In the autumn, after the yellow petals are gone, they still hug the edges of the roads and decorate fields and hills, but are less noticeable.

I pick these weeds and have them in my studio, and from time to time I make an arrangement and paint it. In this particular painting, I wanted to capture the feeling of low, raking light on these weeds in late autumn. The color was very important to express this mood in the composition, so I decided on analogous warm colors with strong value contrast. I moved the sunflowers, flax, and baby's breath around until the right movement and interaction of forms were achieved. Thumbnail sketches were then developed in order to get the right rhythm of the brushy shapes in the background. A diagonal, curvilinear movement was chosen to counter the diagonal, curvilinear flow of the weeds.

Casein was used for the medium because of its soft matte visual quality, and because it can be applied from transparent to opaque, and worked light to dark or dark to light. It was also used because of the fine opaque detail that was necessary for the weeds. I also decided to use a fairly smooth, rigid illustration board on which to build the casein surface and for ease of brush flow with the detail.

The composition was developed by first painting the background, loosely working dark on light and light on dark. I wanted much of the background to be darker in value to serve as a foil for the lighter still life of weeds. When the background was finished, I painted the detailed weeds, making sure that the background color was repeated. The painting is mostly in the semineutral earthy colors of late autumn: raw sienna, burnt sienna, and burnt umber, with just a little pure-intensity cadmium orange and Shiva rose used. (Shiva rose is a casein color similar to permanent rose.)

THE ANALOGOUS COLOR SCHEME

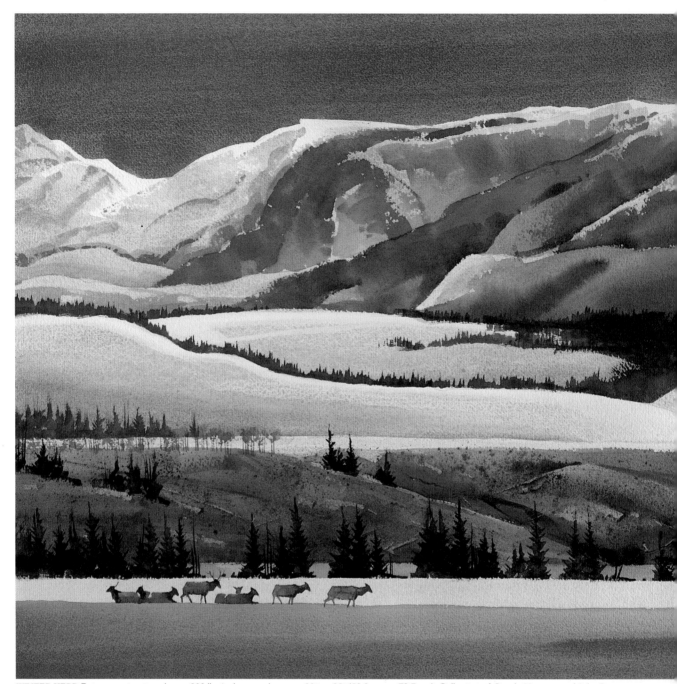

WINTER HERD Transparent watercolor on 300 lb. Arches rough paper, 20" × 29" (50.8 cm × 73.7 cm). Collection of Carole Hennan and John Bruce.

I love the evening winter patterns of the high country. The full moon reflecting on the snow gives so much light that it almost seems like daylight but without the color. It has been five years since I have lived in this part of the San Juan Mountains, but the memories are strong, and I decided to paint the feelings that I have about this area.

This painting is similar to *Winter Night, Upper San Juans*, shown in Chapter 2. I decided to use *Winter Herd* here to illustrate the subtle differences between this analogous-color-scheme painting and the first monochromatic one.

The emphasis of this painting is on value, to move the eye through the composition. However, intensity is also important. I

have intentionally neutralized the manganese and phthalocyanine blues in the sky and background mountain ranges. As I painted the foreground mountain forms, trees, and snow, I used stronger, full-intensity blues and more contrasting values.

To create interest within a painting, many times it is important to vary the color of the blue quite subtly rather than to just stay with the same blue. Here there are three blues used: phthalocyanine, cerulean, and manganese. In addition, each color has a full range of intensity and value, allowing the eye to feast on the subtle changes. Also, you can sense manganese blue's complement cadmium red deep in this composition where the blue has separated and settled in the neutralized mixture.

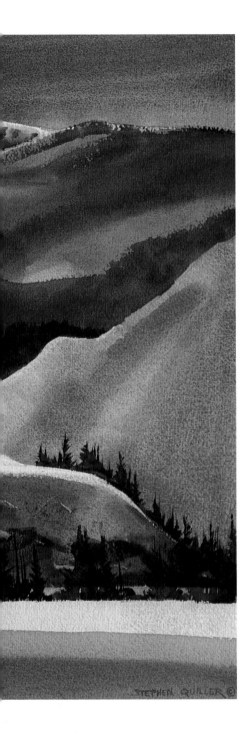

STEPHEN QUILLER ©

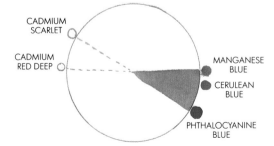

CADMIUM
SCARLET

CADMIUM
RED DEEP

MANGANESE
BLUE

CERULEAN
BLUE

PHTHALOCYANINE
BLUE

WORKSHOP: ANALOGOUS COLOR SCHEMES

These exercises can be done in the media of your choice. Each progressive study becomes a little more difficult. And of course, each study can be done with different colors and a different subject for completely different results. Experiment with these exercises. Then, when you feel that you understand the analogous scheme concept, develop other studies using ideas in this chapter. Have fun!

EXERCISE 1

Using a sketch or a photograph, select a simple subject such as a group of buildings, some mountain forms, or water and rocks. Choose three analogous colors that will best express the mood of your subject. Decide which color will be the dominant, intermediate, and subordinate. Develop the painting, emphasizing the semineutral colors that will be mixed by adding the complement. Have some full-intensity color and the strongest contrast in the area of emphasis.

EXERCISE 2

Arrange a still life of objects with warm analogous colors. For example, you might place a lemon, an orange, and an apple on a soft yellow or raw sienna tablecloth, with a clear or opaque white vase. Move the arrangement around until an interesting composition appears. Intentionally shift the color scheme of the painting to the cool side using blue, blue violet, and violet colors, plus their complements to neutralize, and white and black if they are necessary for the study. Paint a composition emphasizing a somber mood. Use a lot of semineutrals in the composition and some pure color in the area of emphasis. Keep the values fairly analogous with some stronger contrast in some locations to lead the eye.

EXERCISE 3

From a sketch or photograph, choose a landscape that has a background of sky and mesas, hills, or mountains, with a foreground subject such as barns, adobes, or houses. Develop the background area in high-key warm analogous colors so that it has a soft, shimmering effect. In the foreground buildings and land forms, use stronger contrast, mostly semineutrals with some pure intensity in the area of emphasis and other accents.

THE SPLIT-COMPLEMENTARY COLOR SCHEME

The concept of the split-complementary color scheme is fairly simple if one thoroughly understands the complementary and the analogous color schemes. Basically, it is an analogous color scheme with one contrasting color. Sometimes this scheme is called an analogous color scheme with a dischord. To locate the colors to be used in this relationship, begin by choosing three analogous colors that will convey the dominant mood of the composition. Then take the middle color of this analogous color scheme and select its complement to be used as the contrasting accent color.

This reintroduces the concept of warm and cool that was used in the complementary color scheme but lost in the analogous color scheme. I love the split-complementary color scheme because I think that the accent color makes all the difference. This color can be used as an undertone or an accent color and provides the opposite color balance to the dominant analogous relationship. The split-complementary color scheme provides the harmonious analogous relationships plus the balance of the contrasting color for a rich, unifying color scheme. This scheme can be used in a variety of exciting ways.

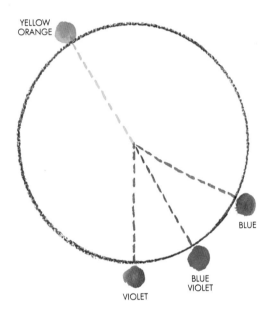

This is an example of a split-complementary color scheme palette. Violet, blue violet, and blue are the dominant colors in this scheme. Each of these colors can be used to full intensity or neutralized, in lighter or darker values. The accent color is found by splitting the three colors to find the middle color, which in this case is blue violet. Blue violet's complement, yellow orange, is then used as the accent balancing color. To choose the colors in a split-complementary color scheme, the artist must first ask what mood needs to be expressed, then select the colors that will create this feeling.

The mood to be expressed in this study is one of coolness and isolation. Blue, blue violet, and violet, with yellow orange as an accent, will create this mood. The three cool colors have been used in lighter and darker values. Violet was applied in full intensity on the roof. The trees have been painted with a semineutral mixture of blue violet and yellow orange. The light yellow orange in the windows and neutralized yellow orange on the snow provide a nice accent to the dominant cool scheme.

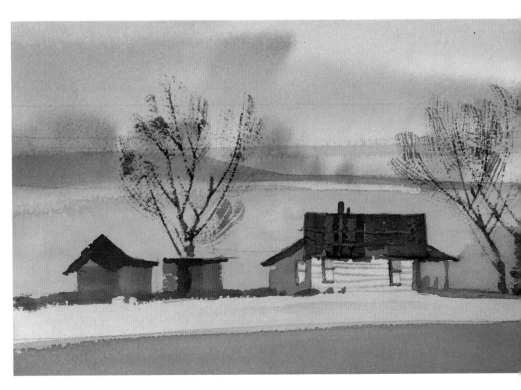

SELECTING COLORS FOR THE SPLIT-COMPLEMENTARY COLOR SCHEME

I have defined basically what a split-complementary color scheme is and how to determine the colors it includes. Let's look at my color wheel after page 16 and explore some of the ways to use pigmented colors. Using the color scheme yellow green, green, and blue green, with the accent color red, notice all the pigmented colors located within that range. Every one of these colors could be used to paint this particular color scheme. However, most artists will limit their palettes, choosing just four or five colors, so that the painting's color relationships usually seem more coherent and not so patchy.

Colors for a split-complementary color scheme can be located on the outside of the color wheel. For instance, emerald green, viridian green, and manganese blue, with alizarin crimson, could make a very pleasing scheme. But actually the colors on the inside of the wheel can work well for a more neutralized composition. Let's take an example of Hooker's green dark and cobalt green, both semineutral colors, and a pure hue like manganese blue, with semineutral Mars violet as the accent balancing color. These colors could have a wonderful visual impact for the right painting. The most important thing is to be selective and choose the colors that will best fit the mood to be expressed.

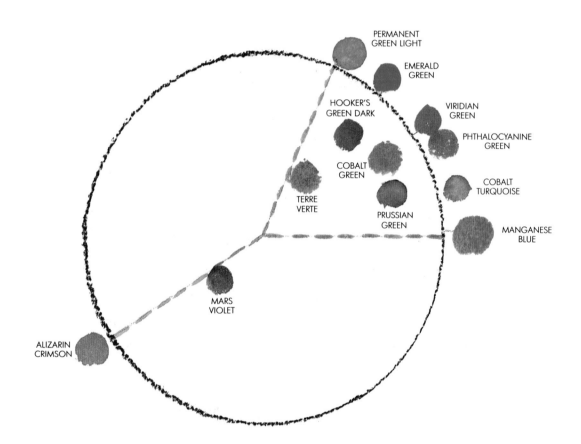

Here are some of the pigmented colors located in the color scheme yellow green, green, and blue green with the accent color of red. All these colors can be used straight from the tube or mixed to form more colors within this range. Notice that as the colors approach the center of the color wheel, they become more neutralized.

COLOR RELATIONSHIPS IN THE SPLIT-COMPLEMENTARY COLOR SCHEME

The split-complementary color scheme is really a combination of the analogous color scheme and the complementary color scheme. As in the analogous scheme, there are three closely related colors, and each of the three colors has part of the other color in it, ensuring that it will be harmoniously pleasing to the eye. Like the complementary scheme, the split-complementary color scheme has a contrasting, subordinate color that can be used as a pure accent or hinted at in a more neutralized manner to provide color balance. All these colors can be used in lighter or darker values by adding white or black, and neutralized by adding the complement. In choosing this color scheme, the artist is using a selective, limited palette that will create a distinctive mood with the three dominant colors, yet provide a little pizzazz with the contrasting color.

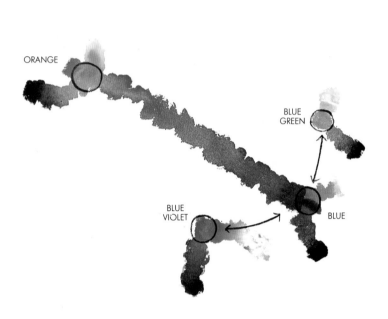

This diagram shows the color relationships in the split-complementary color scheme. The three dominant colors are blue violet, blue, and blue green. Each of these colors has the common color of blue, which ensures a close, harmonious relationship. Orange, the complement of the middle color blue, provides a subordinate warm balance to a dominant cool scheme. (In a predominantly warm scheme the reverse would be true.)

MIXING SEMINEUTRALS WITH THE SPLIT COMPLEMENT

There are two ways you can mix semineutrals in the split-complementary color scheme. The easiest way is to always use the complement of the middle color (also called the split complement) to create the semineutrals of all three of the analogous, dominant colors. The advantages in doing this is that the artist is using a very limited palette. Also, every semi-neutral color, either dominant or subordinate, has some of the split-complement mixed in, creating some unity. The disadvantage is that some of the semineutrals are not quite as beautiful. Because two of the dominant colors are not neutralized with their own true complements, the combination of semineutrals does not look quite as pleasing.

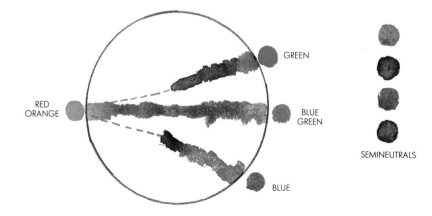

This diagram shows how semineutrals can be mixed using the split complement. The three dominant colors are green, blue green, and blue, and the split complement is red orange. All three of the analogous colors use red orange to mix their semi-neutral. The blue green and red orange are direct complements and neutralize each other completely. However, neither the green nor the blue is the direct complement of red orange, so the semineutrals are not as visually pleasing. The semi-neutral created on the green side becomes a warmer brown green. The semineutral made on the blue side becomes a warmer brown blue. To the right of this color wheel is a chart showing semineutrals of these four colors.

MIXING SEMINEUTRALS WITH DIRECT COMPLEMENTS

Another way of creating semineutrals in a split-complementary color scheme is to use direct complements. In doing so, each dominant color will have its true complement placed on the palette. Thus the colors on the palette increase, even though two of the complements will never be seen in the finished painting. The obvious advantage to this is that the semineutral colors are a bit more pleasing. In the painting process it takes a little more thought to remember to mix the true complement to neutralize, but the results are definitely worth it. This is how I usually approach semineutral mixing in this scheme.

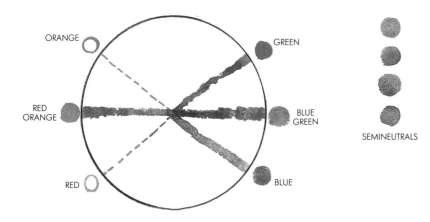

This diagram illustrates three analogous colors: green, blue green, and blue, neutralized by their true complements. Each of the semineutrals is visually pleasing. The red orange remains the subordinate color and can be used as a pure accent or a secondary semineutral to add visual balance. The orange and red are used just to neutralize the blue and green and will not actually be seen in the finished painting. To the right of the color wheel are the semineutrals of the four colors made by using their true complements.

COLOR PROPORTIONS IN THE SPLIT-COMPLEMENTARY COLOR SCHEME

The proportions of colors used in the split-complementary color scheme can orchestrate visual excitement, but they will seem confusing if used poorly. It is best if the three analogous colors are not used equally because they can tend to compete for attention. Instead, one color can be more dominant, one intermediate, and one subordinate. The complementary color should also be subordinate. It can be a pure hue accent or a semineutral for a subtle opposite to give color balance.

Here we have dominant cool colors and a subordinate warm one. The three cool colors are blue (phthalocyanine blue) used as a dominant, violet (mauve) as an intermediate, and blue violet (ultramarine violet) as a subordinate. The subordinate warm color used as a pure accent and as a semineutral is yellow orange (cadmium orange). The colors are repeated in various areas of the composition to help move the eye throughout the study and provide visual balance.

This study of the same composition uses dominant warm colors and a subordinate cool color. The three warm colors are orange (cadmium scarlet) used as the dominant, yellow orange (cadmium orange) as an intermediate, and yellow (cadmium lemon) as a subordinate. The complementary subordinate cool color is blue violet (ultramarine violet). Notice that the cool blue violet is just hinted at in the study but provides enough to give relief from the dominant warm scheme.

THE SPLIT-COMPLEMENTARY COLOR SCHEME

APPLYING SPLIT-COMPLEMENTARY COLOR IN A TRANSPARENT-OPAQUE MANNER

There are many ways to apply paint to create visual excitement. One way is a transparent-opaque approach. This type of application is not new. Rembrandt worked with thin transparent and translucent areas against opaque applications to create form. American genre painters like Eastman Johnson and some European impressionist painters such as Joaquín Sorolla worked with thick and thin surfaces. And many English watercolor painters such as J. M. W. Turner, William Blake, and Samuel

Palmer have used this approach. Today artists are increasingly concerned with the visual quality of the paint surface.

Split-complementary color can be used in this way. The transparent layer is applied first; this can be one of the three analogous colors or the contrasting color. Once this transparent layer is dry, the opaque colors can be put down. Care must be taken to leave some of the undercolor to create the desired effects of transparent-opaque.

In this study, yellow, yellow orange, and orange are the dominant analogous colors and blue violet is the subordinate contrasting color. The blue violet is first used with a transparent application. After the wash has dried, the analogous colors and white are added opaquely, leaving some of the transparent blue violet visible. Notice the visual contrast between the transparent and opaque colors, which enhances the contrast between the analogous warm colors and the cool split complement.

Again in this study, yellow, yellow orange, and orange are used as the dominant analogous colors and blue violet as the subordinate complementary color. However, orange is used here as the transparent underlayer. Yellow, yellow orange, and blue violet are then put down opaquely, allowing the orange to show through in some areas. Notice the vibration and the visual quality that are achieved using contrasting colors and paint applications in this way.

INTERACTION OF TRANSPARENT, TRANSLUCENT, AND OPAQUE

Another way to create visual interest in the split-complementary color scheme is through interaction among transparent, translucent, and opaque colors. In this approach, as in any other color application, the key is the amount of each color used and how the colors are put down. Interaction is the key word: The colors must interact and the applications must interact. If color or paint applications are isolated, they will look out of place.

A translucent wash or glaze over a transparent area can be very exciting. This allows the transparent color to radiate very subtly through the translucent. I like to work with complements in a transparent-translucent manner because of the subtle semi-neutrals that can be achieved.

The dominant analogous colors used in this study are green, blue green, and blue. The contrasting subordinate color is red orange, which was first applied as a transparent wash. Once the wash was dry, the mountain area was put down opaquely, using all the colors in a dominant-subordinate manner. Then a translucent mixture of green and white was washed over the transparent red, letting some of the undercolor show through. Notice the visual interaction of the three paint applications and look at the beautiful translucent semineutrals that have been created with the red and green.

GLAZING WITH SPLIT-COMPLEMENTARY COLOR

Another way to create visual interest in a painting is through glazing. Until the mid-nineteenth century, glazing color was very common. In this technique, also called *grisaille*, the artist first applies semineutral colors in order to build the form of the composition. When the undercolor is dry, pure color is glazed thinly and transparently over the surface to add the color to the form. The result is a striking visual realization of both form and color. This process has been developed in oil painting, but fine results can also be achieved in watercolor and acrylic.

In the split-complementary color scheme, glazing can be achieved using the contrasting color. The undercolor is applied in either an opaque or a transparent manner, and allowed to dry thoroughly. The complementary color is then washed over the desired areas, creating rich semineutrals.

In this study, yellow green, green, and blue green are used as the analogous dominant colors; red is used as the subordinate glazing color. First the sky was washed in, using the pure red at the horizon and a mixture of semineutral blues and greens in the upper region. When this wash was dry, the yellow green and green were applied to the water area. The rocks were then put in with semineutral mixtures of all the colors. Finally, thin transparent red was glazed over some areas of the water to create the semineutral greens and reds. Notice the visual quality of the foreground water forms made by the glazing.

THE SPLIT-COMPLEMENTARY COLOR SCHEME

SIX STUDIES

As with any other color scheme, there are many things to think about in order to create a successful painting. With the split-complementary color scheme, the first thing to decide is what color will work best for the particular mood of the subject. Then the palette should be organized so that there is a dominant, intermediate, and subordinate in the analogous colors. The complementary color should work with and add balance to the composition. The color value and intensity should guide the eye throughout the composition. Finally, any and all paint applications should be integrated in the painting.

Here are six studies using the same color scheme, each with entirely different results. All the paintings use the same split-complementary color scheme. The analogous colors are red violet (cobalt violet), violet (mauve), and blue violet (ultramarine violet). The complement is yellow (cadmium lemon). Both red violet and blue violet are mixed with their complements yellow green (permanent green light), and yellow orange (cadmium orange) in some of the studies to create their semineutrals.

In this study, the majority of the values are analogous light. A few darker values are added under the eaves, on the windowpanes, and in the tree to bring out the forms. The sky is a semineutral ultramarine violet, while the rest of the colors are pure but tinted. The yellow is used as a pale accent color on the roofs and snow.

This study is more subdued. Most of the values are on the darker side, and all the analogous colors have been neutralized by their complements. The yellow accents in the windows are pure hue, while the yellow tints on the snow are semineutrals. Notice how the semineutral colors add to the mood of this composition.

This composition is built on analogous light values, and all the colors are used as pale semineutrals. Handling the color in this way creates a hazy, soft atmosphere. Observe the beautiful semineutral colors and how they add to this feeling.

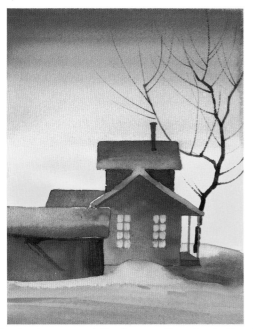

Here the sky shows a gradation from a soft semineutral to a light, pure yellow. This provides a bright backdrop for the silhouette of the buildings and the tree. The tree and buildings are darker in value, and neutralized in color, to create the contrast and colors of twilight. The bright yellow of the windows repeats the yellow in the sky.

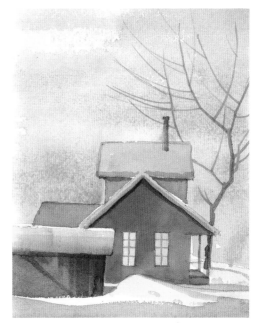

Soft analogous light values are used in this study; all the colors are semineutrals. The atmosphere is one of early morning chill. Notice how the soft, warm semineutral yellow balances the cooler analogous tones.

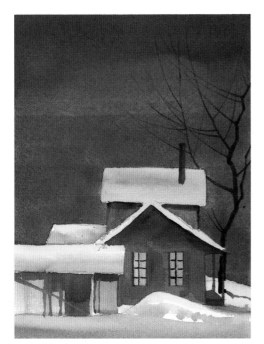

The values in this study contrast vividly, creating a powerful impact. A strong, intense ultramarine violet is used for the sky. Pure cobalt violet is used in the upper building but neutralized in the lower one. Pale yellow and semineutral violet tones are used on the roofs and snow.

THE SPLIT-COMPLEMENTARY COLOR SCHEME

THREE PAINTINGS

As stated earlier, the split-complementary color scheme combines components of the analogous and complementary color schemes. Three analogous colors create mood and harmony, while the contrasting accent gives optical balance. In the following three paintings the complementary accent color has been used to work best with the direction of the painting. For instance, *Dawn, South Fork of the Rio Grande* uses a soft, opaque red orange scumbled over cool blue greens to accent the dominantly cool scheme. In *Coastal Cliffs* a pure, warm opaque orange has been used on the sheep's faces, and a transparent metallic copper glaze has been incorporated in some of the rock areas. In the third painting—*Late January, San Antonio, Colorado*—blue violet is used in a light opaque manner as well as in translucent applications for the cool accent. In each of the three paintings, the complementary accent color provides body and enriches the overall composition.

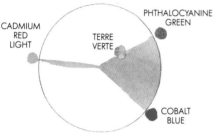

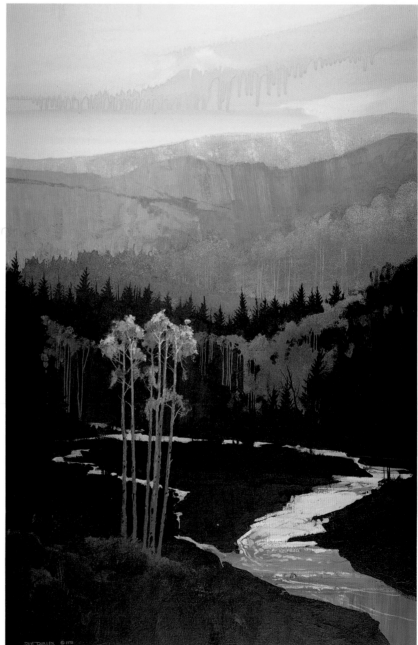

There are certain unexpected moments when I see something that must be recorded. It could be the way the light strikes a landscape, or certain patterns or shapes, but I have learned to drop everything and make a sketch or take some notes of that first impression. I have found the hard way that if I come back later to record the idea, the impression is never the same.

The idea for this painting happened at one of those unexpected times. I was driving over a bridge on an early summer morning to go fishing. When I looked upstream, the beautiful light and vertical patterns of the foreground aspen against the landscape overwhelmed me. I stopped and made a brief sketch and some notes. Later in my studio I referred to my study and notes to bring back that impression.

The color was the most important aspect of my impression. Since I was painting early morning, I chose green, blue green, and blue for the dominant cool colors. To represent the warm accent, a red orange was selected. I decided on casein for the painting medium because it has a soft quality that represents this time of day.

Finally, I chose a vertical format to depict the mountainous terrain and to repeat the vertical aspen patterns. The positioning of each aspen tree was important; I had to keep in mind exactly how it would break up the space of the landscape and water patterns. I had to repaint the aspen a few times until it felt just right. The finished painting comes very close to expressing my initial impression.

DAWN, SOUTH FORK OF THE RIO GRANDE Casein on heavyweight Crescent illustration board No. 100, 29″ × 19″ (73.7 cm × 48.3 cm). Collection of Charlene Quiller.

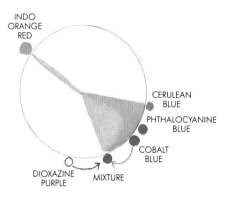

INDO ORANGE RED

CERULEAN BLUE

PHTHALOCYANINE BLUE

COBALT BLUE

DIOXAZINE PURPLE MIXTURE

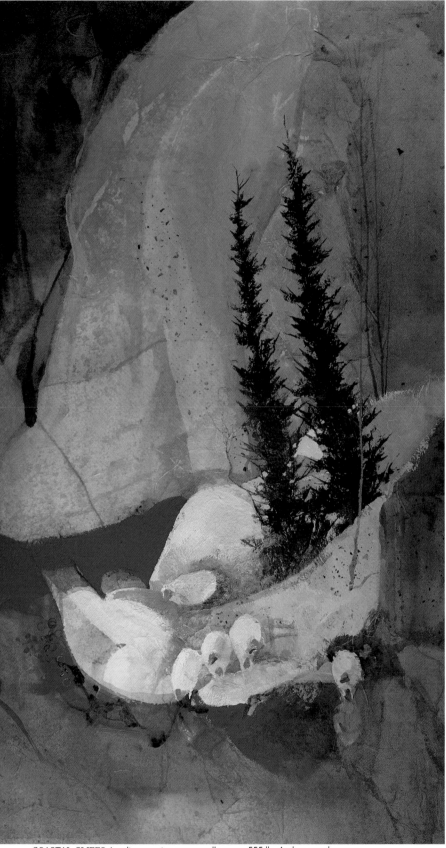

COASTAL CLIFFS Acrylic over rice paper collage on 555 lb. Arches rough paper, 33" × 19" (83.8 cm × 48.3 cm). Artist's collection.

Many of my paintings start from drawings done on location, and occasionally I like to try a painting that is a little more free-form. In this instance, the composition was triggered by some abstract studies of Chinese paintings. One such sketch was taped to a wall by my easel, and I taped a heavy piece of watercolor paper to my board. The entire painting was then done vertically on the easel.

Unryu, Chiri, and Hosho rice papers were torn into free-form shapes of various sizes and placed on a table close by. I chose acrylic for the medium because of its binding ability for the collage approach and because of its rich color and versatility of applications from transparent to opaque. I decided to use a rather cool palette of blues and violets and a metallic silver with a warm orange and copper metallic accent. These colors were placed on my palette and I was ready to begin.

First Liquitex Matte Medium was used to laminate the rice paper to the watercolor paper, loosely following the compositional sketch. Light transparent colors were washed onto the surface with large brushes. I then added some wet darker colors to bring out the force of the composition. Up to this point, I was still working abstractly, but soon the subject began to emerge. I then started to paint the representational shapes of spruce, rocks, and sheep. Notice how the pure orange accents of the sheep's heads and the soft neutralized orange areas of the painting serve to balance the dominant blue and violet cool colors and give a pleasing effect on the eye.

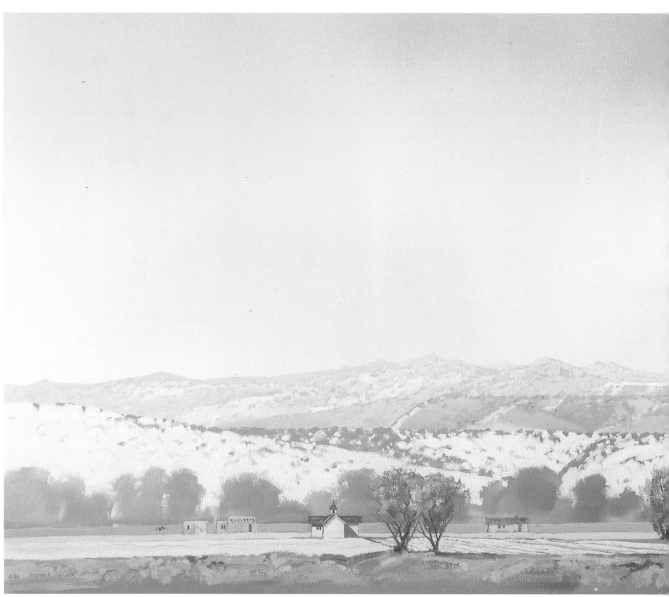

LATE JANUARY, SAN ANTONIO, COLORADO Casein and acrylic on 140 lb. Arches cold-pressed rolled paper, 27" × 40" (68.6 cm × 101.6 cm). Courtesy of Mission Gallery, Taos, New Mexico.

This Hispanic village is on the Colorado/New Mexico border, not far from where I live. I love to sketch there at various times of the year and it is always different. Late January has a special kind of light. It is a hazy, golden light that is most dramatic in late afternoon. That is the inspiration for this painting.

The painting is actually quite large for water media, but it needed to be to capture this light and the expanse of the country. The split-complementary colors used are yellow, yellow orange, orange, and blue violet.

First the oversized paper was soaked and stretched on a large board. Then layers of soft transparent acrylic yellows, yellow oranges, and oranges were washed on. When the sky seemed right, warm underwashes of yellow orange and orange were applied to the mountain and foreground areas. For this, direct complements of yellow orange and blue violet were used. The value of both colors was kept light to give a soft optical balance. As the ranges of mesas become closer, the colors contrast more in value. The strongest intensity and contrast is in the church, trees, and foreground areas, but all the color is somewhat neutralized by adding either the complement or white. The finished painting comes close to capturing how I feel about this country during this time of year.

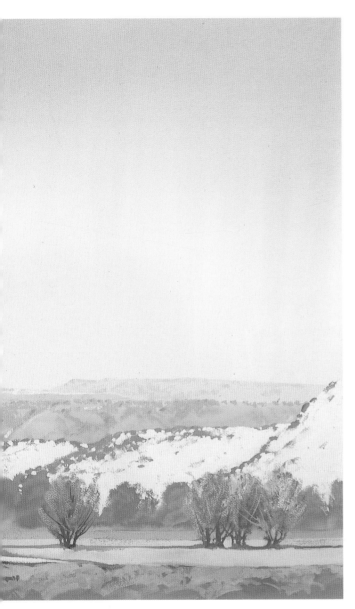

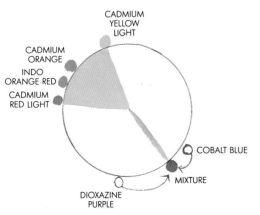

CADMIUM
YELLOW
LIGHT

CADMIUM
ORANGE

INDO
ORANGE-RED

CADMIUM
RED LIGHT

COBALT BLUE

MIXTURE

DIOXAZINE
PURPLE

WORKSHOP: SPLIT-COMPLEMENTARY COLOR SCHEMES

EXERCISE 1

From an original sketch or photograph, develop a simple composition of two or three building forms. Keep the shapes simple so that you can concentrate on color rather than intricate details. Do two studies using the same composition and the same color scheme: green, blue green, blue, and red orange. In the first study, use light analogous values and pure hue to create a soft, airy, cool composition. In the second, use the same light analogous values, but all semineutral colors, to give the feeling of a more subdued light.

EXERCISE 2

Select the subject of a landscape of some sort with strong light. This could be of mountains, mesas, desert, or seacoast. Choose a color scheme with warm dominant analogous colors and a cool subordinate complement. Apply your paint both transparently and opaquely. Use the cool subordinate complement as the underwash and then apply opaquely the warm light and textures of the landscape forms, letting some of the undercolor show through.

EXERCISE 3

Choose a subject that will work well for a subdued evening mood. Use analogous darks to provide all the low value in your painting, and semineutrals to supply all the color. (You may want to refer back to the value charts on pages 28 and 29.) Use analogous cool colors and one subordinate warm color. Organize the cool colors so that they are repeated throughout the composition. Repeat the semineutral subordinate warm in a manner that will give color balance to the study.

4 TRIADIC COLOR SCHEMES

In the preceding two chapters we have worked with the monochromatic, complementary, analogous, and split-complementary color schemes. There has been a logical progression from the use of one color, to its complement, to closely related hues, to a common contrasting color. In using all these color schemes, we have found how direct complements can create pleasing semineutrals and ideal optical color balance.

The triadic color scheme introduces a new and altogether different concept in color application: using contrasting colors that are *not* direct complements. As mentioned several times, true complementary colors create appealing semineutrals. When the contrasting color is not a true complement, the semineutral can be an ugly muddy color. However, there is a point where the contrasting color moves far enough away from the direct complement that the semineutral becomes pleasing again.

The triadic color scheme is based on this concept. This scheme allows more variety of color than any of the other schemes discussed so far, since none of the three colors in a triad are analogous. As we will discover in this chapter, using a triadic color scheme allows you to combine colors that you would ordinarily never think of using together, and yet mix a whole range of subtle semineutrals, create striking color contrasts, and achieve a fresh, harmonious effect overall. I know you will enjoy exploring this approach!

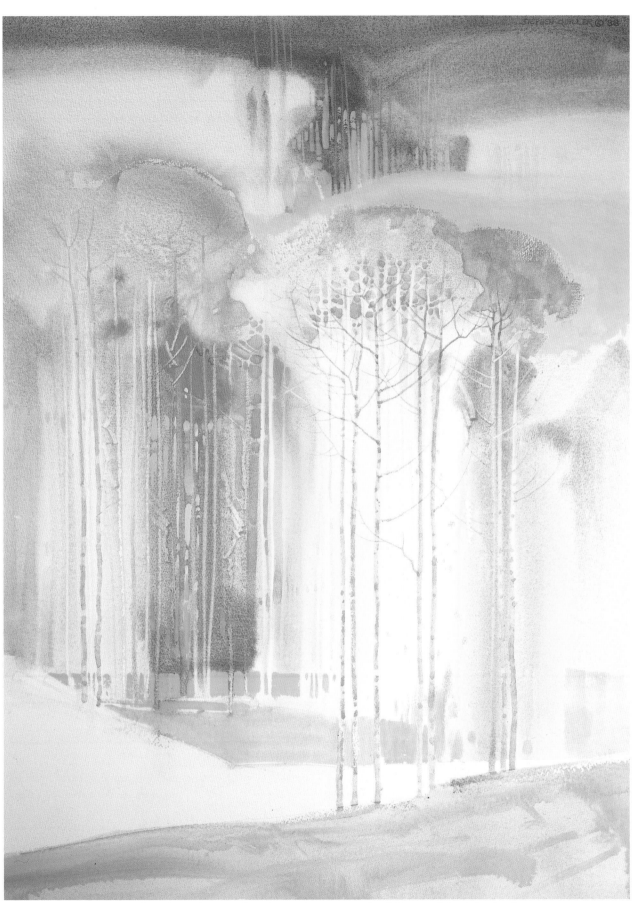

AUTUMN IMPRESSIONS Watercolor and gouache on 555 lb. Arches rough paper, 33″ × 24″ (83.8 cm × 61.0 cm). Artist's collection.

CHOOSING COLORS FOR A TRIADIC COLOR SCHEME

To understand how triadic color schemes work, we'll have to return once again to a color wheel. This time it's a simplified one, with only twelve colors: the three primaries, three secondaries, and six tertiaries. The basic idea with a triadic scheme is that the three colors must be equidistant from one another on this color wheel, so that when they are connected by straight lines they form an equilateral triangle. (A simpler way to locate a triad is a pick every fourth color.) When any two of these contrasting colors are mixed together, they will make beautiful semineutrals, even though they are not complements.

As an example, let's use orange (cadmium scarlet), violet (mauve), and green (viridian)—the three secondary colors—for a triad. With this color scheme there are two cool colors (green and violet) and one warm color (orange). Thus, more than likely, the scheme will be dominantly cool and subordinately warm. Each color can be lightened or darkened in value. Each can also be mixed with either of the other two colors to create a semineutral.

This color wheel shows the twelve equally spaced colors including primaries, secondaries, and tertiaries. To locate a triadic color scheme, choose every fourth color on this wheel. For example, yellow, blue, and red are connected by the solid triangle, and green, violet, and orange are connected by the dotted triangle. Any three equidistant colors should make a beautiful triadic scheme.

DOMINANT, SUBORDINATE, AND INTERMEDIATE COLOR

As just mentioned, in a triadic scheme of the three secondary colors, green and violet are cool colors and orange is a warm color. Usually an artist using this triadic scheme will choose to work dominantly cool, since two of the three colors are on the cool side. The first step in painting is to visualize the subject and select the dominant cool color, intermediate cool color, and subordinate warm color. It is more pleasing to the eye to work with these color proportions. As with the other color schemes, equal or nearly equal amounts of each hue will create a disturbing conflict to the eye.

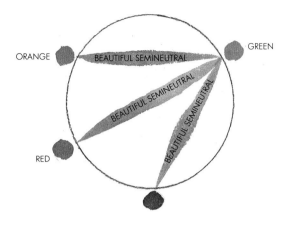

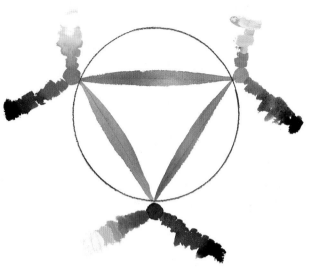

This study illustrates the range of contrasting color mixtures that create beautiful semineutrals. Green (viridian green) is the color used to mix with the contrasting colors. Green's complementary color red (alizarin crimson) can be mixed for a nice semineutral. As the contrasting color moves to the left or right of red, the mixture becomes muddy. However, when the color moves far enough to the left or right, the mixture becomes pleasing again. In this illustration the contrasting colors are the other two colors of a triad scheme, violet (mauve), and orange (cadmium scarlet).

This diagram shows the range of color in the secondary triadic scheme green, violet, and orange. Each color can be mixed with one of the other two colors to create an exciting semineutral. Also, all three pure colors—and all their semineutrals—can be lightened and darkened in value with white and black.

This study uses the secondary triad viridian green, mauve, and cadmium scarlet. All the colors are in semineutrals with the exception of some pure orange on the adobes and land. The dominant color is a cool green used in the sky, the mesas, and the foreground. The intermediate color is violet used in all the areas as well. The subordinate color is a warm orange hinted at in the sky and used for accents on the adobes and foreground. Notice how the orange shimmers next to the cool greens and violets.

THE PRIMARY TRIAD—YELLOW, BLUE, AND RED

This triadic scheme is the first one many art students think of but the hardest to make work well. This is because when any two of these colors are mixed, the result is a secondary or tertiary color. Thus a myriad of new colors can be mixed from these three primaries, even if some of them are partially neutralized.

However, a primary triadic scheme can still be harmonious because all the colors in the painting are made from just three colors and have different combinations of those pigments in common. I have known artists who use just three primaries and glaze all their color to achieve any color. They get wonderful results because of the relationship of just three common colors. I feel, however, that it can be dangerous to use a formula color mixture for every painting. There are a world of ways to use paint, and each painting is best approached in its own unique way.

I have noticed that Edward Hopper used a primary triad often in his work in a very effective way. As with every color scheme, the relationship of value, intensity, and dominant and subordinate colors is the key to making this triad work.

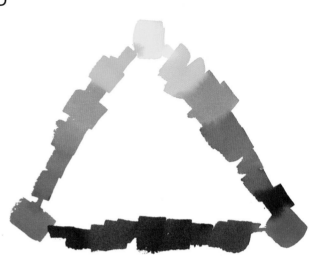

This is a primary triadic scheme using yellow (cadmium lemon), blue (phthalocyanine blue), and red (alizarin crimson). Notice that all the semineutrals mixed look much like the secondary and tertiary colors but are more neutralized. A mixed color will never be as vibrant as a pure hue straight from the tube. However, all the semineutral mixtures have a common relationship because they were all mixed from the same three primaries.

Here is a study in the primary triad scheme yellow, blue, and red. Blue is used as the dominant color, red as the intermediate color, and yellow as the subordinate color. Although I have two warm colors and one cool, I have reversed the standard approach and have a dominant cool scheme. Where the colors overlap, semineutral greens, violets, and oranges are created. Notice that the mixed color is still related to the primaries because of the common pigment. Very little pure intensity is used—just a spot of red on the figure and lighthouse roof. Value is the key that leads the eye through the composition.

SECONDARY TRIADIC COLOR SCHEMES

This triadic color scheme makes use of the secondary colors on the color wheel—orange, violet, and green. Each is equally spaced from the next on this wheel, and all are located equidistant between two major primary colors. For instance, orange is halfway between the yellow and red primaries. Because of this, the mixture of any two secondary colors takes on a semineutral tone. For example, orange, which is a mixture of yellow and red, mixes with violet, a blend of red and blue. The orange has yellow in it and the violet has blue. Thus the resulting color is not a fresh, pure red violet, but a neutralized one. What makes every mixture in this color scheme harmonious is that all of them contain two of the three common colors. Even though they are somewhat neutralized, they all relate to the three pure secondary hues.

CADMIUM
SCARLET

MAUVE

VIRIDIAN
GREEN

In this composition, I used the secondary triad orange (cadmium scarlet), violet (mauve), and green (viridian green). Much of the color is a semineutral mix of two of the three pure hues. The strong contrasting value pattern and diagonal lines are a major strength of this sketch. Notice that the only pure color in the whole study is the orange on the roof.

TERTIARY TRIADIC COLOR SCHEMES

Tertiary triads are similar to the secondary triad in that every mixture of two of the three pure colors results in a semineutral. There is a range of mixtures of each of the two colors, depending on the proportion of each color mixture, the concentration of pigment used, and the value of lightness and darkness. There should be a dominant, intermediate, and subordinate relationship of the colors.

There are two different tertiary triads—and they are indeed very different. One triad is the combination of yellow orange, red violet, and blue green. The blending of these three colors can result in some spectacular color combinations. I have used this scheme to achieve color in my paintings that I had not thought possible. The other triad scheme is yellow green, blue violet, and red orange; it also has many possibilities.

PERMANENT
GREEN LIGHT

BLUE
VIOLET

CADMIUM
RED DEEP

This is a quick sketch of some high country mountain spruce and water patterns in the San Juan Mountains near Wolf Creek Pass. The yellow green (permanent green light) is used as the dominant color, blue violet (blue violet) as the intermediate color, and red orange (cadmium red deep) as the subordinate and the warm accent color. Beautiful neutralized red violets, blue greens, and oranges are possible with this triad of colors, and this scheme is worth a try. Go for it!

CADMIUM ORANGE WINSOR VIOLET MANGANESE BLUE

This is a small sketch of a church on the high road to Taos, New Mexico. A New Mexico workshop that I instruct stops here almost every summer to paint. The warmth of the adobe and the New Mexico light call for this particular color scheme. I used yellow orange (cadmium orange), blue green (manganese blue), and red violet (Winsor violet). The study is made up entirely of semineutral mixtures of these colors. There are beautiful semineutral red oranges, blues, and greens that are possible with this scheme.

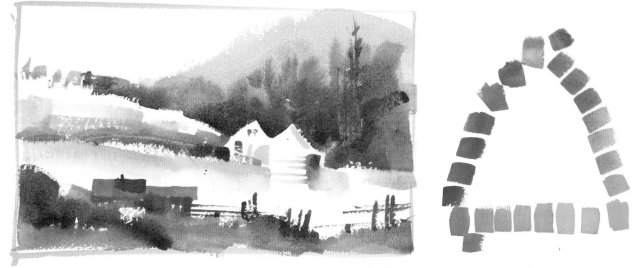

Here is a quick study using the same triadic colors as the previous study. However, in this sketch most of the color is in the semi-neutral range. There is very little pure hue. Notice how different this work is from the previous piece. Actually, you could do ten studies emphasizing different colors, values, and intensity ranges using the same three colors, and they would all be different.

CHOOSING COLORS FOR A TRIADIC COLOR SCHEME

OTHER POSSIBILITIES OF PURE HUE TRIADS

In addition to the primary, secondary, and tertiary triadic color schemes, a host of other triadic schemes are possible. Refer to my color wheel after page 16 and notice all the pure colors on the outside of the wheel. Any pure color can be used as long as it is very close to equidistant from two other colors on the wheel. For instance, Indian yellow, cerulean blue, and cobalt violet form an almost equidistant triangle on the color wheel, creating an eye-catching color scheme with some lovely semi-neutral color mixtures possible by mixing any two of these three colors. These are colors that one normally would not think of using together, and yet these color mixtures will give surprising results. Remember that with just one color scheme such as this one, many entirely different paintings can be done depending on which colors are used dominantly, intermediately, and subordinately; also, the painter may vary the intensity and value.

Take a look at my color wheel and see how many different triads you can locate. Choose one that sounds appealing and do a variety of subjects with it. You will probably respond to some triad color relationships more than others.

Here are four triadic color schemes I have selected and the resulting sketches. Each one takes on its own life. Even though these are just studies, you can already see the rich color relationships and the start of some interesting possibilities. Along with each study are swatches of each of the three pure pigmented colors and an example of the semineutral that can be mixed by any two of the colors.

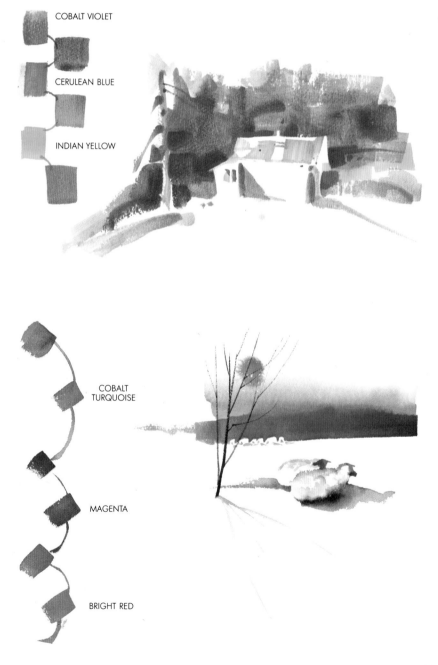

COBALT VIOLET

CERULEAN BLUE

INDIAN YELLOW

COBALT TURQUOISE

MAGENTA

BRIGHT RED

While playing with some of the possibilities for triads on my color wheel, I have been amazed at some of the wonderful color possibilities. This is one of my favorites: cobalt violet, cerulean blue, and Indian yellow. For the watercolor painter, this scheme provides some very interesting interaction of pigments as well as beautiful color combinations. Both cobalt violet and cerulean blue are heavily pigmented colors, meaning that the pigment will settle in the recessed pockets of a rougher paper. Indian yellow stains much more evenly, coating the entire surface of the paper. Mixing the Indian yellow with either of the other two colors will provide a mottled, textural look that is very nice. Also notice some of the beautiful semineutral greens, red oranges, and violets that can be mixed.

Who would think of using cobalt turquoise, magenta, and bright red together? This is just a slight shift from a blue green, red violet, and red orange tertiary triad. Yet what wonderful color relationships they make, and what beautiful semineutrals! This scheme utilizes one warm color and two cool colors, so it usually works best if used in a dominantly cool color scheme. This quick study of sheep is dominantly cool, relying on the cobalt turquoise and magenta. Bright red serves as the subordinate accent color on the sun and the sheep's faces.

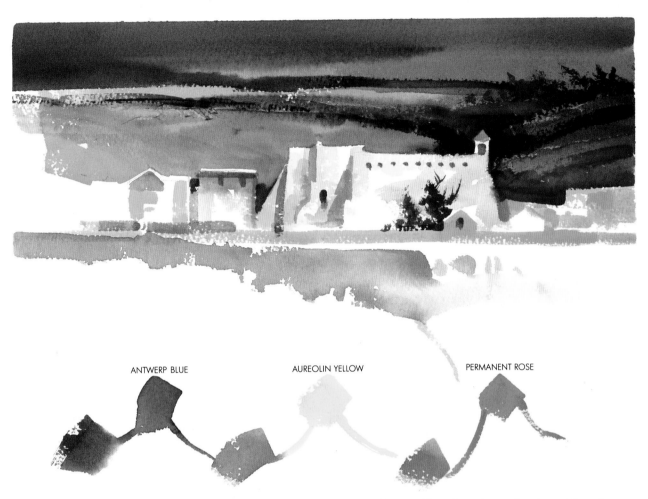

ANTWERP BLUE AUREOLIN YELLOW PERMANENT ROSE

Antwerp blue, aureolin yellow, and permanent rose are close to a pure primary triad. Notice, however, that the resulting secondary mixtures are somewhat neutralized. Two of these three colors are warm, thus the selection of a warm composition. Virtually any color can be mixed from these three colors, but yet the color scheme has unity because only the pigments of these three colors are used. Try this scheme on still lifes, such as a delicate flower arrangement, and see the beautiful results.

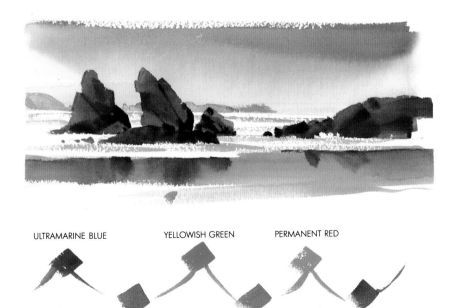

Some color schemes lend themselves better to certain types of light and terrain than others do. The light that can be created with the triad ultramarine blue, yellowish green, and permanent red is on the green side of yellow. Thus it works best for paintings with a "cooler" light, such as scenes of the Northwestern coast. The earthy semineutrals that can be mixed are fantastic. Here I have used dominantly the yellowish green and ultramarine blue. The permanent red was used subordinately and as a semineutral in the rocks, water, and wet sand to warm the foreground area.

ULTRAMARINE BLUE YELLOWISH GREEN PERMANENT RED

TRIADS USING PURE HUE AND SEMINEUTRAL TUBE COLORS

Sometimes using semineutral colors from the tube in a triadic scheme along with a pure color can be pleasing. It is important to remember how to locate the semineutral color so that it is in proper relationship with the pure color for a beautiful triad. For example, let's use blue violet as the pure hue color; we want to find two semineutrals that will go with it. Blue violet is a tertiary color, and in a pure hue triad, yellow green (permanent green light) and red orange (cadmium red deep) would be used. To locate any pure color's semineutrals, just draw an imaginary line from the pure hue to the center neutral. Any color that falls on or near this line can substitute for the pure hue in a triadic scheme. For example, on the line from yellow green (permanent green light) to the neutral, two colors are located: Hooker's green light and terre verte. Either of these colors can be used instead of yellow green. On the line from red orange (cadmium red deep) to neutral is the color Indian red. Thus, a triadic color scheme like blue violet (ultramarine violet), Hooker's green light, and Indian red can work well.

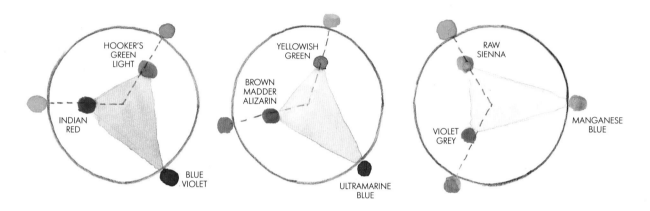

In this chart the first diagram illustrates the triad mentioned above. Blue violet is the pure hue used, while the two semineutral colors are Indian red (moving in from cadmium red deep) and Hooker's green light (moving in from permanent green light). The second circle shows the triad containing the pure hue ultramarine blue and two semineutrals brown madder alizarin (moving in from permanent red) and sap green (moving in from yellowish green). The third wheel shows the triad using the pure hue manganese blue and two semineutrals violet grey (moving in from Winsor violet) and raw sienna (moving in from cadmium orange).

Here is a study using two semi-neutral colors—light red and cobalt green—and one pure hue, mauve. The two semi-neutral colors give the sketch an earthy, less vibrant feel than a pure-color triadic scheme would. In this composition, cobalt green is used as the dominant color and mauve is used as the intermediate, while light red is used as the subordinate. I think of the light red as notes of semineutral color that add life to this motif.

LIGHT RED COBALT GREEN MAUVE

SEMINEUTRAL TRIADIC COLOR SCHEMES

When we think of a triadic color scheme, we usually think of pure colors such as red, yellow, and blue; or orange, green, and violet. But other kinds of triads are possible using semineutral colors. The same appealing color relationships are possible, though the color change is more subtle. In landscape painting this can be used to advantage if the artist wants certain earthy atmospheric moods. To locate the semineutral, just look for any equidistant triangle of colors on the inside of the color wheel. The closer the colors are to the center of the wheel, the more neutralized the colors are. This also means that there will be less color range. The further out the colors are located, the less neutral the color relationships.

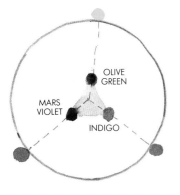

This is a diagram of two semineutral triad color schemes. The first uses three colors located very near the neutral—Mars violet, olive green, and indigo. This scheme could be used for a very earthy composition. The second scheme has a larger triangle of the colors violet grey, raw sienna, and Prussian green, which means that there is more range of color. I particularly like this scheme and think there are many possibilities for it.

Here is a color study using the semineutral triadic scheme indigo, Mars violet, and olive green. This is a very neutral color scheme that gives an earthy feel. Certain compositions lend themselves to this scheme, such as old buildings, broken-down interiors, or dried landscapes. Give it a try and see what happens.

This is a very beautiful triadic color scheme. Prussian green, violet grey, and raw sienna form a perfect inner triad of colors, and the resulting color mixtures produce lovely, very neutral blue violets, oranges, and yellow greens. Here the raw sienna is used as the accent color and is softly repeated throughout the composition. Violet grey and Prussian green are used more dominantly and the study takes on a feeling of soft fantasy.

THREE PAINTINGS

During the few years that I have been experimenting with triadic color schemes, I have been fascinated by their versatility. The many lovely semineutrals that can be mixed from three colors give a different look from the semineutrals mixed from direct complements. The three paintings I have chosen as examples of triadic schemes use different triadic relationships from the color wheel. *Sea Cliffs—Northwest Coast* incorporates the tertiary color triad of blue violet, red orange, and yellow green in an acrylic rice paper collage. *Spring Run-off* uses the tertiary triad scheme of red violet, yellow orange, and blue green with transparent, translucent, and opaque applications in watercolor and gouache. The secondary triad of green, violet, and orange was chosen for *Summer Mountain Patterns*, and again, watercolor and gouache were used for the media.

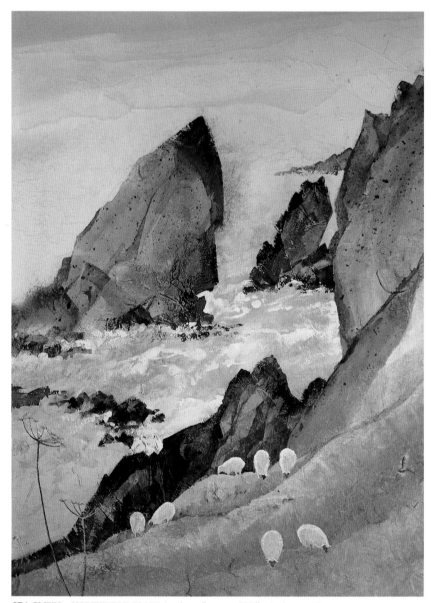

When I found this trail to a lookout over the sea, I knew that I needed to paint it. I did some line studies and a quick on-location watercolor to capture the mood.

Later that winter, back in Colorado, I decided to do a large acrylic collage of the subject. I chose to work with rice paper collage because of the atmospheric, textural effect needed in the painting. Acrylic was my choice because of its versatility and strength of color.

I wanted a limited color palette and thought that a triad might give me the range I needed. Also the subject needed a cool light; this led me to a palette of yellow green, blue violet, and red orange. (The semineutrals that can be created from these colors are beautiful blue greens, red violets, and oranges.) My palette consisted of Acra red and indo orange red for mixing the red orange; permanent green light, emerald green, and Hooker's green dark for the yellow green; and a mix of cobalt blue and dioxazine purple for the blue violet. The resulting color mixtures with the collage provided the mood for this powerful spot on the coast. However, the key to the structure of this painting is value. Squint your eyes and see the strong light-and-dark value pattern throughout the composition. The strong diagonal lines give an added force to the composition.

SEA CLIFFS—NORTHWEST COAST Acrylic collage on 555 lb. Arches rough paper, 32″ × 24″ (81.3 cm × 61.0 cm). Artist's collection.

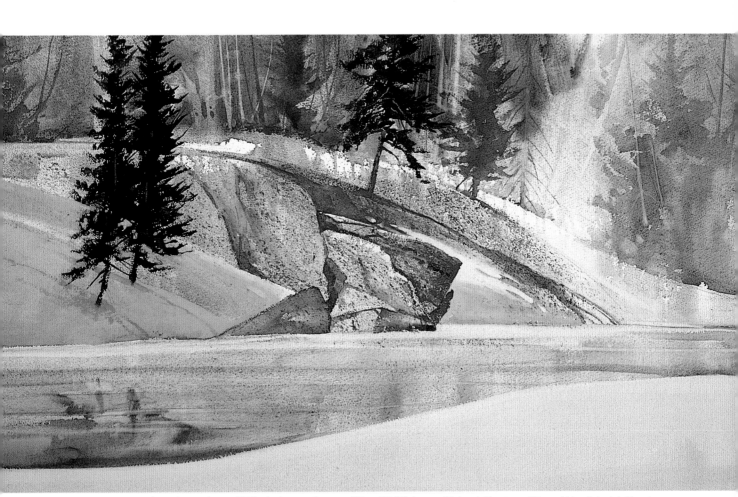

SPRING RUN-OFF Watercolor and gouache on 555 lb. Arches rough paper, 23″ × 34″ (58.4 cm × 86.4 cm). Courtesy of Dr. and Mrs. Robert A. Varaday.

Early spring in the high country is one of my favorite times of year to paint. Snow is melting, water is flowing, ice forms are breaking up, and intense light creates strong shadow patterns. During this season, I like to make some line sketches of these patterns and make some notes with my trusty Pentel Rolling Writer. With this particular subject, I was drawn to the rhythm of the tree patterns, rocks, snow, and water, and I was particularly interested in the rock texture and the light.

Back in the studio, I wanted to choose colors that would represent how I felt about that area and light and decided that a triad of red violet, yellow orange, and blue green would be ideal. I chose three colors in the blue green range: cobalt green for rock moss and forest patterns,

cerulean blue for the snow shadows, and Prussian green for the dark trees. In the yellow-orange range I used cadmium orange and raw sienna, and in the red-violet range I used cobalt violet and violet grey.

I wanted to keep the painting light and airy. Referring to my sketch, I laid in wet broad areas of color. I was working vertically with the painting and let wet paint drip onto dry white paper. I also spattered with my brush in the rock areas to help achieve the rock texture. As the painting progressed, I laid down translucent and opaque layers of cerulean blue and white gouache to give the feel of snow. In the end, these colors were a far cry from the actual colors of the subject, but the colors show how I feel about early spring run-off.

CHOOSING COLORS FOR A TRIADIC COLOR SCHEME

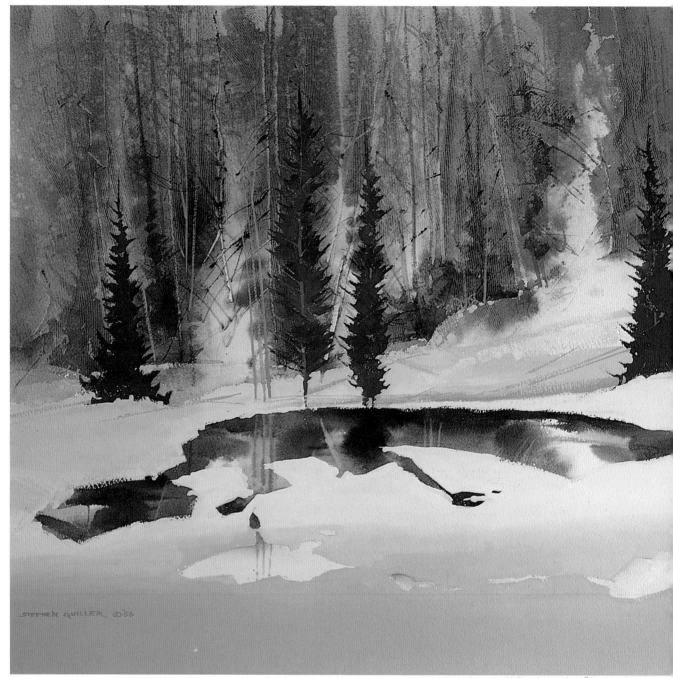

SUMMER MOUNTAIN PATTERNS Watercolor and gouache on 300 lb. Arches cold-pressed paper, 19" × 29" (48.3 cm × 73.7 cm). Artist's collection.

This painting uses one of the first triadic color schemes I ever worked with. It scratched the surface of the many possibilities available using three equidistant colors. Having explored the triad's potential more during the past two years, I feel that it offers the artist a whole new direction in color usage and gives a fresh look for color interaction.

As I made the sketch for this painting, I noticed violet tones in the dead snag and forest patterns and decided to use violet as part of the palette. Also, I wanted some warm hints of color in the composition, so a triad of green, violet, and orange was the answer. Winsor green and emerald green were used for the forest

and land areas, mauve was mixed into the forest patterns, and cadmium scarlet was the orange used for the hint of warm.

I decided to use watercolor and gouache combination because of the transparency, translucency, and opacity this painting needed in the forest, water pockets, and meadow. Also, because watercolor and gouache both use the same binder of gum arabic, they are chemically and visually compatible. The final painting has green as a dominant, violet as an intermediate, and orange as a subordinate and accent color. It was fun to see how these colors worked together; it gave me the impetus to use the triad in future paintings.

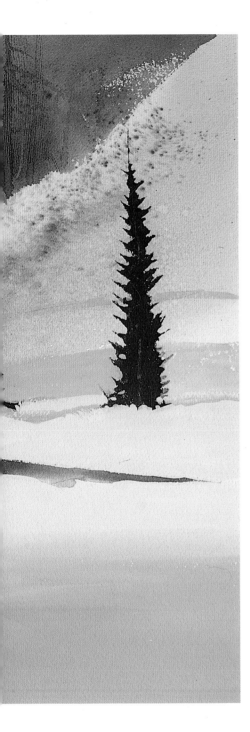

WORKSHOP: TRIADIC COLOR SCHEMES

EXERCISE 1
Select a tertiary triad such as manganese blue, Winsor violet, and cadmium orange. Choose a simple subject such as a landscape or still life. Do a line drawing of the subject in black and white and use it for reference. Now do six small studies, changing the color emphasis each time. Vary the value and intensity and the dominant, intermediate, and subordinate colors to make six distinctly different images.

EXERCISE 2
Use the secondary triad of mauve, viridian green, and cadmium scarlet. Working entirely with abstract shapes such as rectangles, triangles, and curvilinear forms, totally emphasize the value and color. Vary the size of the shapes and the intensity and value of the color to draw the eye to the area of emphasis and to move the eye through the composition. Choose the dominant, intermediate, and subordinate colors and decide whether to make the composition predominantly warm or cool. Make the color sing!

EXERCISE 3
Choose an all semineutral triadic color scheme of violet grey, raw sienna, and Prussian green. Try to convey an image that is soft and dreamlike or fantasy-oriented. To do this, work with light analogous value colors and repeat the colors throughout. Use a curvilinear motif such as a floral still life or figurative theme and watch these rich colors help you create this expression.

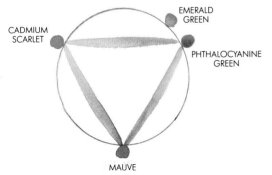

CADMIUM SCARLET

EMERALD GREEN

PHTHALOCYANINE GREEN

MAUVE

5 GOING BEYOND STRUCTURED COLOR

Up to this point, I have discussed and demonstrated how structured color can work. As you have seen, my paintings in the first four chapters use directly or follow pretty closely the monochromatic, complementary, analogous, split-complementary, and triadic color schemes. Many times I do stay entirely within these color schemes, but more often I use color with a more personal approach. I have used the structured color schemes enough that I need not rely on them now. With many of my paintings, I have an intuitive sense for a certain color that is needed.

There are many ways to use color in a painting. One way is to depict an object or scene literally. Another is to create space and depth through warm and cool and value change. Yet another is to use color to express. Each color we use on the palette has a unique visual quality. We can also use repeated color in order to lead the viewer's eye throughout the composition. As we have seen earlier in the book, color can be used to create unity and a harmonious feeling. Also, color can be used to convey a distinct mood. Although I use all these aspects in my work, I tend to concentrate on the last four.

I do feel that the best way to learn color is through developing knowledge of the fundamental structured color schemes. Once this foundation has been laid, the artist can go further and become more personal with color. Too often the student wants immediate, successful results without going through all the work that is necessary to grow. A good example of this is an experience I once had while giving a workshop. I had been giving a one-week workshop, once a year, to an art guild in a large city. Every year it had been a painting workshop focusing on water media, and every year the guild members had sold out the enrollment and had a waiting list. One year when they called and asked if I would like to teach, I agreed but thought it would be fun to change the format of the workshop. I planned that the first three days of the class would concentrate on sketching and composition as they relate to the development of a finished painting, something that many of these painters really needed. The last two days would then emphasize the water media.

One week before the workshop, I received a call from the workshop chairperson. She said that the last two days of the workshop were completely filled, with a waiting list, but that there were only three students signed up for the first three days! I cannot emphasize enough how important it is to know as much as possible about every aspect of painting, including color. Take the time to learn and apply these concepts, and it will help you to grow on your painting quest. Ultimately, all the theories and art principles are simply tools to help the individual artist express his or her perception of life in paint. The more we paint, the more we grow and change, becoming more individual and seeing more uniquely. A completed painting with an original approach to portraying nature will help the viewer to look, perceive, and feel more deeply.

As I have mentioned, I developed my color sense through years of studying and experimenting with structured color theory. There is a point now when the brush, hand, and eye become synchronized instruments for the mind, and everything flows. As the painting begins, I interact with the media, paper, and color. I listen to where the painting wants to go and respond to it. I actually feel as if I am part of the painting. For instance, if I am painting an aspen tree, I *become* my vision of the aspen tree—the texture, color, light, and form. This is much more interesting than trying to force it to go where I want it to go. For this reason I am careful not to have too clear of a vision of how the painting will eventually look. This will inhibit the creative growth of the painting. I choose to use my subject as the starting point for an exciting journey. It becomes an excuse to play with color, brushes, and paint, and to express. That is why I feel it is important to paint subjects that I know well, such as mountain rhythms or New Mexico field patterns. I can think less about the subject because I know it well, and more about responding to the color and paint flow.

I have found that once I developed a personal approach to my painting and color, many people became interested in how I see. They would like to crawl inside and view my world. A friend once told me that when he drove through the country where I paint, he does not see the color that is in my paintings. But when he closes his eyes and thinks about the country that I paint, the colors he sees are the colors in my paintings. This is how I would like to have people react. I want my color not to be a literal interpretation of what is out there, but a personal vision of how I perceive it.

An admirer of James Whistler once told him that he had been to the coast and that the colors he saw were the same as the ones in the paintings. Whistler replied that nature was improving! When I look at the work of many great painters, I feel that what makes their paintings unique and memorable is that they have a personal vision. Their colors are their own. I think of Thomas Moran, J. M. W. Turner, John Singer Sargent, Winslow Homer, Vincent van Gogh, Claude Monet, and Pierre Bonnard, all great colorists and all with this personal vision. Their interpretations are certainly not literal. Yet when one sees the country they painted, the colors they chose reveal their acute feeling for the area. This individual vision sets these painters apart from many average artists.

Another aspect that sets them apart is their "mark," the way they put their brush to the paper or canvas. I love to see the mark of the artist, and it distresses me to think that we are getting away from that. Much work today is sterile. The smooth rendering of photo-realism and the images done with an airbrush are some examples. I can admire their technical perfection but miss the unique signature of the artist, the mark!

As you look through the paintings in this chapter, there will be some diversity in terms of application of color, paint, technique, and subject matter. The style will show through whether it is a loose, intense-color winter light painting, or a sensitive evening transparent watercolor of the Oregon coast. I have had people tell me that they can recognize my paintings anywhere.

This chapter is divided into four areas because I think it easiest to talk about my color in this way. The first is my approach to color while painting on location. I have found that I use color and perceive color a bit differently when working on location. The second section focuses on studio work that is inspired by color studies I have done on location. The third deals with my paint application of underlays and overlays of transparent, translucent, and opaque color to achieve beautiful color interaction. The fourth section is about some paintings I do that are inspired by an inner vision. They derive mostly from an inner sense for color and have no exterior source. As you read through this chapter and look at the paintings and their approaches, keep in mind the color foundation in the first four chapters. It underlies every painting in this chapter. Enjoy!

WORKING ON LOCATION

Yes, color must be seen beautifully, that is, meaningfully, and used as a constructive agent, borrowed from nature, not copied, and used to build, used only for building power, lest it will not be beautiful.

Robert Henri

Andrew Dasburg, a Taos painter from the modern school, once said to paint from your periphery. When you sense a color out of the corner of your eye and turn to look at it, only to find that it is not there, that is the color to use.

In nature, if you look closely, there are many colors. In a deep forest there are not just greens, blue greens, and yellow greens, but orange greens and violet greens, gray greens and neutralized terre verte greens. The keenness of the eye and one's inner sense is what will make the painting special.

Color should never be randomly used. There should always be a reason, whether it is an intuitive idea, an idea that has been seen, or a theoretical idea. Every stroke of color, like every stroke of the brush, should help convey that idea.

The more one paints, the more one looks, and the more one studies, the more one will see. The eye needs to be able to see color. For instance, the freshly plowed field of earth is not just dark brown. Depending on the adjacent fields of yellow corn stubble or green grass, the plowed earth will be violet brown or red brown. Color affects color and makes it take on new life.

Light affects color. The Oregon coast, the mountains of central Mexico, and the Rocky Mountains all have vastly different atmospheric light. Some lights are hazier, some yellower, and some crystal clear. Look at the reflected light on a fallen aspen or birch tree. The light bounces off the same surface where the object's shadow falls, and when the light is reflected back, it contains the color of that surface. For example, light reflected off surrounding grass will give a greenish cast to the base of a tree trunk.

Backlight, overhead light, and direct light all affect the color we see. Early morning light is a cooler light, while late afternoon light is warm. Both of these are raking lights, creating strong light-and-shadow patterns on the terrain, great for painting. Mist and fog, twilight and dawn are all good reasons to use light and color in a distinctive way. The key to all painting is that the subject you are working with must truly inspire you, and that you must look deeply both internally and externally at what you see and feel.

Everything we see and everything we feel comes from our life experiences up to the present. We see differently because we have each been brought up in our own unique way. That is what painting is really all about: our own individual response to the subject we are painting. We are drawn to subjects that will trigger this personal response, and we tend to choose subjects that help us make this statement. Consider Vincent van Gogh. When we think of van Gogh's work, we think of thick impasto, curvilinear brush strokes forming patterns that set him apart from other painters. He chose subjects such as cypress trees, sunflowers, and rolling hills and fields, which lend themselves to this curvilinear motif. I believe that he did not have to search out his subjects, but rather that these subjects found him, because they formed part of his inner character and vision. But in the end it is not the subject, but how the subject is painted, that will make a great statement.

I feel that the subject is the excuse to paint, that the subject matter finds you rather than vice versa. I know that subjects for my best paintings will come when I least expect it. And I feel that I am drawn to these subjects because of my background. But the subject is simply the reason to start to play with the shapes in the composition, the color, the value, and the paint application; ultimately, it is the excuse to create.

Once the subject has chosen me, I try to get as involved as possible with it. I let my emotions flow toward the subject and get completely immersed in it. As I paint, I become part of the subject, rather than a spectator looking in. I let the paint and color flow; as mentioned earlier, I sometimes feel that I am just an instrument for the resulting finished composition.

USING THE QUILLER WHEEL TO SET UP A PALETTE

There are different ways that I set up my palette when painting on location, and I will now focus on these. But my color usage is essentially a composite of all the information we have discussed so far in this book. When I work on location, I do not work with a particular color scheme. However, all my color mixing is based on analogous, triadic, or complementary color mixing approaches. When I think about it, all I really have to work with is analogous or contrasting color mixtures, so it is important for the mixture to be pleasing and harmonious with the surrounding color fields.

I will first demonstrate how I use my outdoor palette, which contains the primary, secondary, and tertiary colors of my color wheel. I mentioned how to set up this particular palette in Chapter 1. The colors on this palette are cadmium lemon, cadmium orange, cadmium scarlet, cadmium red deep, alizarin crimson, permanent violet, mauve, blue violet, phthalocyanine blue, manganese blue, viridian green, and permanent green light (with a few substitutions for acrylic).

As I look at my subject, I get a sense for the color that is needed. This is usually determined by the color of the subject,

the existing colors in the painting, and an inner feel for what color is needed. The choices I have for mixing just one color are many. Let's use the color mauve as an example. I can use the color straight from the tube, but very seldom when I work on location does this happen. I can lighten the color by adding white or diluting the color with water. If I feel that it needs to be a green mauve, I can mix in some of mauve's triad viridian green to give me a beautiful range of semineutral blue violets to blue greens. On the other hand, if I need an orange violet, I can mix the triad orange of cadmium scarlet to give me a beautiful range of semineutral red violets to red oranges. Or if I feel that the violet needs to be neutralized by its complement cadmium lemon to create a beautiful mauve semineutral, that can be done. Also, an analogous color can be mixed, such as permanent violet, to move the mauve toward red violet; or blue violet can be added to move the mauve toward that color. So the artist has a multitude of choices for each color, and for exactly how to obtain that color, giving endless possibilities for striking color combinations.

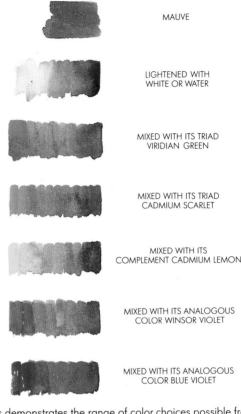

MAUVE

LIGHTENED WITH
WHITE OR WATER

MIXED WITH ITS TRIAD
VIRIDIAN GREEN

MIXED WITH ITS TRIAD
CADMIUM SCARLET

MIXED WITH ITS
COMPLEMENT CADMIUM LEMON

MIXED WITH ITS ANALOGOUS
COLOR WINSOR VIOLET

MIXED WITH ITS ANALOGOUS
COLOR BLUE VIOLET

This demonstrates the range of color choices possible from mixing just one color, mauve, on my palette. As you can see, it can be used straight, lightened, mixed with its triad family, mixed with its complement, or mixed with its adjacent analogous colors. All the resulting color mixtures are beautiful.

MY PAINTING APPROACH ON LOCATION

Painting on location is different from working in the controlled studio environment in numerous ways. For years I worked almost entirely in the studio because I felt that I was overly influenced by nature when I worked on location and could not get enough of my own personal feeling and color into the painting. Recently, though, I have worked on location a lot more, and feel that these paintings are becoming very personal.

When working on location, I have learned to eliminate much of the detail and to simplify the shapes. I remind myself that it is important to work with just the essential shapes that initially attracted me. Otherwise I can get caught up in picky details that will actually detract from the main motif. Also, while working on location I am dealing with constantly changing light. There may be bright light when I begin painting and a heavily overcast sky halfway through. Light is always moving and shadows are constantly changing. For this reason, I have developed a memory that keeps steadfastly reminding me of the original light in the painting. If the light changes too much, I will pack up and return at the same time the following day. Besides the light, there are the bugs, wind, rain, and temperature that can be factors in the painting process.

On the other hand, there is the inspiration of working directly with nature. This contact with the natural environment is a great experience, and I have found that the more I interact with the subject, the more deeply I see. When working on location, I set up my French easel and get my board, paper, palette, paint, brushes, and towels prepared. Then I meditate with the paper and the subject in front of me—visualizing, in a positive way, the brush and color flow needed to construct the form. As I do this, an interaction builds between me and what I am about to paint. When this energy has mounted to a peak, it is time to begin the painting!

On the next two pages you'll see two paintings done with this approach. Both were done on the same creek within one hundred yards of each other and within three weeks of each other, yet they are very different. The key to both of these paintings is that I was excited about the subjects. The initial excitement about the light, color, and shapes of each composition was transferred to the completed painting. When this happens, the chances are good that the painting will be successful. Both of these paintings were done using my standard palette, described on the opposite page.

I came across this subject while hiking with friends along a remote mountain trail. The patterns of the cascading waterfalls, the rock forms, and the diagonal fallen logs interested me.

A week later I was back to do a transparent watercolor of the area. To make the painting work, I had to leave out several branches and twigs, and a few rocks. Also, the flow of water in the lower area had to be rearranged, and the distant aspen and spruce patterns needed simplification.

I used my standard color palette and found myself mixing a lot of triad relationships. In many of the red-violet rock forms, notice the mix of blue green or yellow orange. In the distant green trees, I melted in soft tones of violet. Yet where I wanted a strong accent of yellow-green moss or algae on the central rock, I used its complement, a dark red violet, to help it stand out.

The lower right waterfall is left diffused with a lighter value to bring the eye into the composition. The central area of rocks and waterfall is given more pure hue emphasis, more value contrast, and a bit more detail to hold the eye.

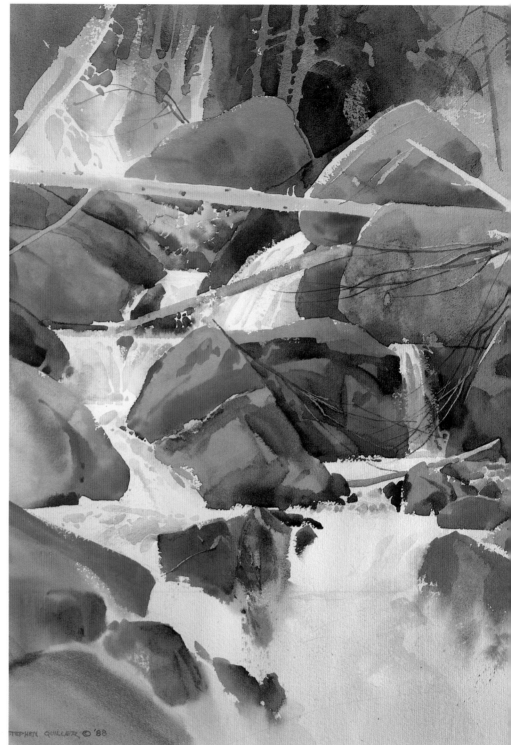

ROUGH CREEK WATERFALL Transparent watercolor on 300 lb. Arches rough paper, 26" × 19" (66.0 cm × 48.3 cm). Artist's collection.

I had originally set my easel on the trail, much further above the stream, and had sketched two large logs fallen on rocks over the stream. But as I went down to get water from the stream, I noticed this composition. The abstract shapes and diagonal movement of the background area, log and branches, rocks and water were very exciting to me. I brought my easel down, turned my paper over, and started this painting. This composition took two sessions, and probably two-thirds of the time was spent standing back observing and thinking. Many overglazes of paint were needed to develop the final value and color.

In this painting, I used my standard palette. I approached the color in a variety of ways. The log is a series of complements: yellow to violet, and yellow orange to blue violet. Much of the water and upper right back area is a series of analogous yellow green, green, and blue green color that has occasionally been mixed with triad families of oranges or violets. And again, while color is very important to the composition, the value is what brings the color and the shapes out. The strong value patterns are what make this painting work.

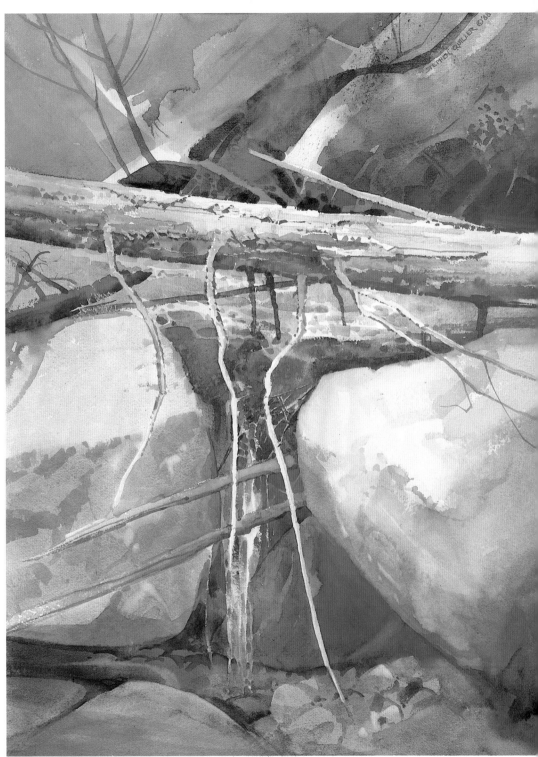

EMERALD POOL Transparent watercolor on 300 lb. Arches rough paper, 26" × 18" (66.0 cm × 45.7 cm). Collection of Roger Steeb.

ALTERING THE TRAVELING PALETTE

When I travel, I use my standard color palette, but I take a variety of other colors along to match the needs of each specific area. Inevitably the area that I am painting will call for certain colors that are not on my regular palette. All I need to do is be in the place for a short time and soak up the atmosphere, light, and culture, and this experience will let me know what colors I need to add.

Too many times I have seen artists using exactly the same techniques, formulas, and color sequence for every painting, and the resulting image looks very much like the previous one. The paintings look as if they have been through an assembly line. To avoid such results, I try never to have preconceived ideas or formulas. Instead, I prefer to approach each piece as a new, fresh, individual work that will seek its own direction.

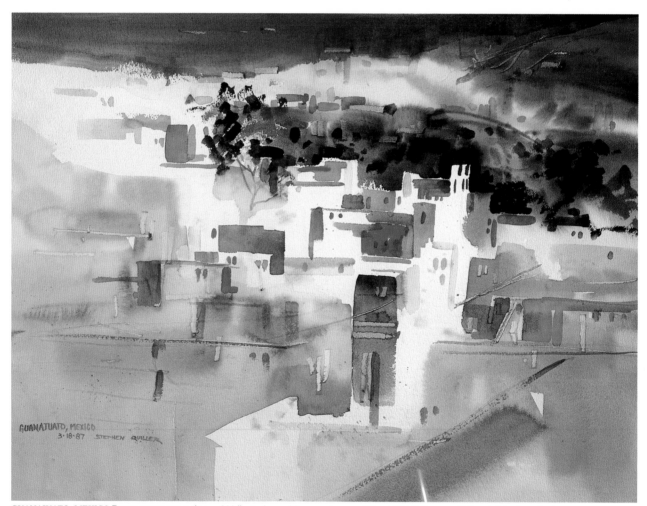

GUANAJUATO, MEXICO Transparent watercolor on 300 lb. Arches cold-pressed paper, 18" × 24" (45.7 cm × 61.0 cm). Private collection.

I love to travel, and one spring I went with some artist friends to this Mexican city and some of the outlying villages to paint. It was a magical experience. The city shapes and colors, the marketplace, and the people were the most paintable subjects I have ever seen. The resulting paintings were new and very different for me. I used my standard color palette but found that I did not use any of my permanent green light or cadmium lemon yellow. Colors I added were Naples yellow, ultramarine blue, and sap green. I had hardly ever used Naples yellow before, but I went through two tubes in the eight days I was there! The atmosphere and whitewashed buildings were bathed in Naples yellow. I also found that ultramarine blue, a "red" blue, was everywhere in the shadows and colors of the buildings.

Once I set up the palette, I worked wet with large 2-inch and 1½-inch brushes, laying in the light and shadow patterns, and exploring the large masses of colored shapes. I had to work very quickly because it was a hot, dry day. As the painting dried, I switched to a ¾-inch single stroke and a size 12 round brush to lay in the darker shapes and detail accents. The finished painting took less than two hours, but actually this subject needed to be done that quickly to achieve the spontaneity and freshness of light that I felt was important to capture the feeling of this area.

OTHER PALETTE ARRANGEMENTS

I have recently started painting on location with opaque acrylic. This has been a new challenge and an exciting adventure. I did this series of paintings in a remote steep canyon, heavily timbered with aspen and spruce, with a small stream and beaver ponds, accessible only with a four-wheel drive. I took a studio easel and a glass palette, working very large. Each painting took at least five to six sessions to complete. I was after the depth and range of forest patterns and the quiet light that was there each morning.

I am convinced that the more one paints, studies, and observes outstanding paintings in collections and museums, the more knowledge and growth one will have. I used to be intimidated by summer greens, the intense greens of aspens and forests. But as I mentioned earlier in the book, during a trip to England I did on-location painting using violets with my greens; and I studied the English watercolor painters. Since then I have felt very comfortable painting greens; summer forest patterns are now among my favorite subjects.

When I set up a specific palette for an area such as a deep forest containing aspen, spruce, and a beaver pond, I need to focus on the main color emphasis and what I am after in the composition. In this series I am after the soft light and the subtle rhythm of the forest patterns, as well as the backlight on the foreground trees and beaver pond. To set up my palette I want a good variety of greens, everything from yellow green to deep cool forest greens. For the two acrylic paintings shown here I used cadmium yellow light (to mix with emerald greens for lively yellow greens), emerald green, bright aqua green, and Hooker's green dark (for the main greens from which to mix forest colors), cobalt blue (as an analogous color mix for cool forest greens), dioxazine purple (as the cool triad mix for greens and to achieve a dark value), indo orange red (as the warm triad mix for green), red oxide (as the neutral orange triad mix with violet), Acra violet (as the complement for the greens and as an underwash to provide a hint of warm), and, of course, white to lighten any of the hues.

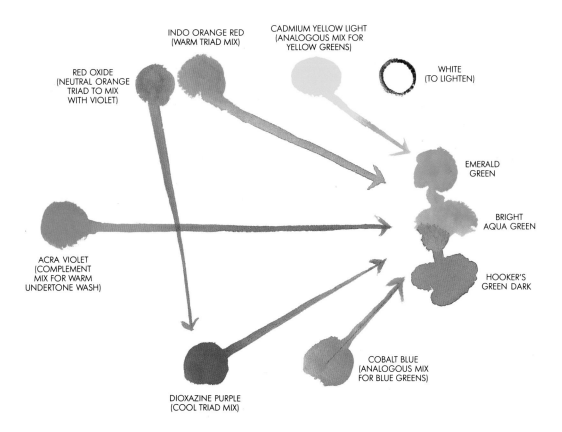

RED OXIDE
(NEUTRAL ORANGE
TRIAD TO MIX
WITH VIOLET)

INDO ORANGE RED
(WARM TRIAD MIX)

CADMIUM YELLOW LIGHT
(ANALOGOUS MIX FOR
YELLOW GREENS)

WHITE
(TO LIGHTEN)

EMERALD
GREEN

BRIGHT
AQUA GREEN

HOOKER'S
GREEN DARK

ACRA VIOLET
(COMPLEMENT
MIX FOR WARM
UNDERTONE WASH)

COBALT BLUE
(ANALOGOUS MIX
FOR BLUE GREENS)

DIOXAZINE PURPLE
(COOL TRIAD MIX)

This is how I set my palette for the forest pattern paintings done in opaque acrylic. Three greens were used to fill the range of warm, cool, and neutralized tones representing this subject. White was used to lighten the colors, and yellow to develop the yellow-green hues. Orange is the warm triad for green, and it produces beautiful semineutrals. Red oxide is an earthy orange providing nice woody accents, and it is a triad mix with violet. Blue was used to develop the cool blue greens; violet is green's cool triad mix. Acra violet was used as green's complementary mix and also as the warm undertone wash.

WORKING ON LOCATION

I had been doing an on-location water-color in an area close to this pond and took a break to do some fly fishing. As I walked by the edge of the pond, the sun had just come over the mountain barely enough so that the edge of the beaver dam and foreground spruce were catching the light. Much of the background forest was still in shadow, with patches of sub-dued light filtering through. Layers of elon-gated aspen and spruce stretched back into the forest, creating a sense of order and rhythm that I wanted to capture.

I went out every morning for a week and could work only from 9:30 A.M. until 1:00 P.M. After that time the light had moved too far overhead. I started this painting with a thin transparent wash of Acra violet. When this dried, I laid an opaque layer of a varied mixture of cobalt blue, dioxazine purple, and Hooker's green dark with a brayer to give a somewhat textural feel to the surface. I did not completely cover the underlayer of the Acra violet, but allowed some of the deep red to radiate through. When this layer dried, I began painting the background patterns. First I tried to cap-ture the subtle nuances of color as I started in the upper left corner. I slowly moved down and to the right. The difficult thing about painting the background area was to keep the value very close while subtly changing color to create depth.

When the background was completed, I painted the sunlit spruce in the foreground, starting at the top and slowly working down. This tree was painted lighter and brighter than its surroundings to stand out. Finally I added the beaver pond, focusing on the sunken logs and shadows.

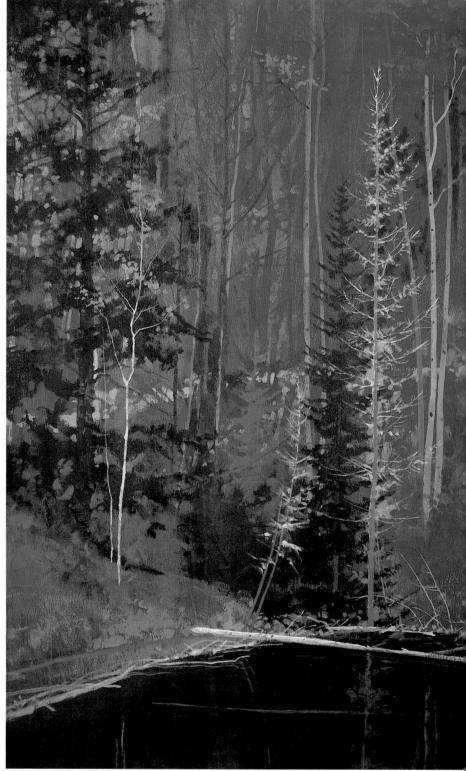

EDGE OF THE BEAVER POND Acrylic on Crescent illustration board No. 100, 36″ × 24″ (91.4 cm × 61.0 cm). Collection of Carole Hennan and John Bruce.

This painting portrays a composite of three different areas. Not far from the place where I had painted *Edge of the Beaver Pond*, I noticed a series of dead spruce. What interested me was the repetitious patterns that the branches made in the sunlight against the deep, dark forest shapes. I started the painting in the same way as the first one, by putting down an underlayer of transparent Acra violet and an overlay of blue, green, and violet applied with a brayer. The background forest patterns were laid in slowly with dark analogous colors. The dead spruce in sunlight were then added in warm orangish tones. I was careful to develop the rhythm that was so apparent in the trunks and branches.

At this time, I moved my easel to a new beaver pond that has a back edge with a soft symmetrical curvilinear movement. (This line would repeat a line in the upper forest shadow area.) I then painted the edge of the pond and the pond itself.

Finally I moved to a third beaver pond where I had noticed these two aspen. I wanted to paint them in backlight so that they would not stand out too much, but subtly move with the rhythm of the rest of the painting. The aspen added to the vertical movement of the composition and connected the lower forms of the beaver pond with the rest of the painting.

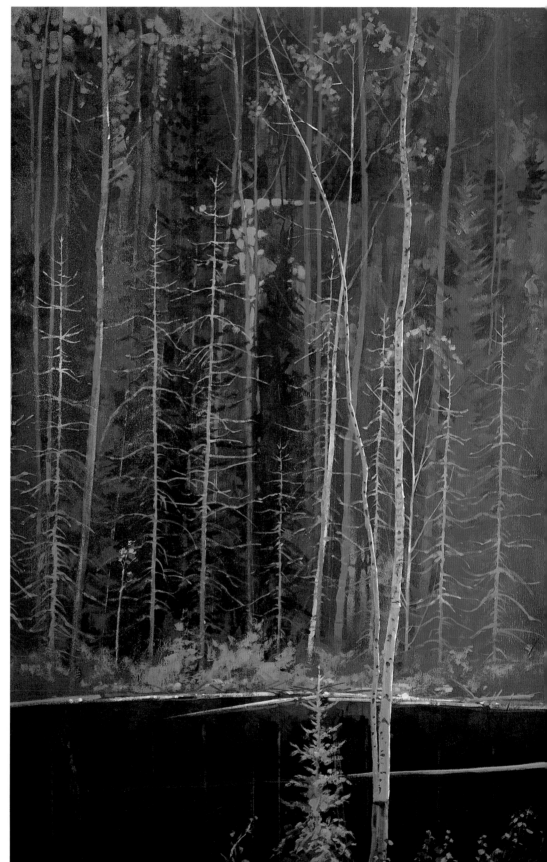

QUIET LIGHT Acrylic on heavyweight Crescent illustration board No. 100, 36″ × 24″ (91.4 cm × 61.0 cm). Collection of Mr. and Mrs. Alex Thomas.

DEVELOPING STUDIO PAINTINGS FROM ON-LOCATION COLOR STUDIES

Many times when I work on location, I gather information for my studio painting—just keynotes of information that will release from my memory the essential material necessary for later work. I try not to get too much information or too detailed a color study because that will block the creative growth of the studio painting.

For this reason I do not use photographs. During my early painting years, I would photograph subject matter while I traveled. But three weeks later when the color prints returned, many times I could not even remember where they were taken.

I have found that if I do a simple line or color sketch, I have had to look more closely and deeply at the motif. It is easy then to internalize the material and it becomes part of me. Because of this, I am much more enthusiastic toward the subject, and that positive energy goes into the painting.

As I sketch with pencil, pen, or watercolors, I am looking for keynotes, a haiku, the essential force of the scheme. I try to put down the important compositional lines and the colors I sense that represent this area. Later in my studio, I set up my line and color studies and begin my painting.

This page of color studies was done in Taos, New Mexico, in mid-November. These studies were not done with the idea of later developing a finished painting, but rather to become more familiar with the color, shapes, and textures of the area at that time of year. I wanted to internalize the color of the sage, scrub oak, juniper, pinon, cottonwood, and adobe. I keep pages of studies like this filed in my studio for later reference; they often come in handy when I am planning a painting.

FOUR PAINTINGS

On-location color studies can inspire my studio painting in a variety of ways. The first two paintings shown in this section, *October Field Patterns* and *Early Spring Light*, were triggered by the excitement of the initial color sketches. The third painting, *Spruce Tree House, Mesa Verde*, was done after four color studies examining the shapes of the area as the light changed. Finally, *The Mushroom Gatherers* evolved from some color studies that had nothing to do with the final subject.

Here is a quick watercolor sketch capturing the color of this area. The sketch probably took less than ten minutes, yet I had enough room to elaborate and play with the general color shapes. I found these color notes useful as I worked on the final painting.

OCTOBER FIELD PATTERNS Acrylic and casein on 300 lb. Arches rough paper, 20″ × 29″ (50.8 cm × 73.7 cm). Courtesy Mission Gallery, Taos, New Mexico.

In northern New Mexico, each autumn month has its own distinct flavor. In October the color is starting to change but there are still many shades of green. The light is more golden and there is a haze in the air. Soft mauves are in the hills, fields, and shadows.

I have some favorite areas where I sketch and paint, and this painting shows one of them. This October day I drove along a rim looking down on some fields and distant hills. When an area would catch my eye, I would get out and walk, observing the various colors and shapes. On this occasion I did six brush drawings and three or four watercolor sketches.

Later, back in the studio, the brush drawing and watercolor sketch on this page were set up by my painting table. Acrylic and casein were chosen for the painting because I felt that I could best capture the color and light with these media. As you can see, color was rearranged to work with adjacent complements: yellow to violet, yellow orange to blue violet, reds to greens, and red violet to yellow greens. Some of the lines of the composition in the hills and field patterns were also rearranged. In all, the field drawing and watercolor sketch were essential information in the development of this painting.

DEVELOPING STUDIO PAINTINGS FROM ON-LOCATION STUDIES

This study was based on an on-location line drawing. I wanted to capture the feeling of light and texture—and, most of all, the color of the bank in the foreground. The sunlight created strong contrasting light and shadow on the snow. Parts of the bank had melted, exposing open patches of raw sienna and ochre grasses. The bare willows in the foreground were in deep semineutral red-violet tones; this all added color relief to the blues and greens.

Early spring light—what a magical time of year! The snow is melting, with patches of raw earth showing through; water is opening while some ice is still creating patterns along the water's edge. Long diagonal light leaves rhythmic shadows on the land.

I had noticed the area shown in this painting for some time. The snow for some reason had held longer in this area and the pockets of light and shadow seemed like jewels coming through the spruce. I first did a quick on-location sketch and then returned a day later with my son to do a watercolor field sketch and to fish. These two sketches gave me enough information to develop a finished painting later.

In the studio, I placed the two studies by my painting table and taped down a full sheet of watercolor paper. Before starting the painting, I spent time meditating and visualizing, and building energy that would carry me into the painting. I started with a wet textural wash of transparent green acrylic, spattering and scoring at will with a toothbrush and razor blade. When this was dry, I laid in the large and small spruce patterns. Next I applied layers of translucent and opaque casein to the snow fields, being careful to provide transitions between the transparent acrylic and the opaque casein areas by gradually strengthening the translucent casein.

I painted the opaque casein around the spruce shapes and in pockets on the trees to make it look as if sunlight were coming through. This is how I perceive the shapes this time of year. Instead of seeing a tree shape in front of a sunlit snow field, I see a spruce shape that is formed by the light surrounding it and coming through it. I referred to the color sketch to get color that would represent the snow bank. I used raw sienna, Shiva violet, Shiva rose, and cadmium red extra pale, along with the white and cerulean blue used for the snow. Touches of these same colors were used in transparent and opaque ways in the upper green forest field and large tree shapes, to repeat the color and move the eye through the composition. The large stringy willow forms were put in to connect some of the banding planes in the composition. I then used transparent acrylic for the water area, applying it with horizontal movement to represent slow-moving water. Colors from the upper areas were used to represent reflections.

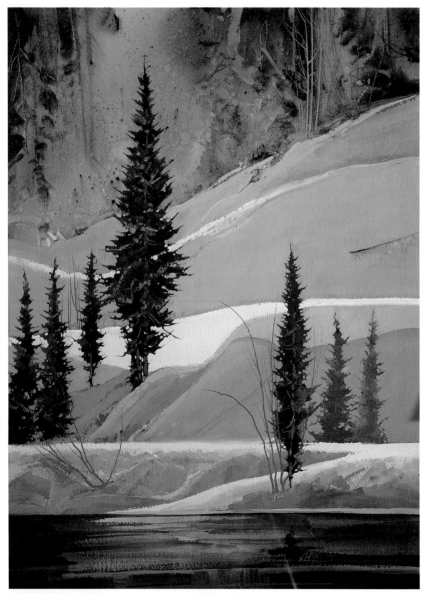

EARLY SPRING LIGHT Acrylic and casein on 300 lb. Arches rough paper, 29″ × 21″ (73.7 cm × 53.3 cm). Collection of Kyle and Diane Deaver.

Painting quick studies on location can be a lot of fun and can help you get to know your subject well. Here are four studies of the same subject, all done the same day, each one about twenty to thirty minutes apart. Notice how the light changes with each sketch. The sun was moving farther to the west (or to the right of each study) as I painted. In my sketchbook I noted the colors I was using for each sketch. All this proved very valuable when I did the final studio painting.

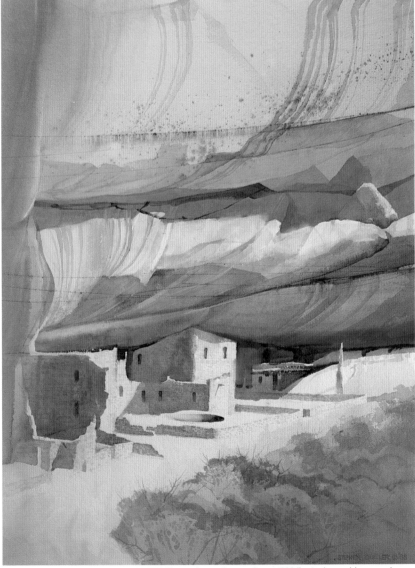

SPRUCE TREE HOUSE, MESA VERDE Watercolor and gouache on 300 lb. Arches cold-pressed paper, 19″ × 25″ (48.3 cm × 63.5 cm). Collection of Vicki and David Ford.

A few days later, back in the studio, I was ready to work on the final painting. I decided to use the same palette I had used in the field studies—purple lake, ultramarine blue, alizarin crimson, brown madder alizarin, Naples yellow, and raw sienna. The way the color was used, it closely resembles a split-complementary color scheme with analogous cool red violets, violets, and blue violet, and yellow and neutral yellows as the subordinate contrast. I wanted a strong feeling of sunlight on the cliff dwelling forms, so the strong contrasting value in this area would be critical, as well as the play of warm color against cool. I also decided to place the building shapes a little farther to the left and make room for the narrow, horizontal, deep-set cave area to its right. This seemed to work better abstractly as a design.

I began the painting by wetting the surface except in the building area and laying down a warm golden wash. While this was still very wet, cool violet washes were applied to the upper area, and a single-edge razor blade loaded with cool pigment was swept across the paper in a soft horizontal curvilinear manner. I let the color fuse down, giving a general feeling of weathered rock. When this was dry, I developed the building area, using contrasting warm and cool tones and strong contrasting value. The cool washes of the foreground scrub oaks were laid in to further develop the light and shadow pattern of the painting. I then mixed white gouache with some of the warm color to further lighten the sunlight on the ground and building areas. Finally, more cool washes were used in the upper rock wall.

DEVELOPING STUDIO PAINTINGS FROM ON-LOCATION STUDIES

Many times, when working on location, I just do color studies that will work as reference material for my studio paintings. Sometimes I do ten or more in a session and work with any area that catches my eye. Usually these studies deal more with color and color relationships than with composition. There might be a group of weeds of varying soft earth tones, autumn aspen and evergreen color variations, or sunlight and shadow on mountain forms. Each study usually takes fifteen minutes or less and is usually quite abstract. I will tape the studies onto a studio wall and let the color soak into my mind. Against the white of the paper, the studies glisten like little gems, and some seem to me complete in themselves.

Here are three such studies done in our south central Colorado autumn. The upper one was done at the base of brushy country that moves into the Sangre de Cristo mountain range. The middle sketch was done further up in elevation on a mountain pass. The color is similar in both studies, but if you look closely there are differences between the color relationships in the two pieces that would be critical if each study were used as the basis for a larger studio painting.

The lower sketch is one of those that occasionally stand out and inspire me to pursue them further. Always it is the color relationships that interest me; many times the final painting uses the same colors but portrays a totally different subject.

Such was the case with this study. It was a sketch of sage, chamisa, scrub oak, other brush, and ponderosa pine, and was done on a scrap of 300 lb. Arches rough paper. It was late afternoon and the raking sunlight gave me a vibrant palette. I taped this piece onto my studio wall along with the others. As the days went by, I kept coming back to this sketch. There were two things that impressed me. First, some of the color relationships of the ground cover were exciting. The colors I thought most interesting were cobalt violet, cobalt green, permanent rose, and cadmium orange. The second thing I noticed was the staining of the colors and the heavy interaction of their pigments. The cobalt violet and cobalt green pigments seeped into the recessed pockets of the paper, providing a nice texture that further enhanced the visual interaction of color. I decided, on the basis of this color sketch, to do a painting in my autumn impressions series. *The Mushroom Gatherers* is the resulting work.

THE MUSHROOM GATHERERS Watercolor on 300 lb. Arches cold-pressed paper, 21″ × 29″ (53.3 cm × 73.7 cm). Collection of Patricia Henderson.

I have a friend who lives in the mountains; after seeing this painting, he said that this is the last place he would want to be if he were gathering mushrooms—there are too many people! Of course the painting is a fantasy that came from who knows where, and was triggered by the lower color sketch on the facing page. It grew into this image because I listened to it. The interaction of color and shapes told me that there should be figures.

When I started the painting, I had a general vision of where I wanted it to go. I knew that I would try to stay with a limited palette of cadmium orange, cobalt green, and cobalt violet. I knew that there would be curvilinear aspen shapes. And I knew that although the viewer would notice color, value would be the key to the composition.

I wet the paper and tried not to have too much of a preconceived idea as to where the shapes and color would go. Working with a 2-inch and a 1½-inch single-stroke synthetic brush, I let each stroke of color indicate where the next would go. Most of the background mountain patterns were put in at this time. Much of the central and foreground area was left untouched or with just tints of color.

Next, using what I call the reverse negative approach, I painted strokes of cadmium orange and cobalt violet around the central branch structure of the main aspen trees. Then I painted washes of cobalt violet and cobalt green around the lower trunks to bring them out and to bring out the curvilinear shapes of the lower part of the foliage. The red-violet and blue-green "lollipop" trees were then put down, bringing out the rest of the light aspen forms. I decided to let the horizontal bands form in the lower foreground area and brought all of the aspen and spruce trunks to meet the ground at the back band. The lower part of the main aspen trunks were then painted darker against the light negative space. Next I put down the upper tips of the spruce forms and the final foreground washes. Lastly, the figures were put in, each one taking on the character of the rest of the painting.

The three main areas of emphasis during the development of the painting were patterning, rhythm, and value. It was important for all the aspen forms to work in a rhythmic patchwork, and for their trunks to be spaced in a nice syncopated rhythm. The finished painting takes on a carefree feeling with a festive, carnivallike color.

PAINT APPLICATIONS

After developing an understanding of color, one is ready to start playing with various paint applications that can create exciting visual interactions of color. I first became aware of this while looking at the paint application and surface texture of some master paintings in museums. Some painters, like Joaquín Sorolla, treated their oil paintings almost like watercolors. Very thin veils of color were applied and then an impasto swatch of light paint was added to create a sparkling spot of sunlight in an area of water. A general rule for oil paintings of the seventeenth-century Dutch school was that dark areas were painted thin and light areas were painted thick. Also, as described in Chapter 3, the old masters used glazing to create an impression of great depth with glowing layers of color.

For the last fifteen years, I have experimented with various visual effects that can be created through transparent, translucent, and opaque applications. Although I primarily use water media—transparent watercolor, gouache, acrylic, and casein—the same or similar effects can be achieved with oil, oil and acrylic, watercolor and pastel, oil wash and oil pastel, and so on. It just takes a little experimenting and imagination.

I have selected four of my paintings, as well as several preliminary studies, as examples of how color can be further used in exciting ways to create a nice surface texture and beautiful visual qualities. The first example, *Spring, Valdez*, demonstrates glazing methods of transparent and translucent color, as well as applying a light opaque over a dark transparent. The second painting, *Winter Pool*, shows the interaction of transparent and opaque color. *San Antonio Cemetery*, the third piece, demonstrates the interaction of adjacent transparent, translucent, and opaque color applications. The fourth image, *Autumn Field Patterns*, shows scraping and incising through opaque layers of color to a transparent underlay. As you look at each of these paintings, notice also the colors chosen to create harmonious relationships. Although I will use water media to demonstrate all the paint application techniques just described, they will work with most media (or media combinations).

GLAZING METHODS FOR TRANSPARENT AND TRANSLUCENT COLOR

Glazing has been in use for centuries. As mentioned earlier, grisaille was used by the old masters. First they built the composition in light and dark values using black, white, and a few earth colors, and then they glazed over with transparent pure hue. In this way, the masters ensured that the forms were fully realized and that the value worked throughout the whole composition. When the underpainting dried, transparent, pure color was applied, allowing the understructure to show through. The colored glazes would add a rich, glowing depth to the painting.

In this study I used a yellow-orange transparent acrylic as the underwash. Blue-violet casein color was then applied over the acrylic in opaque, translucent, and transparent ways. Notice that in one area I left the yellow-orange acrylic uncovered to show its transparent brilliant intensity. In other areas the translucent casein takes on a cloudy quality, allowing the underlayer to barely peek through. In the lower area the casein is used transparently so that the yellow orange is more visible. Play with this method. Experiment with a variety of media using complementary colors. Make sure that the media you use are compatible by referring to a reference source on artist materials, such as *The Artist's Handbook of Materials and Techniques*, 4th revised edition, by Ralph Mayer (New York: Viking, 1981).

A CONTROVERSIAL COMBINATION: TRANSPARENT AND OPAQUE COLOR

Until the mid-1970s, using transparent and opaque color together was taboo in water media. But we have grown in our outlook toward painting, and now any approach is considered acceptable as long as it works. The painting is what counts, and if the impact of the idea is enhanced by the combination of transparent and opaque color usage, so much the better! Many of the great water media painters such as Turner, Sargent, and Homer had this philosophy. Opaque gouache or body color was widely used to give life to the composition.

In oil painting there has been the same general feeling that mixing transparent and opaque color was taboo; all the painting should be covered with opaque oil paint. However, many painters at the turn of the century used very thin transparent and translucent coverage with some thick impasto strokes to achieve exciting visual color interaction. The surface texture can add to the color's visual impact. Milton Avery, a noted American painter, started combining transparent and opaque oil coverage in the mid-1950s, and this set his work apart from that of other painters. Many of the large abstract paintings of the 1960s and

1970s done in oil, acrylic, or a combination of both have very thin transparent veils of color interacting with thick impasto painted strokes.

Oil painters have been using light opaque over dark transparent color to advantage for the past century; Ralph Blakelock is one example. With the development of landscape painting, there came new ways of seeing. Instead of always painting from the back to the front (such as sky, mountains, and then trees) the artist began to see that many times the backlight popping through and around an object *forms* the object. Painting a dark transparent or opaque mass and allowing it to dry provides an underlayer around which to paint.

Because I have lived in the mountains for many years, my eye has been trained to see this way. The brilliant white snow field that is behind the spruce actually radiates the light around the tree and allows me to see the form in a distinct way. The only way to get this particular visual effect is to paint a dark mass first, and then paint light opaque around it to form the object's shape.

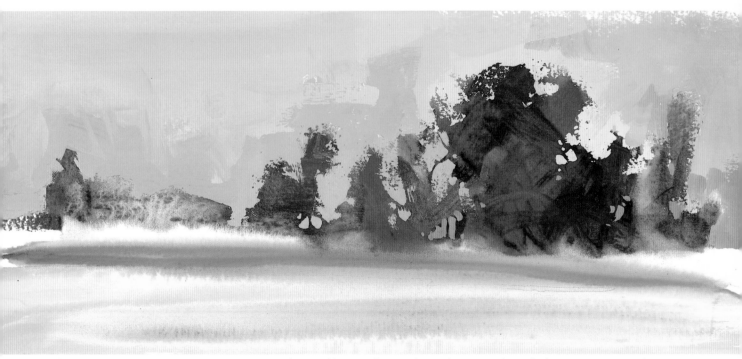

In this study I first applied a dark transparent mass of green, blue, and violet acrylic color. When this was completely dry I used opaque light yellow-orange to red-orange casein to paint over and around and sometimes through the tree forms to create their shapes. The resulting image has a fresh, spontaneous visual quality that is also a very different approach from the way most painters would treat this subject: painting the sky first, and then the trees over it.

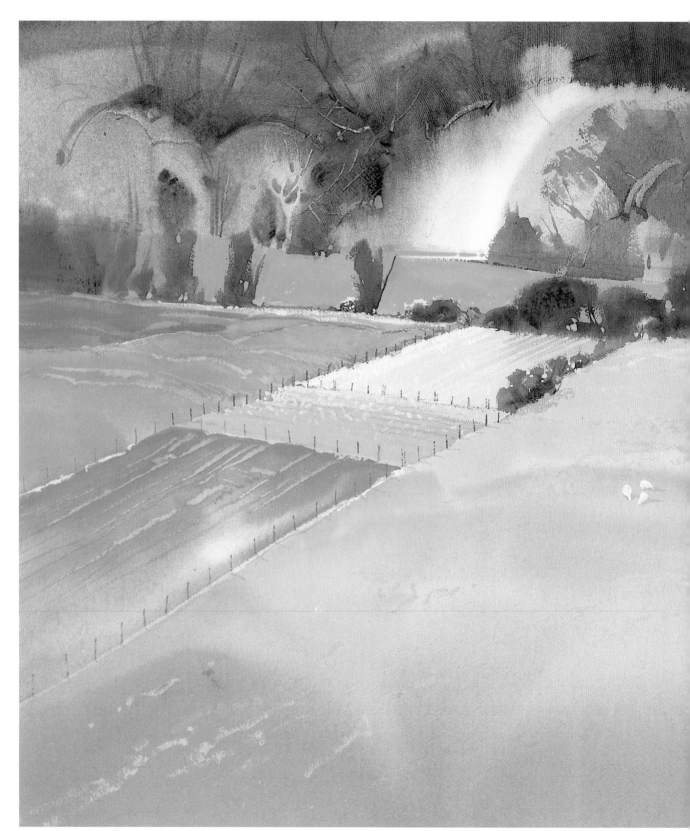

SPRING, VALDEZ Acrylic and casein on 550 lb. Arches cold-pressed paper, 26″ × 34″ (66.0 cm × 86.4 cm). Collection of George and Ruth Gilfillan.

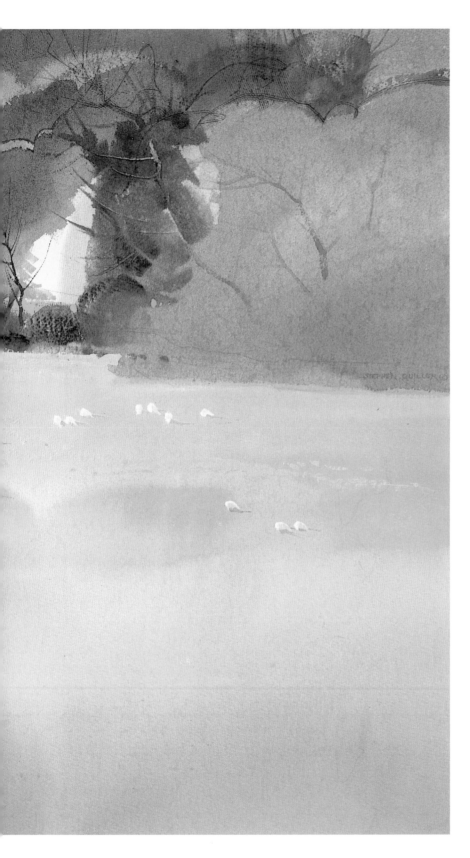

This painting was done from an idea that came to me on the rim above the Valdez valley, which lies a bit north of Taos, New Mexico. In the spring and early summer the red violets of the trees and willows (again, not weeping willows, but shrubs) play against the greens of the grass and budding foliage. It is a beautiful time to paint.

This is a good painting to use as an illustration of glazing methods using transparent, translucent, and light opaque color over dark transparent paint. I will discuss each of these methods and how they were used in this painting.

The glazing method can be seen primarily to the right of the diagonal line that divides the painting, covering the lower half of the painting. First a rich transparent layer of Acra violet acrylic was applied wet to this whole area. When this area dried, I added casein in transparent, translucent, and opaque ways over the underlayer. Soft neutralized yellow greens, greens, and blue greens were used in many places to complement the red violet. In the smaller field patches and the upper corner of the large field, the color was used opaquely. But in the lower parts of the fields, I applied the casein translucently and transparently to let the warm acrylic radiate through. Along the edges of some of the fields the transparent red violet was left untouched to give a crisp cloisonné or outlining effect.

The light opaque color application over a dark transparent underlay can be seen in the upper central band of willows and trees. First dark red-violet and blue-green shapes were painted wet on wet with acrylic. These were just general shapes that covered more area than the finished forms indicate. After they were dry, opaque light green casein was mixed and painted around and into the dark masses of color to develop the shapes of the willows, shrubs, and tree branches.

In the finished painting, I have attempted to create an interaction of opaque, translucent, and transparent color through direct application and glazing that is a visual feast for the eye. The color and paint application were chosen to represent how I feel about spring in northern New Mexico.

TIPS FOR COMBINING TRANSPARENT AND OPAQUE COLOR

Actually, combining transparent and opaque color is not a simple thing to do. Too often, opaque application of paint is used as a cover-up. By this I mean that a mistake was made in a transparent watercolor and the artist simply mixed some opaque gouache color and painted over the marred area. This usually results in what I call a "postage stamp" look. The paint looks as if it were tacked on like a stamp to a letter. To work effectively, the opaque-transparent approach needs to be planned from the start of the painting.

The idea of transparent and opaque color paint application can be used with either abstract or representational art. I see transparents and opaques in nature. Sky and water seem to me

transparent, while land forms seem solid and opaque. But sometimes I simply use the combination of transparent and opaque to create more visual interest.

The key is that it works. I have found that it is harder to use this combination well if the surface is mostly transparent with just some opaque areas. It can be done, but too often the opaque looks tacked on. If the painting is primarily opaque, with some areas of transparency, the technique is much easier. The best thing to do is to experiment and find what works best for you. Try using transparent glazes of a certain color followed by some opaque overlays of the complementary color. Adjust the value of the colors to create even more visual interest.

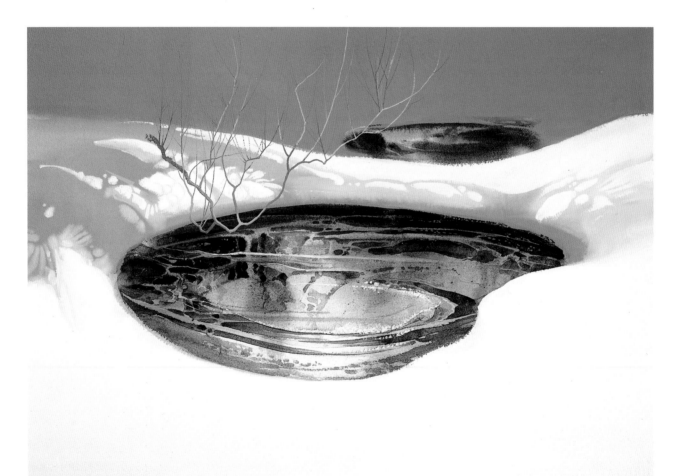

WINTER POOL Transparent watercolor and casein on 300 lb. Arches cold-pressed paper, 18½" × 26" (47.0 cm × 66.0 cm). Collection of Charles and Nancy Wallick.

When I started this painting, I wanted to capture the feeling of the transparency of the water and reflections against the opacity of the snow and willow branch. I decided to use transparent watercolor for the water passages and opaque casein for the snow, shadows, and willow branch. I chose a basically complementary color scheme of dominant green and blue green, with subordinate red and red orange.

I first put down a transparent wet-on-wet wash in both the pool areas. Filling in the pools of color, I was trying to create a feeling of the water patterns and diffused rock forms below. When these

passages dried, I came back in with some glazes of color to give a touch more definition. At this point, a few opaque red notes were placed into the green areas of the water. Next I painted the snow and shadow areas opaquely. First I wet the paper and then washed on cerulean blue. While this was still wet, I painted titanium white into some of the blues, giving the illusion of moving shadows. Solid warm whites were added once the paint was dry, to give the feeling of brilliant sunlight.

Finally the willow branch was put in. The placement of this branch was critical to the visual impact of the painting.

INTERACTION OF TRANSPARENT, TRANSLUCENT, AND OPAQUE COLOR

Visual interaction can be explored much further with the interaction of transparent, translucent, and opaque color. Each of these applications has a distinctly different look. Transparent color allows light to easily penetrate its veil to the white surface and reflect back to the eye, which gives a fresh, vibrant look. Translucent colored areas have a cloudy, milky look; although the light does penetrate the paint film to the surface, the reflected color has a softer, chalky look. Opaque colored areas have a solid film that does not allow the light to get beneath the paint. The color we see is reflected only from the paint itself.

I like to make all three of these applications interact. The painting *San Antonio Cemetery* is one example.

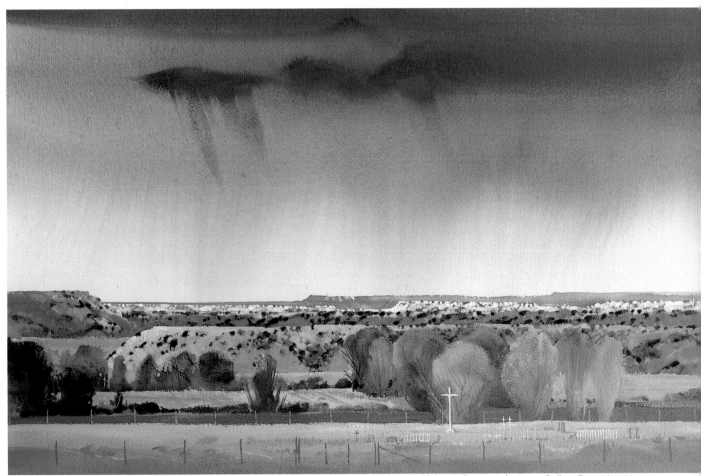

SAN ANTONIO CEMETERY Acrylic and casein on 550 lb. Arches rough paper, 22" × 33" (55.9 cm × 83.8 cm). Courtesy of Mission Gallery, Taos, New Mexico.

I have done a lot of sketching and painting around this small village at the border of Colorado and New Mexico. Early summer when the cottonwoods have leafed out and the various greens of the land have emerged is one of my favorite times. I had located this cemetery, which sits on a mesa at the edge of the village, and went there to do a line drawing and a watercolor sketch. The large white cross and the other elements of the cemetery interested me because of the way they related with the rest of the landscape.

Back in the studio, I wanted to capture the feeling of early summer rains and the fresh greens of this time of year. I also wanted to get the feeling of the textures of the rocks, junipers, and piñon that dot the mesas. For these reasons I chose acrylic and casein for the media and transparent, translucent, and opaque paint applications for color interaction.

First the walking-rain sky was washed in transparently with acrylic. When this was dry the entire land area was washed with transparent Acra violet. (I felt that this would be a good base color because its complement is a yellow green, and I would use these tones in some of the overlaying colors.) Once the wash was dry, all the mesa forms were developed. Dark violet acrylic strokes of paint were placed wet on the mesa shapes, translucent blue-green casein was put over and around the dark forms, and finally highlights of opaque yellow-green casein were added. A similar approach was used in the foreground tree area. The red-violet and green tree forms were painted transparently with acrylic. When these were dry, opaque and translucent areas of light green casein were painted around the trees, leaving some of the red-violet underlay of acrylic showing.

It is important that this painting has similar paint handling throughout. Because of this, the eye senses a consistent direction. The red-violet underlay of acrylic also serves as a unifying device. The common color radiates through from the distant hills to the foreground cemetery.

ENERGIZING THE PAINTING SURFACE

Color is not the only way to create energy in a painting. As I have discussed with regard to earlier paintings, the paint application—such as the interaction of transparent, translucent, and opaque paint—can add visual interest. This can be achieved with acrylic, oil, casein, or gouache used by themselves, or with acrylic and casein, acrylic and oil, watercolor and gouache, or acrylic and pastel in combination. The action of the paint brush can also be of help to give life to a composition. Quick-moving, facile strokes have a spontaneous quality that give a snap to a painting. A splatter of paint in the right area, a scoring or scraping through the paint to an underlayer will give an unexpected freshness and energy if done well.

In this study the paint has been used to show energy. First a warm golden transparent acrylic was applied over the entire surface and allowed to dry. Then translucent and opaque red violet, violet, and blue violet casein were added. While the casein was still damp, a single-edged razor blade and a pocket knife were used to scrape through to some of the undercolor. After the paint was completely dry, opaque red-orange spatter was applied.

My favorite time of year in northern New Mexico is late autumn. The land is alive with a myriad of colors and a low, slanted light. enjoy painting and sketching there at this time and exploring the many out-of-the-way roads, landscapes, and villages. This paint-ing came from one of those treks. Sepia ink-wash sketches and notes were taken for later development in the studio.

I first taped my watercolor paper to a board and placed it on an easel. Wetting the paper completely, I loaded my 3-inch brush and painted warm transparent tones of acrylic that can be seen in the sky area and the orange undertone on the rest of the painting. While the paper was wet, I added the furthest mesa forms with Acra violet and red-orange acrylic applied with a single-edged razor blade. Dark patches of violet acrylic were applied to the mesa areas. Casein was then used for all the overlaying color. In the mesas, opaque light orange and blue were painted over and around the dark acrylic to create the mesa's texture. In the field patterns, translucent and opaque casein were used freely to create the patchwork quilt effect. Throughout each section, I played with the paint, scraping and scumbling color, trying to add energy and life to the composition. (In some fields, parallel scrapes with a pocket knife suggest furrows, for example.) In each area I selected color that would go with the undercolor as well as with the rest of the color scheme. Accents of trees, sheep, and ditches were placed to give the final touches to the painting.

The completed painting reflects the fact that I had fun working on it. The color has a life that resembles how I feel about New Mexico this time of year. The paint application also has an energy that I associate with this country in November.

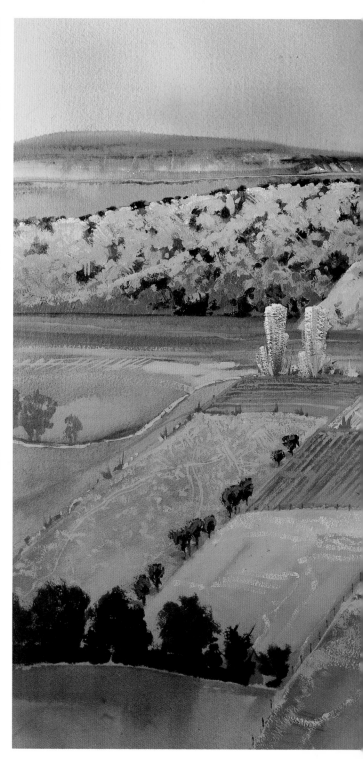

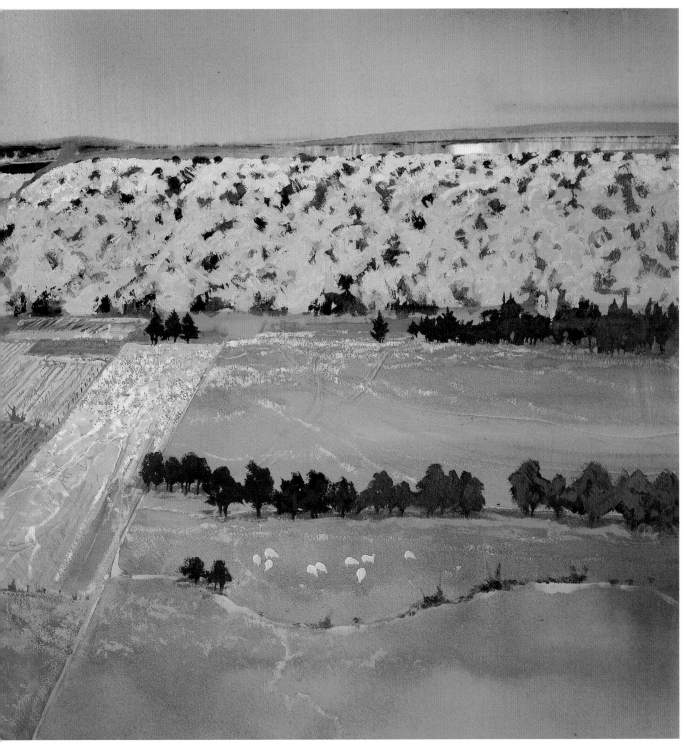

AUTUMN FIELD PATTERNS Acrylic and casein on 555 lb. Arches cold-pressed paper, 27" × 39" (68.6 cm × 99.1 cm). Collection of Mark and Greta Allison.

INNER VISION

Every artist responds to different subject matter and approaches his or her painting in a unique way. When an artist's subjects, responses, and approaches come from within, I like to call them an inner vision. A painting nurtured by inner vision usually has slightly deeper feeling and is more personal to its creator. "The answer lies within" is a phrase from a well-known song by Cat Stevens. I feel that this is true, and that exploring painting from within is one way to seek the answer.

I am always responding to patterns and rhythm in nature. I find this when I see spruce and aspen on a mountainside, pockets of light through backlit trees, or the movement of light and shadows on snow. My feeling for patterning and rhythm is deepset. It has come over many years of observing, contemplating, and painting nature. This is so much a part of me that it is part of my inner vision. I can be driving in a car or fly-fishing, and suddenly an idea will come. The idea will usually be very clear, and inevitably as I work out the idea on paper, patterning, rhythm, and color become essential elements of the composition.

I think that the inner vision plays a very important part in my painting. Whether I am in the studio or working on location, most of the decisions about each painting are directed from within. That is to say again that I am not trying to duplicate nature but rather paint how I feel about nature. I pay attention to my thoughts, feelings, and sensations for my interpretation of the subject.

Each painting and each inner vision must follow its own course. Each work must have its own color and composition. It cannot follow formulas used in past successful paintings but must have its own unique spirit. When the artist truly captures this inner spirit, I believe it will be sensed by the viewer. The energy put into the painting will always remain and can be felt by someone who is appreciating the piece.

To me, the painting process becomes all-important. The flow that I get into when a painting is going well is more pleasing than any other experience I know. The process of painting becomes addictive. At this time it does not matter whether the painting will sell or not, or even whether it will eventually be a successful painting. It only matters that I am exploring my thoughts and feelings, playing with the media application and color, and developing a composition. In the end it will either be framed and sold or be scrapped and remembered as a learning experience.

These next four paintings are examples of pieces that relied strongly on my inner vision. Each one was approached in its own individual way and allowed to seek its own course. *The Apple Tree* was inspired by some abstract forms in Chinese sumi painting. *Returning from the Sea* came from an idea I had while driving on a mountain road in Colorado. *Erosion* grew out of a subject I noticed while eating a sack lunch on the bank of a river during a fishing trip. *Mountain Shadows* came from memories of mountain forms. Let's take a close look at each of these paintings and see how this inner spirit comes through and how the color is used to add to this spirit.

I have long been an admirer of Chinese sumi painting. I like the free-form way they break up two-dimensional space, their unusual vantage point, and their flat, diagonal shapes. When my compositions seem too static and I feel that I am in a rut, I look at these black and white wash drawings. I particularly like doing abstract wash compositions, utilizing some of the drawing's main elements. This study is representative of the numerous ones I have done after Chinese sumi painting.

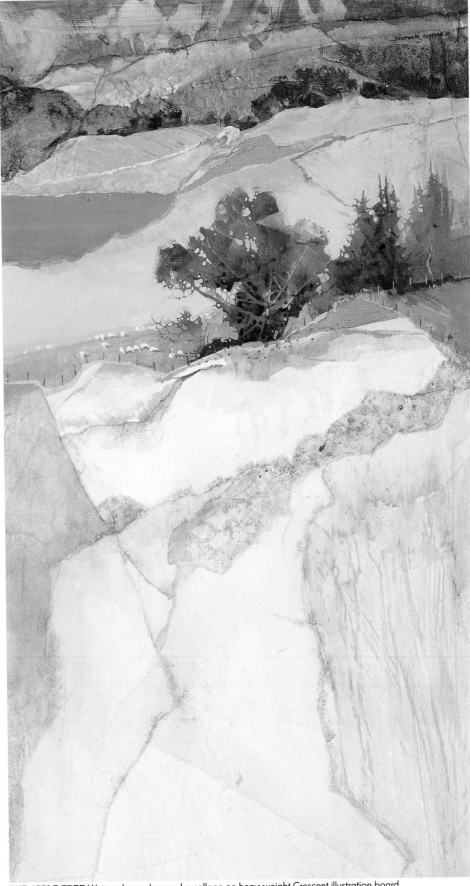

A few years ago I went to the art museum in Phoenix when it was having a show of Chinese sumi paintings. I was particularly drawn to the way the composition had been developed. The asymmetrical, free-flowing, diagonal paintings were very refreshing. I purchased a book and a catalog and studied these paintings. I was not interested in duplicating the paintings, but in doing some abstract studies from them.

When I had done a few, I decided to apply some of these ideas to my painting. I selected one abstract study and just looked at it for a long time. Eventually I began to sense an aerial view of some of my New Mexico field patterns. I decided on a palette of colors, from a full range of greens to the complementary reds and red violets.

I first tore large and small shapes of many kinds of rice paper and laminated them onto a watercolor board with acrylic matte medium, following very loosely the abstract preliminary sketch. When the acrylic medium was dry, I began applying transparent watercolor to the large general passages. I varied the greens from yellow green to blue green to green earth, letting the torn general shapes dictate the overall pattern and reacting to these shapes and the color. I adjusted the value of each shape to work with adjacent shapes and chose to use the complements red violet and red with the yellow greens and greens. Opaque and translucent gouache were then used to interact with the transparent watercolor.

It was fun to create this painting and watch it grow. Each shape and color told me what to do next. The entire painting was done on an easel, which made it easy to get back and study the process.

THE APPLE TREE Watercolor and gouache collage on heavyweight Crescent illustration board No. 100, 36″ × 20″ (91.4 cm × 50.8 cm). Collection of George and Keitha Woodard.

I receive many of my ideas for painting while driving. I was on a high mountain road in Colorado in mid-August. I had been planning in the autumn to spend some time painting, on the Oregon coast, so the ocean was on my mind. As my mind drifted, I soon clearly saw many sheep moving rhythmically over sand dunes from the sea. My initial vision was the dunes and sheep in earthy tones and white, with a brilliant sea green light in an upper horizontal passage where the sun touched the ocean. I pulled to the side of the road and did a sketch of this vision. That evening I did a more detailed sketch and jotted down some notes.

The more I thought of this idea, a cherry bark rice paper seemed to be the perfect surface for it, because the flicks of bark embedded in the paper gave a texture similar to sand on the beach. I decided to work with oil wash, casein, and Prisma-color pencils. I later also used oil pastel and gouache. The finished image has as much drawing as it does painting, and I feel the interaction of the media works well.

I began by placing my two sketches on the floor next to the easel so that I could refer to them occasionally. Next I taped the rice paper to a sturdy piece of white illustration board. I then dipped a large oil wash brush in turpentine and applied the burnt sienna oil washes. During this process, I kept foremost in my mind the idea of patterning and rhythm of the beach, sand dunes, and sheep. I then painted in the sea forms and sky, using cool blue, blue green, and green tones of casein. Then it was time to start developing the sand dune forms and sheep. As I mentioned earlier, my original thought was to have this area in earth tones and white. But somehow as these images developed, they called for more color and different media. I went with these thoughts and used more of the colors of my Prismacolor pencils, as well as some oil pastel for larger areas of solid color. For the opaque white highlights on the sheep, permanent white gouache was used.

From the start, this painting was a new direction for me. Until I started each passage, I did not know how it would be handled or what media would be used. It was frightening to explore unknown territory this way, because there was a good chance of failure. There was also nothing more thrilling than helping it develop along its own original path!

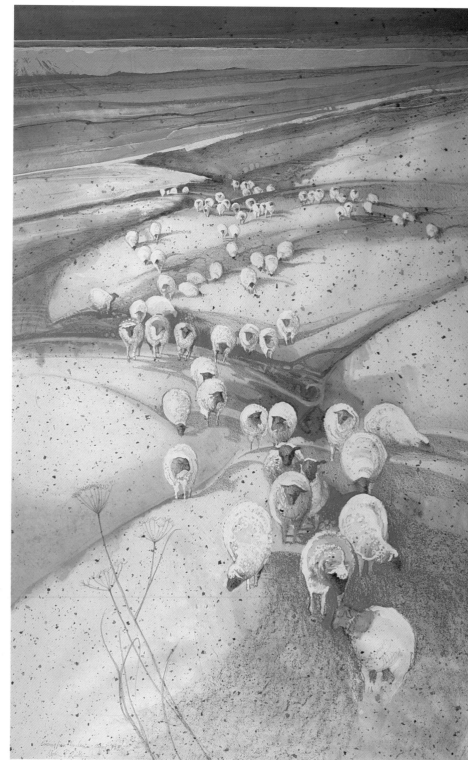

RETURNING FROM THE SEA Mixed media on cherry bark rice paper, 38¼″ × 25¼″ (97.2 cm × 64.1 cm). Artist's collection.

On a warm, still summer day, fly fishing in a secluded area of the Conejos River is hard to beat. I always carry a day pack with my sketchbook and lunch to top it off. This particular day the fishing was good. I sat down on the bank with my waders still in the water and got out my lunch. While I was eating, I noticed the erosion along the bank where high water had worked away at the rocks and roots of some spruce. I became interested in the abstract shapes of these organic forms. I reached for my sketchbook and did a fairly involved sketch, paying attention to the variety of shapes, textures, value, and active and passive space. I then went back to the business at hand . . . fishing!

Days later in the studio, I decided to do a large painting from this sketch. I firmly believe that the subject is just the excuse to paint. By painting this subject that I was excited about, I could enjoy exploring color and texture and water media in a challenging, different way. The rolled paper was cut to size and soaked in my bathtub. Thirty minutes later it was removed, blotted, and stapled to a heavy, rigid plywood board.

When the paper dried, I lightly sketched the subject with a 2H pencil and began to play with media and color. I worked with acrylic and Prismacolor pencil. The acrylic was used transparently for the most part, but in a few cases translucently and opaquely. Color was primarily warm yellow to yellow orange against red violets, violets, and blue violets. But I also added some metallic coppers, silvers, and pewters to the violet areas to give an added shimmer. The Prismacolor pencils were used to give a linear texture to the roots and rocks. I paid fairly close attention to the values in my sketch. Even though I had a heyday with the color, the value is the key to making this painting work.

Occasionally I hate to see the process of the painting come to an end. *Erosion* is one of these paintings. I enjoyed working on it so much that I wanted to continue, but knew that it would become overworked if pursued further.

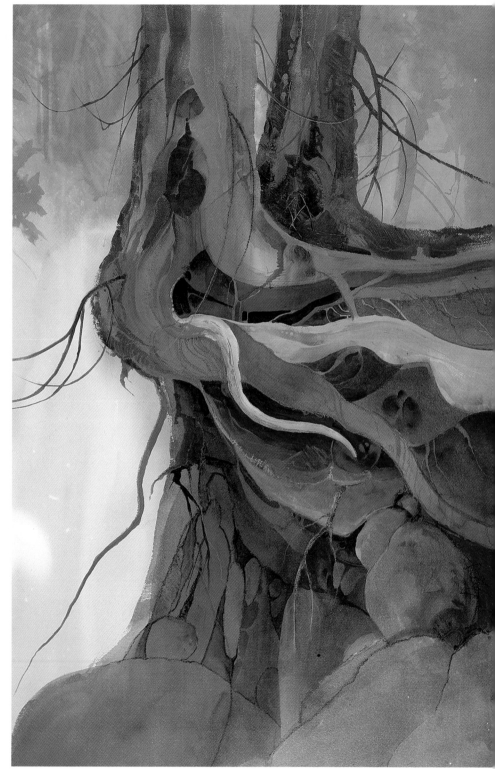

EROSION Acrylic and Prismacolor on 140 lb. Arches cold-pressed paper, 36" × 26" (91.4 cm × 66.0 cm). Collection of Jo Nelson.

Although I still paint directly from nature, many times I work in the studio and follow my inner vision—especially with a subject I know very well, such as the mountains. Some paintings—such as *Mountain Shadows*—I do with no preliminary planning at all.

I cut my heavy watercolor paper to size and taped it to a heavy plywood board. Before actually beginning painting, I spent time meditating and visualizing with the paper. I decided to use dominantly analogous violet-range colors and to start by working with acrylic transparently. Having worked with the mountain motif for so long, I can sense what I want to do and what forms are needed for each passage. I chose to start transparently because I could create great depth from distant transparent to foreground opaque. Also, I like the look of the interaction of transparent and opaque media.

I wet most of the surface and started painting with a 3-inch squirrel-hair brush. The upper middle left area was left dry while I placed juicy washes of red violet everywhere else. With the paper still very wet, I used a single-edged razor blade to form the upper distant mountain form with cobalt blue, and added direct brush spatter to give life to the upper passage. When I had completed this initial stage, I stood back and let the paint suggest the next forms. The distant transparent aspen were put in, and then the strong diagonal of dark spruce. Each layer of color suggested the next form, and the painting just went its own direction. I tried not to force it to do what I wanted it to do, but instead let it go where it "needed" to go.

MOUNTAIN SHADOWS Acrylic and casein on 550 lb. Arches rough paper, 34" × 26" (86.4 cm × 66.0 cm). Collection of Carole Hennan and John Bruce.

This is an example of the visual interaction of transparent and opaque applications. The light red-violet aspen and the darker violet spruce have been painted transparently with acrylic, while the blue-green and yellow-green pockets of land seen through the trees were applied opaquely with casein. The yellow-green color was chosen to interact with the red-violet complement.

This detail shows the reverse negative painting approach. The dark aspen branches were actually formed by painting around them—but to a viewer standing back, the spruce do appear to be behind the aspen. First a large dark violet area was painted in the general shape of the aspen form. Then the lighter violet and red violet casein was painted around and through the dark passage to form the aspen. This may seem to be a lot of work, but it is the only way that I can achieve this particular visual effect. Also note that the color has been used in analogous ranges from blue violet, violet, and red violet.

WORKSHOP: GOING BEYOND STRUCTURED COLOR SCHEMES

EXERCISE 1
Organize a painting palette similar to the one suggested for on-location painting on page 96. Select a subject that deals with the play of light, such as a group of old buildings, a wicker rocker on a porch, tree patterns against a dark backdrop, or an old log in moving water. Working very spontaneously, try to capture the quality of light on the scene. Consciously mix the semineutral colors from direct complements or triads. Do four such studies at different times of day: early morning, noon, late afternoon, and twilight. Spend no more than half an hour on each small study.

Back in the studio, set the studies together to notice the range of expressions that can be achieved from one composition. Also note the range of color and the appealing semineutrals possible with this palette.

EXERCISE 2
Choose a sight that has recently impressed you because of its color. This could be landscape patterns, floral patterns, tree patterns, or field patterns, at a particular time of year. Do some quick, small, abstract studies capturing the essence of color that attracted you.

Back in the studio, tape the studies to the wall or a white mat board. Have a cup of your favorite hot beverage and study them. Choose a study that particularly excites you because of the unique color relationships. Now go through old sketchbooks and select an entirely different composition but one that you feel could work with these color relationships. Develop this sketch into a finished painting, determining color by referring only to the study you just completed.

EXERCISE 3
Find a quiet spot and get into a comfortable position. Close your eyes and breathe deeply. Focus on your breathing, gently inhaling and exhaling. Recall a favorite place and time, such as sea grass and sand dunes by the ocean, or a picnic by a mountain stream. See the images vividly and note the color that comes to mind. Spend time contemplating this place and time. When you feel that you have spent enough time enjoying your thoughts, get out a sketchbook and jot down some observations. Particularly note the colors, shapes, and special relationships of figure groupings or landscape arrangements.

In the studio, put the sketchbook away and just start painting. Let the images grow naturally out of the interaction between your paint and paper or canvas. Make use of serendipity! Play with the color and paint application that you feel will best express how you feel about the time and place you have chosen. As a former instructor of mine always said, "Don't fight it, enjoy it!"

6 MASTER COLORISTS

One of my all-time favorite pastimes is to visit art museums, and during the last twenty years I have seen many of the museums in the United States and Great Britain. It is fun to spend a day at a museum alone or with good friends who are interested in art. When I am with others, inevitably at lunch we start a memory game about the art that we have just seen. Each individual takes turns in choosing a work of art for his or her imaginary collection. The person who is selecting must describe the painting or sculpture or give the title of the work, and name the artist. We keep taking turns around the cafe table until all the work that stands out in each one's mind has been selected. The game can become really competitive and heated when someone preempts my next choice! It is also interesting to see what art each individual likes, for many times a friend will choose a piece I had forgotten. It brings back the morning's tour vividly to the mind.

Each new museum is an adventure with its own unique personality. Some are small and intimate while others could take days to see thoroughly. In the large museums I focus on the art periods I particularly like, since there is not time to see all the work in the museum. I choose to see works by Dutch and Barbizon painters; from the impressionist, postimpressionist, and European modern movements; and American art from around 1850 to the present. When I return to a museum, there are a few paintings that are like old friends that I must see. Many of the large institutions have drawing and print study rooms where one can see drawings, prints, and watercolors that are not on display. One normally needs an appointment, and these areas usually have certain hours or days set aside for the public. When I "discover" new artists, I enjoy reading about them. I have a good library of art books (one of my weaknesses) and use the public library and the interlibrary loan program to get books that are not locally available. Before I go on a trip, I always refer to a set of four books titled *Curators' Choice* by Babbette Brandt Fromme (New York: Crown, 1981). These books are broken down into regions of the United States—the Northeast, Southeast, Midwest, and West—and give a brief description of the museums and their collections in each state. Many lesser-known museums are listed and are worth going to.

There are many artists whom I particularly admire and who have influenced me over the years for a variety of reasons, such as drawing skills, color usage, paint application, composition, philosophy, and life-style. I find it helpful to soak in all I can of each artist; many times it inspires me in my painting. This does not mean copying the masters' works. It simply means that when I absorb the work of great artists, their painting will help me to see my own work better. It will help me to see how key lines in my composition can be changed, color combinations improved, or line quality altered to better the statement. In researching all these artists, I have found that they have had one thing in common: They were all students throughout their lives. As you may remember from the Introduction, each artist referred frequently to admired artists of the past and of his or her own era.

I want to devote this chapter to painters, past and present, who have helped me on my quest. I will just briefly mention the personal color usage unique to each artist and other strengths in painting approach, and then mention museums and publications where the artist's work can be seen or read about. I hope that this will be of value to you as well. A few of the books listed are out of print, but I have included them anyway because they are excellent and you might be able to track them down in your library, or through an interlibrary loan program.

Pierre Bonnard, **THE OPEN WINDOW.** Oil on canvas, 46½" × 37¾" (118.1 cm × 95.9 cm). Courtesy of The Phillips Collection, Washington, D.C.

DUTCH PAINTERS

The seventeenth-century Dutch school fostered much growth in the history of painting. Artists began exploring still life, landscape, and genre painting (portraying people in normal everyday life settings). Also, light became an extremely important element of the painting. Chiaroscuro, which is a special treatment of lights and darks in a composition that has a "spotlight" effect, was developed with interior and portrait subjects. It is also important to remember that artists ground their own pigments and made their own paint, and had a limited color palette to choose from. (Most of the colors in use today have been developed since the mid-1800s.) Many great painters came from this era, among them Gerard Terborch, Carel Fabritius, Pieter de Hooch, Jan Steen, Frans Hals, Rembrandt van Rijn, and Jan Vermeer. Of these painters, the two artists that have had the greatest effect on me are Rembrandt and Vermeer.

REMBRANDT VAN RIJN (1606–1669)

The story of Rembrandt, born in 1606, is one of riches to rags. Early in his career his work was much sought after, and he was a wealthy man. As he grew older his work became much looser and more personal. He did not manage his money well and died a pauper. But because he chose his own artistic path, his paintings are still revered today. He was one of the greatest draftsmen who ever lived. He would capture the essence of the subject with a minimum of calligraphic-style line. I love studying his ink wash and reed pen drawings, and his line etchings. But I am particularly interested in his painting during the latter part of his life.

Rembrandt was a master of paint application. He followed the general practice during his time of applying the oil paint very thin in dark areas and thick in light areas. This gives a three-dimensional quality to the form. He would build the composition in earth tones, concentrating on value, and then glaze the pure hues over this underlay, a practice called grisaille (as mentioned earlier). On close examination, the highlights on the jewelry he painted are thick white impasto globs. From a distance they shine and glisten. His loose, personal, painterly application in his later work gives a lush and juicy quality.

FURTHER RESEARCH
Rembrandt Drawings by B. Haak, translated by Elizabeth Willems-Treeman. New York: Overlook Press, 1976.
Rembrandt by Horst Gerson. New York: Harrison House, 1968.

MUSEUMS
National Gallery of Art, Washington, D.C.; Metropolitan Museum of Art, New York; Louvre, Paris; Berlin-Dahlem, Gemäldegalerie; Rijksmuseum, Amsterdam; National Gallery, London

JAN VERMEER (1632–1675)

I will never forget when I saw my first Vermeer, *The Concert*, at the Isabella Stewart Gardner Museum in Boston. Very few paintings have ever had that much effect on me. The quality of soft interior light and the way he developed the surface textures of dresses, tapestry, floor, and wall were unbelievable. Vermeer was from Delft, Holland. Only thirty-five paintings attributed to him exist today. There are many distinguishing qualities to his paintings, the most important being the magical quality of light. His strong horizontal-vertical rectangular geometrical motif and the way he breaks up the picture plane are worth studying. He had a way of painting golden light and many times used ultramarine blue or violet to neutralize yellow, or as an adjacent color. Two centuries later, van Gogh commented on Vermeer's use of yellow and violet, and he readily used this color combination with his own subjects.

Vermeer had a beautiful way of developing pattern, as can be seen with his fabric, floors, and still-life material, and was at his best when painting various visual textures such as paper, skin, fabric, and metal. He had a strong sense of value and intensity, and used his pure hue sparingly with large semineutral masses. In the United States a good concentration of Vermeer's paintings can be seen at the Metropolitan Museum of Art and at the Frick Collection, which is just a few blocks away from it in New York City.

FURTHER RESEARCH
Vermeer and His Contemporaries by Leonard J. Slatkes. New York: Abbeville, 1981.
Vermeer by Arthur K. Wheelock, Jr. New York: Abrams, 1981.

MUSEUMS
Metropolitan Museum of Art, New York; Frick Collection, New York; Rijksmuseum, Amsterdam; National Gallery of Art, Washington D.C.

ENGLISH PAINTERS

The eighteenth and nineteenth centuries were an era when art flourished in England. It was a time when great portrait painters such as Sir Joshua Reynolds and Thomas Gainsborough were much in demand by the aristocracy. Landscape watercolor painting became very popular and was established as an acceptable finished painting medium. This approach to watercolor painting became the foundation of our present-day watercolor painting. Aquarellists such as Thomas Girtin, David Cox, Peter De Wint, John Sell Cotman, and Richard Parkes Bonington were masters of this medium. Master landscape oil painters such as John Constable and J. M. W. Turner were also in vogue. This era produced the great visionary painters William Blake and Samuel Palmer. A few years ago I went to Great Britain to study British painters. My main focus was on the watercolorists, but I developed a keen interest in many other painters as well. Ever since my trip, three British painters in particular keep coming back to me: J. M. W. Turner, William Blake, and Samuel Palmer.

JOSEPH MALLORD WILLIAM TURNER (1775–1851)

J. M. W. Turner was predominantly a landscape painter working both in watercolor and oil. In his watercolors he was very expressive and experimental. He would work in wet areas with a brush full of color or add quick, spontaneous strokes to dry rough paper. He would sometimes use toned paper and many times integrate body color (opaque watercolor). His later oils are very much influenced by his watercolors. He worked on a white canvas and glazed his oil thinly to give his color transparent vibrancy. His late work is actually very abstract, and some suggest he was the forerunner of twentieth-century abstract expressionism. In his oils and watercolors he was most often after a certain atmospheric quality through color and would indicate and suggest forms rather than go into any detailed rendering. The Tate Gallery in London has recently opened a new wing that is to house a large Turner collection.

FURTHER RESEARCH
The Paintings and Drawings of J. M. W. Turner by Martin Butlin and Evelyn Joll. New Haven, Conn.: Yale University Press, 1987.
Turner: Paintings, Watercolors, Prints, and Drawings by Luke Herrmann. Boston: New York Graphic Society Books, 1975.

MUSEUMS
Tate Gallery, London; British Museum (Print Room), London; Victoria and Albert Museum (Print Room) London; National Gallery of Art, Washington, D.C.

WILLIAM BLAKE (1757–1827)

Blake was a mystical painter who claimed to have visions throughout his life. He was very religious and spiritual, and this provided the basis for his subject matter. He felt that because he painted from the imagination, his work was much better than if he had tried to copy nature. He chose watercolor and body color as his media for expression. He was not well known during his lifetime but lived an independent life devoted to his art and poetry. He experimented with water media, stretching them to their limits. I very much enjoy his imaginative, fanciful, curvilinear motifs that take on an ethereal, dreamlike quality. He did not use color to interpret his subjects literally, but rather to convey emotional content. The Tate Gallery in London has two full rooms devoted to Blake's work. The rooms are dimly lit to protect the fragile water media works on paper.

FURTHER RESEARCH
The Paintings and Drawings of William Blake by Martin Butlin (two volumes). New Haven, Conn.: Yale University Press, 1981.
The Paintings of William Blake by Raymond Lister. Cambridge, Mass.: Cambridge University Press, 1986.

MUSEUMS
Tate Gallery, London; British Museum, London; Fitzwilliam Museum, Cambridge, England

SAMUEL PALMER (1805–1881)

Palmer spent a fragile childhood reading classics, learning Latin, and developing his art. He came from a very religious heritage that was to form the spiritual basis for his art. He met William Blake when he was nineteen and was very much influenced by the master. Palmer's best work was done before his mid-thirties. He loved nature, and many of his mature paintings are pastoral landscapes with sheep and figures. He idealized these landscapes, which were from his inner vision. (Because I use sheep in some of my own paintings, I am interested in these works.) Some of his mixed media paintings incorporated watercolor, body color, pen, and varnish. His imaginary landscapes, like Blake's, use a fanciful, curvilinear motif. His color was dreamlike and very emotional.

FURTHER RESEARCH
The Paintings of Samuel Palmer by Raymond Lister. Cambridge, Mass.: Cambridge University Press, 1985.
Samuel Palmer: Catalogue Raisonné of the Paintings, Drawings, and a Selection of the Prints in the Ashmolean Museum, Oxford by D. B. Brown. New York: State Mutual Book and Periodical Service, 1983.

MUSEUMS
Fitzwilliam Museum, Cambridge, England; Tate Gallery, London; Victoria and Albert Museum (Print Room), London

IMPRESSIONISTS

The French impressionist school (late 1860s to early 1880s) grew out of the Barbizon school, whose members tried to capture nature as they saw it and did plein-air (outdoor) painting. Impressionism was also inspired by new theories on the use of color, and it was a reaction against the academic style of painting that dominated the French Academy shows. Many of the artists painted on location (en plein air) and focused on light and color while creating an impression of a moment. They were trying to capture a certain light or atmospheric effect. They used their color scientifically, relying on the ideas developed by M. E. Chevreul, a color theorist mentioned earlier in this book.

They applied the pigment in short broken strokes, a method now termed "broken color." The paintings were much brighter, lighter, and more airy than those done in previous styles. The movement spread throughout the western world—Italy, Scandinavia, Great Britain, the United States, and Spain, for example. Some of the major impressionist painters are Claude Monet, Édouard Manet, Camille Pissarro, Pierre-Auguste Renoir, Edgar Degas, Gustave Caillebotte, Frédéric Bazille, and Mary Cassatt. Color took a giant leap with this movement, and we are still feeling its effects today. The impressionists I have studied most intensely are Monet, Degas, and Cassatt.

CLAUDE MONET (1840–1926)

At an early age Monet began plein-air painting with Boudin and Jongkind. He then moved to the village of Barbizon to paint at the forests of Fontainebleau and was further influenced by Corot and Courbet. Using new color theories, he began experimenting and developed, along with Renoir, the broken-color technique. (Colors were painted close together on the canvas, so that the viewer's eye would blend them into a different color.) Monet was probably the truest impressionist in that he was almost entirely a landscape painter, focusing on color, light, atmosphere, and painting on location. He would sometimes focus on one theme, such as haystacks or the facade of Rouen Cathedral, and paint a series of paintings under different light, at different times of day and times of year.

During the latter part of his life, Monet moved to Giverny, where he organized a large studio and cultivated Japanese gardens and lily ponds. He used these for his subject matter in the rest of his work. I feel that these paintings are the culmination of a life devoted to broken color and impressionist vision. The color in these later canvases is highly expres-sionistic. The large canvases, sometimes diptychs and trip-tychs, are full of spontaneous, action brush strokes; juicy impasto pigment; and a shimmer of light and vibrant color. These paintings are certainly my favorites. Monet focused on shapes and movement, such as water, reflections, and lily pads, and treated the subject very abstractly. His studio and gardens have been restored, and it is possible today to visit Giverny, which is located just thirty miles from Paris.

FURTHER RESEARCH
Monet: The Masterworks by Jean-Paul Crespelle. New York: Universe Books, 1986.
Monet by Robert Gordon and Andrew Forge. New York: Abrams, 1983.
Monet's Years at Giverny: Beyond Impressionism by Daniel Wildenstein. New York: Abrams, 1978.

MUSEUMS
Metropolitan Museum of Art, New York; Museum of Modern Art, New York; National Gallery of Art, Washington, D.C.; Philadelphia Museum of Art; Cleveland Museum of Art; Art Institute of Chicago; National Gallery, London; Musée d'Orsay, Paris; Musée Marmottan, Paris

EDGAR DEGAS (1834–1917)

Degas was a driving force in organizing the impressionist exhibitions. He had come from a wealthy family and had an inheritance, so he did not need to depend on selling paintings. Although agreeing with many of the impressionists' philosophies, he was not primarily an outdoor painter. He studied the masters, particularly Ingres, and believed in a strong structured composition and the use of line. I have learned more about drawing and painting from Degas than from any other artist. His compositions are extraordinary. He often defied existing rules on composition and then made something work through value and color. He was influenced greatly by Japanese art and worked his subjects from a bird's-eye view, diagonal motif, and flat two-dimensional space. He experimented boldly with various drawing materials, pastel, watercolor, oil, intaglio, monoprints, and sculpture.

His main body of work deals with the figure. Degas concentrated on subjects such as racehorses, ballet dancers, and bathers. His later work was much looser, focusing on the generalized form in the composition. His color became far more emotional and powerful during this phase of his career. Yet the value of his drawings and paintings, the dark and light of the color, was always strong and held the structure of the composition together.

If I could study from only one artist, it would be Degas.

FURTHER RESEARCH
Edgar Degas: Life and Work by Denys Sutton. New York: Rizzoli International, 1986.
Degas: Pastels, Oil Sketches, Drawings by Gotz Adriani. New York: Abbeville Press, 1985.
Degas Pastels by Alfred Werner. New York: Watson-Guptill, 1984.

MUSEUMS
Norton Simon Museum, Pasadena, California; Metropolitan Museum of Art, New York; National Gallery of Art, Washington, D.C.; Musée d'Orsay, Paris

MARY CASSATT (1845–1926)

Cassatt came from a wealthy Pennsylvania family. In 1868 she traveled to Europe to study to become a painter. Her travels sent her to Italy, Spain, and Belgium, where she studied the masters. Eventually in Paris she fell under the influence of the impressionists, and in particular, her mentor Edgar Degas. Her oils and pastels are similar in handling and composition to those of Degas. She incorporated the color theories of the impressionists, and many of her works show a soft, delicate use of complements. Her compositions also show her study of Japanese prints. She also did a series of color intaglio prints that are highly original. Mary Cassatt encouraged American collectors to purchase the French impressionists' work, and her influence is one of the reasons American art museums have such good examples of impressionist art.

FURTHER RESEARCH
Mary Cassatt by Nancy Hale. Reading, Mass.: Addison-Wesley, 1987.
Mary Cassatt Oils and Pastels by E. John Bullard. New York: Watson-Guptill, 1984.
Mary Cassatt: A Catalogue Raisonné of the Graphic Work, rev. ed., by Adelyn D. Breeskin. Washington, D.C.: Smithsonian, 1980.

MUSEUMS
Philadelphia Museum of Art; National Gallery of Art, Washington, D.C.; Metropolitan Museum of Art, New York

Claude Monet, WATER LILY POND (LE BASSIN DES NYMPHEAS). Oil on canvas, 35 1/16″ × 36 3/8″ (89.2 cm × 92.3 cm). Courtesy of Denver Art Museum.

POSTIMPRESSIONISTS

Postimpressionism is a general term for two movements that grew out of impressionism beginning in the mid-1800s. Impressionism was concerned with light, movement, and scientific broken-color application. The postimpressionist movements took different paths. Cézanne and Seurat were analytical in their painting, emphasizing form and a preplanned spatial arrangement. This direction would eventually lead to the twentieth-century cubist movement. Van Gogh and Gauguin, on the other hand, were emotional and spiritual in their painting approach. Their intense use of color and spontaneous paint application would lead to the early-twentieth-century fauvist movement. This is an era I really respond to, and many of my favorite painters are from this period, particularly Cézanne, van Gogh, Gauguin, Toulouse-Lautrec, and Bonnard.

PAUL CÉZANNE (1839–1906)

As a young artist, Cézanne was very frustrated. He desperately wanted to paint in the traditional academic manner, but his draftsmanship and paint application were a bit clumsy. He was rejected by the École des Beaux-Arts and his entries in the national salon exhibitions were always refused. When he came in touch with the impressionists, his work began to take on a new character. His mature style is interesting in the use of color, but his major impact was his approach to composition. He used an analytical spatial arrangement in his compositions, simplifying forms and breaking them down into rectangular and triangular shapes. His paintings become exciting arrangements of flat, two-dimensional shapes and color that capture the essence of a subject. He was the leader in the modern art movement that used an analytical, intellectual approach.

FURTHER RESEARCH
Cézanne Watercolors by Gotz Adriani, translated from German by Russell M. Stockman. New York: Abrams, 1983.
A Collection of the Major Paintings by Cézanne in Full Colours. Albuquerque, N.M.: Gloucester Art Press, 1985.
Cézanne: The Late Work edited by William Rubin. Boston: New York Graphic Society Books, 1977.

MUSEUMS
Metropolitan Museum of Art, New York; Museum of Modern Art, New York; National Gallery of Art, Washington, D.C.; Musée d'Orsay, Paris

VINCENT VAN GOGH (1853–1890)

Van Gogh was the Dutch-born son of a minister. Although he had always been interested in art, he first attempted to enter the clergy, but his temperament was not suited for it. He moved to Paris and was in touch with many of the impressionist painters. This introduction to vivid color and to impasto plein-air paint application was the major influence on his painting career.

Most accounts of van Gogh's life depict him as a highly emotional, crazy man. This has sensationalized his life and distracted from the body of his unsurpassed, colorist paintings. He was actually a highly sensitive man who was extremely articulate and intellectual. One needs only read his letters to his brother Theo to get an understanding of this. He was always a student of the masters' drawings and paintings. As mentioned earlier, he commented on Vermeer's use of yellow and violet, two colors van Gogh would use repeatedly in his own work. During his fifteen-month stay at Arles, France, he produced more than two hundred paintings. He worked on location, using complementary color relationships, and sometimes a form of paint application called cloisonnisme that had been developed by his friend Gauguin.

Van Gogh was a master colorist who used his color for passionate, emotional impact. His impasto and curvilinear paint application became his unique signature. To see an original work from his mature period is a stirring, memorable experience.

FURTHER RESEARCH
Van Gogh by Pierre Cabanne. New York: Thames and Hudson, 1986.
Van Gogh, Twenty-Five Masterworks by A. M. Hammacher. New York: Abrams, 1984.
Van Gogh in Arles by Ronald Pickvance, edited by Emily Walter. New York: Metropolitan Museum of Art, 1984.
Van Gogh in Saint-Remy and Auvers by Ronald Pickvance. New York: Abrams, 1987.

MUSEUMS
Vincent van Gogh Museum, Amsterdam; Metropolitan Museum of Art, New York; Philadelphia Museum of Art; Museum of Fine Arts, Boston; Museum of Modern Art, New York

PAUL GAUGUIN (1848–1903)

Gauguin was a successful stockbroker, an avid collector of impressionist paintings, and an amateur painter. At thirty-five, he began painting professionally under the influence of impressionism. He felt, however, that the impressionist paintings used color for decorative effect, and he wanted to use color more intuitively and emotionally. His mature style incorporates an emotional and symbolic power of color. He lived in Pont-Aven, Brittany, for a while before going to Tahiti in 1891. His best-known paintings portray the primitive, unspoiled people there. In these works, large flat fields of intense color are surrounded by black or complementary colored boundaries or outlines. This painting style that Gauguin developed is called cloisonnisme. His emotional use of color is sensational. Moreover, his curvilinear, rhythmic, flowing compositions are equally exciting.

FURTHER RESEARCH
Gauguin: Life, Art, Inspiration by Yann Le Pichon. New York: Abrams, 1987.
Gauguin and the Impressionists at Pont-Aven by Judy Le Paul. New York: Abbeville Press, 1987.

MUSEUMS
Musée d'Orsay, Paris; National Gallery of Art, Washington, D.C.; Museum of Fine Arts, Boston; Metropolitan Museum of Art, New York

HENRI DE TOULOUSE-LAUTREC (1864–1901)

Toulouse-Lautrec was born in Albi, France, into an aristocratic family. Later in Paris he was influenced by Manet, Morisot, and Degas. He was drawn to the night life of Paris, and his images center on cabarets, brothels, and circus themes. His compositions have curvilinear flowing lines that relate him to the art nouveau movement, yet his compositions are also derived from Japanese art with diagonal movement, flat use of space, and sometimes a bird's-eye vantage point.

Toulouse-Lautrec's paintings are characterized by line. The paint application is not painterly, but rather the overlapping brush lines of a superb draftsman. In many instances, he used gouache watercolor on a warm brown cardboard surface. His color is characterized by strong value and rich, pure, vibrant paint in selected areas, with large, quiet spaces filled with semi-neutrals. His paintings have complementary color relationships throughout.

FURTHER RESEARCH
Toulouse-Lautrec: Painter of Paris by Horst Keller. New York: Abrams, 1968.
Toulouse-Lautrec by Edward Lucie-Smith. Topsfield, Mass.: Salem House, 1983.

MUSEUMS
Toulouse-Lautrec Museum, Albi, France; Musée d'Orsay, Paris; Metropolitan Museum of Art, New York; Art Institute of Chicago; Museum of Fine Arts, Boston; Courtauld Institute Galleries, University of London

PIERRE BONNARD (1867–1947)

Bonnard attended the French Académie Julian, where he met fellow artists Denis, Sérusier, and Vuillard. Eventually they formed a group called the Nabis. Within this group, Bonnard and Vuillard painted in a manner called intimism. The paintings were of people in interior settings and had a peaceful, restful atmosphere about them. The images closed off people from the outside world and gave a feeling of security and shelter within their own environment. Bonnard included his wife and dog in many of his compositions. His motifs were mainly horizontal-vertical and were saturated with shimmering color, light, and pattern. It is said that Bonnard would work on many canvases during the course of a day and orchestrate their development to conclusion. His compositions are fairly two-dimensional, and the placement of his various shapes within the picture plane is highly unusual. The most exciting aspect of Bonnard's work is color. His paintings are literally a feast of color. He used color in a decorative sense and borrowed from the impressionists' color theories.

Throughout his paintings, I have noticed complementary color arrangements. In many I also see the use of triadic color, mainly yellow orange, red violet, and blue green. The largest collection of Pierre Bonnard paintings is located at the Phillips Collection in Washington, D.C. It is worth the trip just to experience his powerfully sensitive paintings. (One of them is reproduced on page 125.)

FURTHER RESEARCH
Bonnard by Andre Fermigier, translated by Althea Schlanoff. New York: Abrams, 1969.
Bonnard: The Late Paintings by Sasha M. Newman. New York: Thames and Hudson, 1986.
Bonnard by Sasha M. Newman. London: The Phillips Collection and the Dallas Museum of Art in association with Thames and Hudson Publishers, 1984.

MUSEUMS
Phillips Collection, Washington, D.C.; Metropolitan Museum of Art, New York; Musée d'Orsay, Paris; Musée de Petit Palais, Paris

LATE 19TH- AND EARLY 20TH-CENTURY PAINTERS

The late nineteenth century was an extraordinarily productive period both in European and in American art. American painters of this era were highly influenced by European art movements. Many traveled and studied in England, Germany, and France before eventually developing their own unique styles. Among the many artists I admire from this period are Joaquín Sorolla, Winslow Homer, John Singer Sargent, John Henry Twachtman, and Arthur Melville (a Scottish artist I recently discovered).

JOAQUÍN SOROLLA Y BASTIDA (1863–1923)

Although not well known in the United States today, during his lifetime the Spanish painter Sorolla was considered a master. American painters traveled to his studio in Madrid just to study his work. His one-man show held in New York in 1909 was a smashing success with over 160,000 people in attendance. He considered himself an impressionist, and his paintings capture a moment in time and are flooded with Mediterranean coastal color and light. His paintings shimmer with color, but what distinguishes his work is the large masses of semineutral color that bind his patches of vivid color. He was a plein-air painter, bringing his models before him in the sun-drenched coastal setting. He differs from the French impressionists in color application. Whereas they used broken color, he used solid form much in the tradition of the Spanish masters.

Basic to his sense of form is the use of thin and thick paint application. Much of the canvas was layered very thin in transparent oil with adjacent swatches of impasto, opaque color.

From a distance, a powerful three-dimensional shape appears. Although he was also a portrait painter, his greatest work was in figurative landscape. He was commissioned by the Hispanic Society of America to paint large murals totaling 14 feet by 227 feet, depicting the cultural life of Spain. He accomplished this from 1911 to 1919. Today these murals as well as many of his finished canvases can be seen at this same museum in New York on the Upper West Side.

FURTHER RESEARCH
Los Genios de la Pintura Espanola Sorolla by Florencio de Santa Ana (American translation separate). Santa Fe, N.M.: Quijote Publications.
Sorolla by Trinidad Simo. Santa Fe, N.M.: Quijote Publications, 1980.
The Painter Joaquín Sorolla y Bastida edited by Edmund Peel. London: Philip Wilson Publishers, 1989.

MUSEUMS
Hispanic Society of America, New York; Sorolla Museum, Madrid

Joaquín Sorolla y Bastida, SEA IDYL. Oil on canvas, 59½" × 78½" (151.1 cm × 199.4 cm).
Courtesy of The Hispanic Society of America, New York.

WINSLOW HOMER (1836–1910)

As a young man, Homer began illustrating for *Harper's Weekly*. During the Civil War he was sent to the front to illustrate the life of the soldier. He later traveled to France and then spent two years in Cullercoats, England, studying and painting in an English watercolor style. Back in the United States, Homer eventually established a studio in Prouts Neck, Maine. It is here that he did his great coastal paintings. He also traveled to the Bahamas and the Florida Keys as well as the Adirondacks and Canada. On these outings he worked on location in watercolor.

I feel that his greatest work was in his watercolors throughout most of his career and his later oil paintings of the Maine coast. In these oil paintings, his power of simplicity both in composition and in color are evident. As mentioned earlier, he carried *The Principles of Harmony and Contrast of Colors* by Chevreul with him and incorporated these theories in his painting. Many of the coastal paintings use just two colors, red orange and blue green, but his range of semineutrals and his

mastery of value make the paintings great. After Degas, I have studied and learned more from Homer than from any other single artist.

FURTHER RESEARCH
Winslow Homer Watercolors by Helen A. Cooper. New Haven, Conn.: Yale University Press, 1986.
Winslow Homer—American Artist: His World and His Work by Albert Ten Eyck Gardner. New York: Bramhall House, 1961.
Winslow Homer by Lloyd Goodrich. New York: Whitney Museum of American Art, 1973.
The Life and Works of Winslow Homer by William H. Downes. New York: Franklin, 1974.

MUSEUMS
National Museum of American Art (part of Smithsonian Institution), Washington, D.C.; Metropolitan Museum of Art, New York; Sterling and Francine Clark Art Institute, Williamstown, Massachusetts; *drawing and print study rooms for watercolors*: Art Institute of Chicago; Brooklyn Museum; Museum of Fine Arts, Boston; Portland Museum of Art, Portland, Maine

JOHN SINGER SARGENT (1856–1925)

Sargent was born in Italy to American parents and started painting at an early age. After living for a short time in Paris, he spent most of the rest of his life in London. He made a great living as a portrait painter of high-society Europeans and Americans. I believe that his greatest works were his plein-air oil and watercolor landscapes. In these paintings one can feel his love for both nature and painting; he is not concerned about a commission but is painting just for himself. His paintings are characterized by spontaneous, loose, facile brush strokes. He was a master colorist who consciously worked with warm and cool color in every area of the painting. His outdoor painting captures intense shimmering light.

FURTHER RESEARCH
John Singer Sargent by Patricia Hills. New York: Abrams, 1986.
Sargent Watercolors by Donelson Hoopes. New York: Watson-Guptill, 1984.
John Singer Sargent by Carter Ratcliff. New York: Abbeville, 1986.
John Singer Sargent: Drawings from the Corcoran Gallery of Art by Edward J. Nygren. Layton, UT: Gibbs M. Smith, 1985.

MUSEUMS
Whitney Museum of American Art, New York; Brooklyn Museum; National Museum of American Art, Washington, D.C.; Corcoran Gallery of Art, Washington, D.C.; Museum of Fine Arts, Boston; Metropolitan Museum of Art, New York; Tate Gallery, London; *watercolors can be seen by appointment at drawing and print study rooms at*: Brooklyn Museum; Metropolitan Museum of Art, New York; Worcester Art Museum, Worcester, Massachusetts

JOHN HENRY TWACHTMAN (1853–1902)

Twachtman was born in Cincinnati, Ohio, where he studied under Frank Dubveneck. He went abroad and from 1883 to 1885 studied at the Académie Julian in Paris. There he was highly influenced by the impressionists and began painting in that manner. When he returned to the United States, he bought a farm in Greenwich, Connecticut. Here, like Monet at Giverny, Twachtman did his masterpieces. He concentrated on lyrical themes like a water pool on his farm, and loved to paint snow and atmosphere. His paintings became lighter and lighter until

his canvases were filled mainly with white chalky light. During the winters, he taught at the Art Students League in New York.

FURTHER RESEARCH
John Twachtman by Richard Boyle. New York: Watson-Guptill, 1979.

MUSEUMS
Cincinnati Art Museum; National Museum of American Art (part of Smithsonian Institution), Washington, D.C.; Metropolitan Museum of Art, New York

ARTHUR MELVILLE (1855–1904)

Melville is unknown in most countries outside his homeland of Scotland, but still I feel that he should be mentioned. I saw a few paintings of his when I was in Great Britain, and they were the most memorable images of my five-week studies there. In 1878 Melville went to Paris to study. He was in contact with the impressionists and then went to Barbizon for further growth. After a three-year stay, he ventured to Egypt and the Persian Gulf. His mature paintings center on his travels to Spain, Morocco, and Italy. He worked primarily in watercolor—or, more accurately, water media—to capture a strong feeling for light and color.

Melville developed an approach to his painting that distinguished his unique style. He would first prepare his paper by impregnating it with opaque Chinese white watercolor. He would then make a light drawing and commence applications of transparent watercolor. The white underlayer would enhance the application of pure transparent color, and at times if he wanted to push and pull his paint to create transitions, he would simply scrub the underlayer to lift opaque paint and create

effective blotchy movement. If exhibited today, his work would be as contemporary as most paintings in a national water media show.

During his lifetime he was well known. After returning from Spain, Morocco, and Italy to Scotland, he established himself as the leader of the Glasgow School. He served on committees with Whistler and Sargent to judge and select works of art for exhibitions. Melville spent his honeymoon in France, where he and his wife stayed with Rodin. His work should be known. The color and light that he achieved are unsurpassed in water media painting.

FURTHER RESEARCH
Arthur Melville by Agnes Mackay. Calne, England: Hilmarton Manor Press, 1951. (This is an extremely rare book, with only 500 copies published.)

MUSEUMS
Dundee City Art Gallery, Dundee, Scotland; Glasgow Museums and Art Galleries, Glasgow, Scotland; Victoria and Albert Museum, London

Arthur Melville, AUTUMN—LOCH LOMOND. Watercolor on paper, 23¼″ × 33½″ (59.1 cm × 85.1 cm).
Courtesy of Glasgow Art Gallery and Museum, Glasgow, Scotland.

THE EIGHT AND ITS SCHOOL

In the first decade of the twentieth century, some artists in New York formed a group called The Eight. Many of these artists were dedicated to painting the everyday common life in the city. This was termed the Ashcan school. Some were more experimental and advocated new and unacademic approaches. They all reacted against the traditional school of the National Academy. These eight painters were Robert Henri, John Sloan, George Luks, William Glackens, Everett Shinn, Maurice Prendergast, Arthur B. Davies, and Ernest Lawson. (Connected with these painters but somewhat younger were other artists such as George Bellows and Edward Hopper.) This school helped to change the course of modern art in the United States. Although I have studied and admire all these painters, two really stand out in my mind: Robert Henri and John Sloan.

ROBERT HENRI (1865–1929)

Henri was a dynamic individual and a natural leader. He was the leader of The Eight and probably the most influential of this group. Besides doing his own painting, he was an inspirational art teacher in New York City; many of his students have since become leading painters of newer contemporary schools. He did not teach his students to follow his own painting style, but rather to grow and develop their own personal vision. His book *The Art Spirit* is still in print today, and his philosophy continues to inspire artists. He was a landscape and portrait painter who had learned from the masters Velázquez, Hals, and Rembrandt. He studied the impressionist painting approach and for a while painted this way. He was constantly experimenting with color theories and taught these theories to his students in New York. Finally he settled on the Maratta System, a rationally ordered system of color harmony. Henri developed a very personal style of painting distinguished by loose, spontaneous strokes and harmonious color relationships.

FURTHER RESEARCH
Robert Henri: His Life and Art by Bernard B. Perlman. New York: Horizon, 1984.
Robert Henri and His Circle by William Innes Homer. Ithaca, N.Y.: Cornell University Press, 1969.
The Art Spirit by Robert Henri, edited by Margery A. Ryerson. New York: Harper & Row, 1984.
The Eight by Mahonri Sharp Young. New York: Watson-Guptill, 1973.

MUSEUMS
Whitney Museum of American Art, New York; Wichita Art Museum, Wichita, Kansas; Metropolitan Museum of Art, New York; Museum of New Mexico, Santa Fe; Brooklyn Museum; Art Institute of Chicago

JOHN SLOAN (1871–1951)

Sloan was a newspaper illustrator in Philadelphia who moved to New York and became a great painter and teacher. He was a very close friend of Henri's, and they spent much time together talking of color theories and art philosophy. He was one of the organizers of the famous Armory show in 1913 that brought contemporary art from Europe and the United States together. He was an instructor at the Art Students League and was its president in 1931. His book *Gist of Art* preaches his theories and beliefs on drawing, composition, painting, and color. He used the Dudeen Triangle system for color, a system I studied that was an impetus for the development of my own color wheel. His early painting is of the Ashcan school, painting the everyday life of New York City. In his later years, Sloan became even more experimental with his color application, while painting a series of nudes and landscapes. He also was a fine printmaker and did a series of etchings on genre themes in New York City.

FURTHER RESEARCH
Selection of Etchings by John Sloan edited by Robert F. Bussabarger and Frank Stack. Columbia, Mo.: University of Missouri Press, 1967.
John Sloan: Paintings, Prints, Drawings by Robert L. McGrath. Hanover, N.H.: University Press of New England; 1981.
John Sloan 1871–1951 by David W. Scott and E. John Bullard. Washington, D.C.: National Gallery of Art, 1971.

MUSEUMS
Delaware Art Museum (Sloan Archives), Wilmington; Columbus Gallery of Fine Arts, Columbus, Ohio; Whitney Museum of American Art, New York; Metropolitan Museum of Art, New York; National Gallery of Art, Washington, D.C.; Bowdoin College Museum of Art, Brunswick, Maine

THE TAOS SCHOOL

Taos is a community of artists located in northern New Mexico at the foot of the Sangre de Cristo Mountains. Its culture is based on those of the Indian and Hispanic peoples; several Indian pueblos are nearby.

At the end of the nineteenth century, Anglo artists from the East traveled to the Southwest in search of new painting material. When Ernest Blumenschein and Bert Phillips found Taos in 1898, there were only twenty-five Anglos living in the community. The light and atmosphere of this area are unique to northern New Mexico. The color and texture of the mountains, valley vegetation, arroyos, and streams—and the Indian and Hispanic cultures—opened a new world to these artists.

By 1920 there were many Anglo painters living and working in Taos. Many of these painters had studied in the East and had been abroad to study in England, France, and Germany. Thus their paintings had solid foundation in color and composition. I love the paintings from this era. There is a fresh energy of excitement that radiates from these works. Artists such as Robert Henri, John Sloan, George Bellows, John Marin, Marsden Hartley, Edward Hopper, and Georgia O'Keeffe at one time or another painted this area. Today Taos is a thriving community with new artists settling there all the time.

Each artist of the Taos school has a personal vision and sense of color. Those I have studied most are Ernest Blumenschein, Victor Higgins, Oscar Berninghaus, E. Martin Hennings, Leon Gaspard, Tony Mygatt Lucas, and Doel Reed. Although there is not much literature on any individual artist, there are many books on the Taos school in general. Look through these books and visit some of the collections listed. You will find paintings with fresh approaches, beautiful light, and exciting color harmony.

FURTHER RESEARCH

Pioneer Artists of Taos, rev. ed., by Laura Bickerstaff. Denver, Colo.: Old West Publishing, 1984.
Taos: A Painter's Dream by Patricia J. Broder. Boston: New York Graphic Society Books, 1980.
The Legendary Artists of Taos by Mary Carroll Nelson. New York: Watson-Guptill, 1980.
Taos and Its Artists by Mabel Dodge Luhan. New York: Duel, Sloan, and Pierce, 1979.
Masterworks of the Taos Founders by Peters Corporation staff. Santa Fe, N.M.: Peters Corp., 1984.
Picturesque Images from Taos and Santa Fe by Patricia Trenton. Denver, Colo.: Denver Art Museum, 1974.
Victor Higgins by Dean Porter. Notre Dame, Ind.: University of Notre Dame, 1975.
Leon Gaspard, 2nd ed., by Frank Waters. Flagstaff, Arizona: Northland Press, 1964.

MUSEUMS

Museum of Western Art, Denver; Denver Art Museum; Rosenstock Arts, Denver; Colorado Springs Fine Arts Center; Harwood Foundation, Taos, New Mexico; Helene Wurlitzer Foundation, Taos, New Mexico (*by appointment*); Museum of New Mexico, Santa Fe; Fenn Galleries, Ltd., Santa Fe; Gerald Peters Gallery, Santa Fe; Museum of Albuquerque, New Mexico; Roswell Museum and Art Center, Roswell, New Mexico; San Antonio Art League; Stark Museum of Art, Orange, Texas; Thomas Gilcrease Institute of American History and Art, Tulsa, Oklahoma

Ernest Blumenschein, ADOBES IN WINTER. Oil on canvas, 34" × 50" (86.4 cm × 127.0 cm). Courtesy of Museum of Western Art, Denver. Photograph by James O. Milmoe.

MORE AMERICAN PAINTERS

There are many other American artists whom I admire and from whom I have learned. Some of these are more traditional in their painting, while some are more contemporary. Of the many painters, I will mention N. C. Wyeth, Edward Hopper, George Bellows, Georgia O'Keeffe, Andrew Wyeth, Wayne Thiebaud, and Wolf Kahn.

NEWELL CONVERS WYETH (1882–1945)

N. C. Wyeth studied illustration with Howard Pyle, a well-known illustrator, at the Howard Pyle School of Art in Wilmington, Delaware, in 1902. He spent some time in the West sketching, painting, and illustrating before setting up a permanent studio in Chadds Ford, Pennsylvania. While very young, he became an extremely well-known illustrator. He did the illustrations for *The Last of the Mohicans, Treasure Island, Kidnapped, Robin Hood, Rip Van Winkle*, and many others. These books are still being reprinted with the original illustrations. To me, however, these works are far greater than mere illustrations. He obviously lived in them and used tremendous

imagination and creativity. Wyeth's compositions contain a highly unusual placement of shapes, and his color was magical. He was influenced by the Spanish colorist Sorolla.

FURTHER RESEARCH
N. C. Wyeth by Douglas Allen and Douglas Allen, Jr. New York: Bonanza, 1972.
An American Vision: Three Generations of Wyeth Art by James H. Duff, et al. Boston: New York Graphic Society Books, 1987.

MUSEUMS
Brandywine River Museum, Chadds Ford, Pennsylvania; New York Public Library; Southern Arizona Bank and Trust, Tucson

EDWARD HOPPER (1882–1967)

Hopper attended the William Merritt Chase Art School and studied with Chase and Robert Henri. He went to Paris from 1906 to 1907 and studied the impressionists work. There he became interested in light, and his palette became lighter. His first success was in intaglio printmaking. His prints of people and life in the city show unusual vantage points for composition, strong value relationships, and great line quality.

Hopper was almost forty when he had had enough success in commercial art to begin painting full-time. His subjects are either of the city or rural landscapes and deal with the coldness and isolation of people in their environment. A strong, harsh light, either natural or artificial, characterizes Hopper's paintings. They also have a distinct sense of form. His on-location

watercolors, which Hopper painted throughout his life, also reveal his clear feeling for light and form.

FURTHER RESEARCH
Edward Hopper by Lloyd Goodrich, New York: Abrams, 1985.
Edward Hopper by Robert Hobbs. New York: Abrams, 1987.
Edward Hopper: The Art and the Artist by Gail Levin. New York: Norton, 1986.
Hopper's Places by Gail Levin. New York: Knopf, 1985.

MUSEUMS
Whitney Museum of American Art, New York; Yale University Art Gallery, New Haven, Connecticut; Metropolitan Museum of Art, New York; Museum of Modern Art, New York; Hirshhorn Museum and Sculpture Garden (part of Smithsonian Institution), Washington, D.C.; Wichita Art Museum, Wichita, Kansas

GEORGE BELLOWS (1882–1925)

Bellows moved from Ohio to New York City in 1904 to start his painting career by studying with Robert Henri, and they eventually became good friends. Bellows also studied with H. G. Maratta and learned his harmonious color theories well. He also taught at the Art Students League in New York.

Bellows is best known for his fight scenes, but to me his cityscapes and landscapes are the most exciting. He had a vigorous, spontaneous application of paint and an unusual sense for composition. His color was rich, visually stimulating, and highly personal. He had an elongated, stylized approach to his figures and landscapes that make them easily identifiable.

FURTHER RESEARCH
George Bellows: Painter of America by Charles H. Morgan. Millwood, N.Y.: Kraus Reprint and Periodicals, 1979.
George Bellows: The Personal Side. Macon, Ga.: Museum of Arts and Sciences, 1984.
George Bellows and the Ashcan School of Painting by Donald Braider. Garden City, N.Y.: Doubleday, 1971.

MUSEUMS
Columbus Gallery of Fine Arts, Columbus, Ohio; Museum of Fine Arts, Springfield, Massachusetts; Metropolitan Museum of Art, New York; Whitney Museum of American Art, New York; National Gallery of Art, Washington, D.C.; Corcoran Gallery of Art, Washington, D.C.

MORE AMERICAN PAINTERS

GEORGIA O'KEEFFE (1887–1986)

O'Keeffe studied art at the Art Institute of Chicago and the Art Students League in New York. She taught art in Amarillo, Texas, and West Texas Normal College. In 1916 she had her first one-woman show at Gallery 291 in New York City. She eventually married the director Alfred Steiglitz, who was a well-known photographer.

O'Keeffe is most widely known for her numerous large, abstracted floral paintings, and for her landscapes of the Southwest. (One famous series shows animal skulls against a desert background.) The essence of forms is evident in her paintings, and her motifs follow an abstract, rhythmic pattern. Her paintings are also very sensitive in their use of color, derived from her inner vision.

FURTHER RESEARCH
Georgia O'Keeffe: One Hundred Flowers by Nicholas Callaway. New York: Knopf, 1987.
The Art and Life of Georgia O'Keeffe by Jan G. Castro. New York: Crown, 1985.
Georgia O'Keeffe: The "Wideness and Wonder" of Her World by Beverly Gherman. New York: Macmillan, 1986.
An Enduring Spirit: The Art of Georgia O'Keeffe by Katherine Hoffman. Metuchen, N.J.: Scarecrow, 1984.
Georgia O'Keeffe: Selected Paintings and Works on Paper by Margaret Morris. Santa Fe, N.M.: Peters Corp., 1986.

MUSEUMS
Art Institute of Chicago; Whitney Museum of American Art, New York; Metropolitan Museum of Art, New York; Museum of Modern Art, New York; Philadelphia Museum of Art; Amon Carter Museum of Western Art, Fort Worth, Texas

ANDREW WYETH

Andrew Wyeth is the son of N. C. Wyeth. Born in 1917, he grew up in an extremely creative environment and was painting full-time by his late teens. He had early success with loose colorful watercolors of land and seascapes, a period of his art that I like very much. However, he is best known for his tightly controlled egg temperas and dry-brush watercolors. In these paintings Wyeth applied earthy semineutral textural layers of paint. His use of value is superb. Although he is known as a realist, his paintings compositionally are very abstract. Selecting subject matter around Chadds Ford, Pennsylvania, and Cushing, Maine, he creates moods that emanate from a sensitive, very personal vision. Some of his best egg temperas capture a quality of light that I have only seen in his and Vermeer's work.

FURTHER RESEARCH
Andrew Wyeth: The Helga Paintings. New York: Abrams, 1987.
The Art of Andrew Wyeth edited by Wanda M. Corn. Boston: New York Graphic Society Books, 1973.
Two Worlds of Andrew Wyeth by Thomas Hoving. Boston: Houghton Mifflin, 1978.
In the Footsteps of the Artist: Thoreau and the World of Andrew Wyeth with photos by James A. Warner and Margaret J. White. Wilmington, Del.: Middle Atlantic Press, 1986.
An American Vision: Three Generations of Wyeth Art. Boston: New York Graphic Society Books, 1987.

MUSEUMS
Brandywine River Museum, Chadds Ford, Pennsylvania; William A. Farnsworth Library and Art Museum, Rockland, Maine; Philadelphia Museum of Art; Delaware Art Museum, Wilmington; New Britain Museum of American Art, Connecticut

WAYNE THIEBAUD

Thiebaud was born in Mesa, Arizona, in 1920. He developed an interest in drawing and decided to study commercial art. After working in this field in Los Angeles and New York, Thiebaud returned to school. He attended San Jose State University and California State University, where he pursued his interest in painting. In 1951 he began teaching at Sacramento City College and in 1960 was appointed to the Department of Art at the University of California at Davis. In 1962 he had a one-man exhibit at the Allan Stone Gallery in New York City, for which he received national recognition. His images at the time were of pies, gum ball machines, and food, which tied him in with the pop art movement. He has since done a series of paintings using the figure, and is currently working with cityscape images of San Francisco. All Thiebaud's painting is done from life, from drawings, or from memory.

Thiebaud's work is remarkable for its rich, vibrant color interaction and a method of paint application that emulates the surface of the subject. The paint surfaces have a thick *alla prima* sensuousness about them. The edges of the images in his work have adjacent bands of color that he calls halation, which radiate, create vibration, and ease the transition to the next area. His paintings get to the essence of the subject. He believes that all art comes from previous art and that one must study the masters, go to major exhibitions, and test one's work against the best.

FURTHER RESEARCH
Wayne Thiebaud by Karen Tsujimoto. Seattle, Wash.: University of Washington Press for the San Francisco Museum of Modern Art, 1985.

MUSEUMS
E. B. Crocker Art Gallery, Sacramento, California; Oakland Museum, California; San Francisco Museum of Modern Art

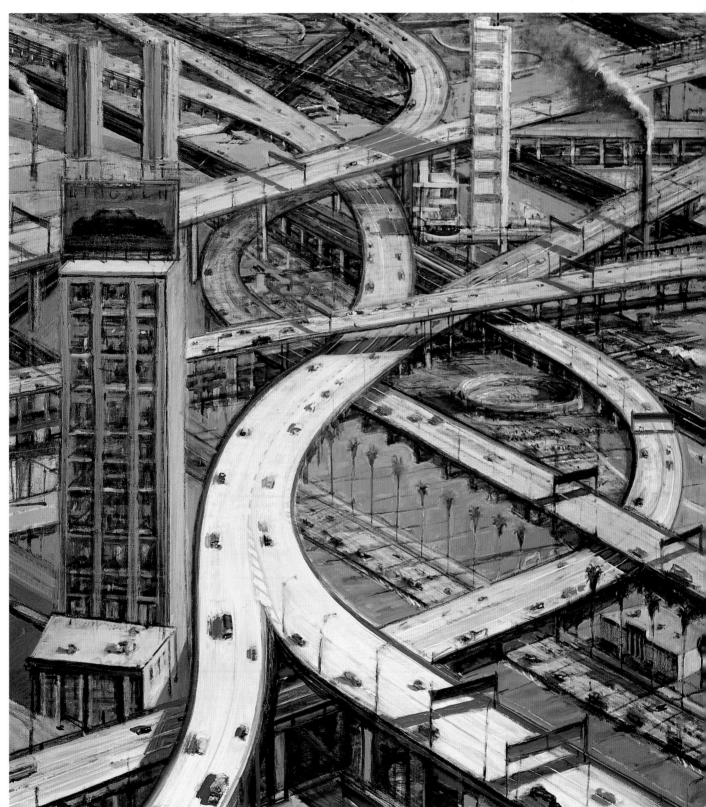

Wayne Thiebaud, URBAN FREEWAYS. 1979–1980, oil on canvas, 44⅜″ × 36⅛″ (112.7 cm × 91.8 cm). Private collection. Used by permission of the artist.

WOLF KAHN

Kahn was born in Stuttgart, Germany, in 1927, and moved to the United States in 1940. He attended the High School of Music and Art in New York City and studied with the well-known abstract expressionist painter Hans Hofmann from 1947 to 1949. He uses a variety of recurrent subjects from nature, such as barns, ponds, forests, and the river. "I think familiarity with a place is essential. . . . In order to make a good painting I have to know the site very well. . . . My art is based on deepening the experience rather than having a lot of different experiences."

Strong gestural drawing and daring color are typical of Kahn's work. His sumptuous fields of color establish the emotional potential of the composition. Kahn's images deal with radiance of light from objects in nature—not so much the divisions between things, but more the *lack* of division between them. Kahn states, "I have no color theory. I think that I just have a good color sense and have learned a lot about color simply by looking at the work of great colorists." Kahn believes that because one is "more alert to the possibilities of color, all sorts of other possibilities then go along with that: the possibilities of greater affection for things, greater tenderness towards the world at large, greater generosity in life generally. . . . If you are an artist in any kind of way, what you are really driving toward is to become a deeper person."

FURTHER RESEARCH

Wolf Kahn: Landscape Painter by Martica Sawin. New York: Taplinger, 1981.
Pastel Light by Wolf Kahn. Barrytown, N.Y.: Station Hill Press, 1983.
Wolf Kahn: Landscapes (catalogue for traveling exhibition) by Dore Ashton. San Diego Museum of Art, 1983.

MUSEUMS

Grace Borgenicht Gallery, Inc., New York; Meredith Long Gallery, Houston; Harkus-Krakow Gallery, Boston; Gerald Peters Gallery, Santa Fe, New Mexico; Fontana Gallery, Philadelphia

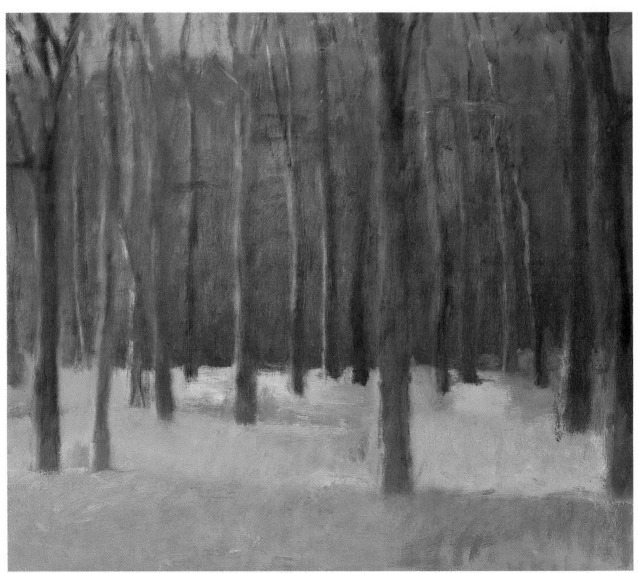

Wolf Kahn, MOVING IRREGULARLY BACK IN A WOODED SPACE. 1987, oil on canvas, 26″ × 30″ (66.0 cm × 76.2 cm). Private collection. Used by permission of the artist.

HISTORICAL PERSPECTIVE ON COLOR THEORY

I firmly believe that a solid foundation in the theory of color is essential in developing a vocabulary of artistic self-expression. The more any artist can learn about mixing color, color relationships, value and intensity of color, how color affects color, the emotional content of color, dominant hue, and how color affects the eye, the more accurately that artist can say what he or she wants to say. Mood, emotion, atmospheric effects, light quality, form, and accurate rendering of the subject can all be achieved with this knowledge. It takes a great deal of time and continual study, but in the end it is worth it. This idea has been constantly reinforced as I delve into various movements throughout art history.

In my research of these movements throughout the history of painting, I have become aware of how certain systems and color theories that developed during various times have influenced the direction of painting. The painters of the Middle Ages and the Renaissance used carefully set palettes and definite tonal relationships in the development of their work. They used a proven system for mixing and applying paint. This approach had been handed down from master to apprentice, generation to generation, in order to ensure that the tradition, quality, and knowledge would continue. The seventeenth-century Dutch school (with artists such as Rembrandt, Vermeer, Rubens, Hals, and de Hooch) used the grisaille (gray) system of painting and glazing color. As described earlier, this system ensured strong value relationships and the solid development of form, as well as beautiful transparent color depth.

The development of color took a giant step in the mid-nineteenth century as a result of the scientific research of the Frenchman M. E. Chevreul. His theories were published in his book *The Principles of Harmony and Contrast of Colors* in 1839. This book was the main influence on color for the impressionists and neo-impressionists and has had a major influence on such modern schools as op art. Chevreul dealt with the harmony of monochromatic colors, adjacent colors, and complements, and the concept of dominant hue. His theories of simultaneous contrast, successive contrast, and mixed contrast are still being taught in color theory education today. The impressionist Camille Pissarro was an advocate of his theories and spread the word to such artists as Cézanne, Monet, Renoir, and van Gogh. As for American artists, it was mentioned earlier that Winslow Homer carried Chevreul's book everywhere and referred to it as his bible. The pointillist scientific painting system of Seurat and Signac is the direct result of Chevreul's theory of mixed contrast.

Ogden Rood, a professor of physics at Columbia College in New York, wrote the books *Modern Chromatics* in 1879 and *Text-Book of Color* in 1881, which were readily accepted by the neo-impressionists. His books dealt more with light, wavelength, and optics concerning color.

Hardesly Gillmore Maratta is certainly not a familiar name today. He was an unsuccessful painter from Chicago who developed a rationally ordered system of color harmony and traveled to the major art centers to demonstrate his system and sell the pigments that were needed to make it work. These pigments were called Margo Colors. From about 1912 to the early 1920s, his teaching attracted the attention of many major American artists, including members of the Ashcan school. Robert Henri, John Sloan, and George Bellows, three artists who used color in very unusual and particularly exciting relationships, were all advocates of the Maratta method of achieving harmony of color through triadic arrangements. Denman Waldo Ross, lecturer of design at Harvard University, wrote a book entitled *The Painter's Palette*, published in 1919, which maps out some of Maratta's triadic color theories. Maratta's theories helped these artists conceive of color harmony and relationships abstractly before painting the picture. Henri actually believed in this system so strongly that he resigned his teaching position at the New York School of Art (the Chase School) over it. He wanted to require all the students to adopt this painting approach, while others felt it should be optional.

Major contemporary art movements such as op art and color field painting have been influenced not only by the nineteenth-century work of Chevreul but also by the work of Josef Albers and Johannes Itten. Albers's book *Interaction of Color* (rev. ed.; New Haven, Conn.: Yale University Press, 1975) and Itten's book *The Elements of Color* (edited by Faber Birren; New York: Van Nostrand Reinhold, 1970) deal with color optics and how color affects color. The ideas of vibration and radiation, so prevalent in these movements, can be found here.

Many of today's painters use the color theory developed by Albert H. Munsell to develop a good basic understanding of the relationship of value, intensity, and hue. Noted color expert Faber Birren has written over twenty books on color, dealing with virtually every aspect of the subject. His work will provide in-depth information for the serious color student.

As you can tell, the history of art and the history of color theory have always been closely intertwined. The work of the authors, scientists, and painters just mentioned—as well as that of many others not mentioned—has made it possible for major art movements to develop. Each new art movement, in turn, has provided new possibilities for color theory. Painting and color theory are constantly in a dialogue, learning and benefiting from each other's breakthroughs.

A similar relationship holds true on an individual level. An in-depth study of color theory will enhance an artist's ability to paint, while hours of painting will enhance his or her understanding of color theory. By developing both together, any artist can build a solid foundation of knowledge that will ultimately free him or her to discover a surer, more personal approach to self-expression.

EPILOGUE

For two weeks I worked on this painting. I had to travel by four-wheel drive two miles down a steep, rocky road to get to the site and set up my large easel and palette that were hidden in the timber close by. It was mid-September, which meant that I could expect any kind of weather from corn snow to warm sun. To continue to work during such changeable conditions, I built a shelter by stretching clear plastic over the top of my easel to some adjacent aspen. But in fact I was enjoying working on this painting so much that I hardly even noticed the weather. Each day I would wake and look forward to working on the painting.

One day early on while working with this composition, I took an artist friend along. He did a completed study while we were there. While driving us home I noticed that he continued to look at his painting, which was braced up against the back seat. I could see that he felt good about his painting. He had created it,

and it was still part of him. He was savoring the moment.

That is how I felt about my painting. I did not want the experience of working on it to end, yet I could not wait to see it completed, varnished, and framed. I loved that painting!

Furthermore, that is how I feel about this book. A lot of time and work have gone into it, and the project has brought me great joy. Much love and caring have gone into the paintings, studies, and manuscript. During the two years that it has taken to complete this book, it has always been on my mind. I would love to hold on to the experience of working on *Color Choices*, yet I am even more excited about giving birth to these ideas in the book. We are here to grow as painters and can do this by reading, learning, sharing our knowledge, and continuing to pursue our painting. I hope that the information and thoughts in this book will help you along your painting path.

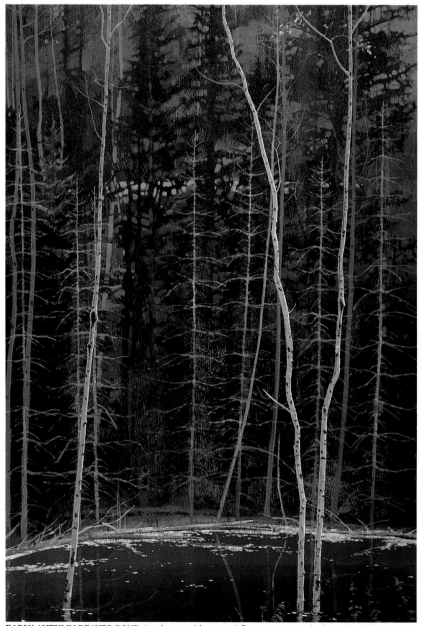

EARLY AUTUMN BEAVER POND Acrylic on cold-pressed Crescent watercolor board no. 114, 24" × 36" (61.0 cm × 91.4 cm). Collection of Doris Hennan, Carole Hennan, and John Bruce.

BIBLIOGRAPHY

Albers, Joseph. *Interaction of Color*, rev. ed. New Haven, Conn.: Yale University Press, 1975.

Birren, Faber. *Color: A Survey in Words and Pictures.* Secaucus, N.J.: Lyle Stuart, 1984.

———. *Creative Color.* West Chester, Pa.: Schiffer, 1987.

———. *History of Color in Painting.* New York: Van Nostrand Reinhold, 1965.

Boyle, Richard J. *American Impressionism.* Boston: New York Graphic Society Books, 1974.

Brett, Bernard. *A History of Watercolour.* London: Hamlyn Publishing Group, 1984.

Chevreul, M. E. *The Principles of Harmony and Contrast of Colors.* New York: Van Nostrand Reinhold, 1967.

Cooper, Helen A. *Winslow Homer Watercolors.* New Haven, Conn.: Yale University Press, 1986.

Dustan, Bernard. *Painting Methods of the Impressionists*, rev. ed. New York: Watson-Guptill, 1983.

Gottsegen, Mark D. *A Manual of Painting Material and Techniques.* New York: Harper & Row, 1987.

Graves, Maitland. *The Art of Color and Design.* New York: McGraw-Hill Book Company, 1951.

Henri, Robert. *The Art Spirit*, edited by Margery A. Ryerson. New York: Harper & Row, 1984.

Homer, William Innes. *Robert Henri and His Circle.* Ithaca, N.Y.: Cornell University Press, 1969.

Hoopes, Donelson F. *The American Impressionists.* New York: Watson-Guptill, 1972.

Itten, Johannes. *The Elements of Color*, ed. Faber Birren. New York: Van Nostrand Reinhold, 1970.

Leymarie, Jean. *Watercolors: From Dürer to Balthus.* New York: Rizzoli International, 1984.

Mayer, Ralph. *The Artist's Handbook of Materials and Techniques*, 4th rev. ed. New York: Viking, 1981.

Myers, Bernard S. *Encyclopedia of Painting.* New York: Crown, 1979.

Nelson, Mary Carroll. *The Legendary Artists of Taos.* New York: Watson-Guptill, 1980.

Nochlin, Linda. *Realism and Tradition in Art, 1848–1900: Sources and Documents.* Englewood Cliffs, N.J.: Prentice-Hall, 1966.

Ocvirk, Otto G., et al. *Art Fundamentals—Theory and Practice*, 5th ed. Dubuque, Iowa: William C. Brown, 1985.

Quiller, Stephen, and Barbara Whipple. *Water Media: Processes and Possibilities.* New York: Watson-Guptill, 1986.

———. *Water Media Techniques.* New York: Watson-Guptill, 1983.

Rogers, Peter. *A Painter's Quest: Art as a Way of Revelation.* Santa Fe, N.M.: Bear & Co., 1987.

Rood, Ogden. *Text-Book of Color.* New York: Appleton, 1881.

Ross, Denman. *The Painter's Palette.* Boston: Houghton Mifflin, 1919.

Saitzyk, Steven L. *Art Hardware.* New York: Watson-Guptill, 1987.

Samuels, Mike, and Nancy Samuels. *Seeing with the Mind's Eye.* Toronto: Random House of Canada, 1975.

Sawin, Martica. *Wolf Kahn: Landscape Painter.* New York: Taplinger, 1981.

Silva, Jose, and Philip Miele. *The Silva Mind Control Method.* New York: Pocket Books, 1978.

Sloan, John. *Gist of Art: Principles and Practise Expounded in the Classroom and Studio.* New York: Dover, 1977.

Truettner, William H., et al. *Art in New Mexico, 1900–1945: Paths to Taos and Santa Fe.* New York: Abbeville, 1986.

Tsujimoto, Karen. *Wayne Thiebaud.* Seattle: University of Washington Press for the San Francisco Museum of Modern Art, 1985.

Vandier-Nicolas, Nicole. *Chinese Painting: An Expression of a Civilization.* New York: Rizzoli International, 1983.

Wilcox, Michael. *The Wilcox Guide to the Best Watercolor Paints.* Perth, Western Australia: Artways, 1991.

Worcester Art Museum Staff and Susan E. Strickler. *American Traditions in Watercolor.* New York: Abbeville, 1987.

Young, Mahonri Sharp. *The Eight.* New York: Watson-Guptill, 1973.

INDEX